Greg 2007

Love from Mom

H TYPEWRITER

Form 621

.30 a.m.

No. if in series

ver by NSP plant...

t. Paul near
High Bridge

Tel.

king up river at raging flood

T. C. - Damn Visit

ger, Rolvaag, McCarthy, Mondale

nor Rolvaag, U. S. Senators

d Congressman MacGregor Stand

Mississippi.

...four tugboats are moored at the foot of the island for protection. Others in the picture, left to right, are Rep. Clark MacGregor, R-Minn.; Gov. Karl Rolvaag, Sens. McCarthy and Mondale, and a secret service man.

—Pioneer Press photo by Roy Derickson.

LARRY MILLETT

STRANGE DAYS

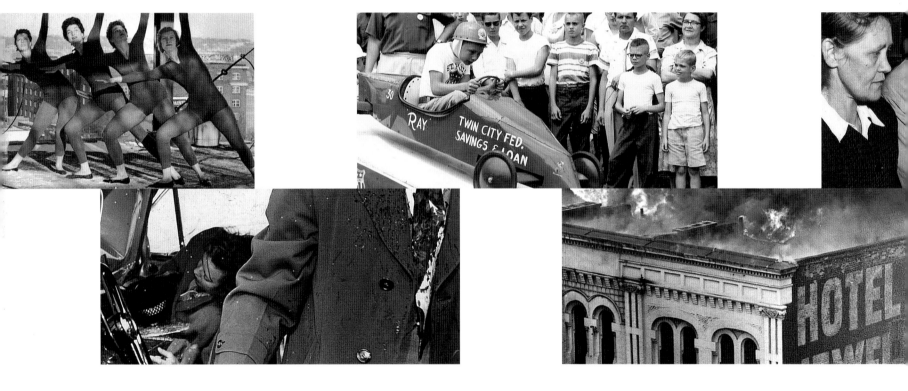

BOREALIS
BOOKS

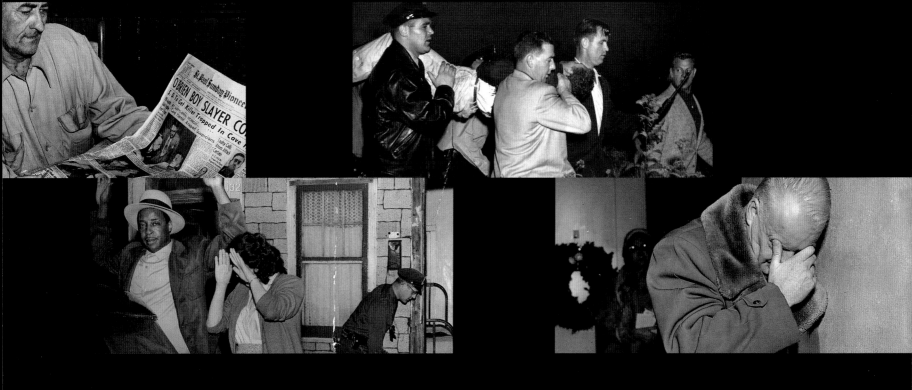

DANGEROUS NIGHTS

PHOTOS FROM THE SPEED GRAPHIC ERA

Borealis Books is an imprint of the
Minnesota Historical Society Press.

www.borealisbooks.org

The Minnesota Historical Society Press
is a member of the Association of American
University Presses.

Manufactured in China by Pettit Network, Inc.,
Afton, Minnesota

Book and jacket design by Cathy Spengler

10 9 8 7 6 5 4 3

∞ This book is printed on a coated paper manufac-
tured on an acid-free base to ensure a long life.

International Standard Book Number
0-87351-504-8 (cloth)

Library of Congress Cataloging-in-Publication Data

Millett, Larry, 1947–
Strange days, dangerous nights : photos from the
speed graphic era / Larry Millett.
 p. cm.
ISBN 0-87351-504-8 (casebound : alk. paper)
 1. Photography, Artistic.
 2. Graphic camera.
 3. Photography—Minnesota—Minneapolis.
 4. Photography—Minnesota—Saint Paul.
 I. Title.

TR654.M55 2004
070.4'9'09776581—dc22

 2003026941

FOREWORD John Sandford

PHOTOGRAPHY HAS NEVER BEEN JUST ONE THING.

Both art and technology, both creative and mechanical, sometimes chemical and at others electronic, sometimes a frozen instant (a bullet caught as it shatters an apple) and at other times moving a thousand times faster than life (a flower grows and unfolds before our eyes), photographic images profoundly affect the way people see—see themselves and the world around them.

Within two decades of its birth in the second quarter of the 19th century, photography had been used to make portraits, landscapes, social documentaries, greeting cards, advertisements, medical records, and pornography; it had been used to document architecture, to cover wars, and to make political arguments.

Even the most casual consideration of the effect of photography demonstrates its impact: We have *seen* John Kennedy murdered, we have *seen* the Challenger explode, we have *seen* the fall of the towers of the World Trade Center.

We have seen these things not only in real time, but over and over again. We have, in a sense, been eyewitnesses to events that may have happened before we were born.

There was a time, not so very long ago, when a combination of cultural and technological conditions produced a Golden Age—no, maybe not a Golden Age, but a Brass Age—of documentary photography. This age lasted some three decades, from the 1930s through the 1950s.

Even before the Thirties, parts of this photo culture were moving into place. By 1903, the *London Daily Mirror* had gone exclusively to photo illustration. In 1911, *Photoplay* was created as the first photo magazine to focus on celebrities. Western Union was transmitting wire photos in 1921. The flashbulb became commercially available in 1930; the exposure meter, which eliminated a good deal of photographic guesswork, went on the market a year or so later. In 1936, *Life* magazine was born.

A number of nonphotographic cultural streams also contributed to the Brass Age. Advertising was exploding, and newspapers were the dominant mass-advertising medium. As such, they had a good deal of space to fill, and photography could fill it (one three-column by six-inch photo would fill the space of a decent-sized story, which might take a reporter an entire day to produce).

And though money was pouring into newspaper coffers, wages were still relatively low—and that meant that large photographic staffs were possible. The end result: huge numbers of photographs were taken and printed, on every conceivable subject.

If you read through newspapers from the Thirties and Forties and Fifties, one thing that eventually dawns on you is the ubiquity of the news photographer: they were everywhere, covering everything—automobile accidents, fires, murders, all the cop news that fought for a hot spot on the Front Page—and they covered it day and night.

They also shot uncountable numbers of routine civic affairs—pictures called "grip-and-grins" in the trade—school events, sports, celebrities, oddities both of nature and humanity, and lots and lots of people who were simply good at something—singing, dancing, fishing, hula-hooping, quilting, baseball, knitting, the collecting of string into large balls.

Newspapers today rarely show detailed photographs of dead bodies; during the Thirties, Forties and Fifties, the code seemed to be, "The more detailed, the better." The newspapers not only showed you a photograph of a dead cop, spread all over the front page, they sent a copy of the newspaper to the new widow and her children; and as they sat on the couch, stunned by the tragedy, looking at the photograph of poor old dead Dad, the photographer got *that* shot and spread *that* all over the paper.

It was a time when you took care of yourself. If you were dumb enough to stand under a burning building, and it fell on you, then tough luck; there was nobody to blame but yourself. But that also meant that when disaster struck, the rubberneckers could get in really close, sticking their noses right into the scene, the photographers right there with them. Some disaster shots have literally hundreds of people in them; each one could make a sociological thesis.

All of this was as true in St. Paul, in the pages of the *St. Paul Pioneer Press* and the *St. Paul Dispatch,* as it was anywhere. The time, and the town, were so intensely photographed that these pictures constitute nothing less than an archaeological treasure trove.

Look at the faces, look at the dress, look at the buildings, look at the cars. Look at the fire-fighting equipment, the dance styles, the streetlights, the strange (to us) civic rituals. Look at the way the people behave, the way men and women relate. Or this: Can you image a time in St. Paul when the sidewalks were jammed—jammed!—with shoppers, when stores jostled elbow-to-elbow for space on the downtown streets?

Look at the iron lungs and the children inside them and what those images say about medical technology and the concept of medical privacy. Experience the shock and horror of a mother who has lost a child, in images so raw that newspapers would no longer print such a picture, even if they got one.

You can look at these pictures and *see* status—status of blacks, of women, of the poor and the rich. And it may not be exactly what we expect, exactly as our myths have it . . . things were more complicated than we remember, from even our short distance.

The photographs in this book are endlessly fascinating, and our guide, Larry Millett, is expert, enthusiastic, and—to be polite—hard-nosed. The combination is perfect for this project; we get a taste of almost everything, from the hilarious to the tragic, from the silly to the murderously bloody.

POLICE AND FIRE LINE PERMIT
MINNEAPOLIS, MINN.

-- Official --

| 1946 | **PRESS CAR** | 1947 |

Police officers and firemen will pass this car and occupants through all police and fire lines, and will extend every possible courtesy at all times.

[signature]
Mayor

[signature]
Chief of Police

[signature]
Fire Chief

INTRODUCTION

IN JULY 1972, a few days before the kidnapping of wealthy Orono socialite Virginia Piper, as the newspapers invariably described her, I went to work as a reporter for the *St. Paul Pioneer Press.* The *Pioneer Press* and its afternoon sibling, the *St. Paul Dispatch,* were then located in a cramped, charmingly dysfunctional Depression-era building on Fourth Street in downtown St. Paul. The newsroom, which accommodated the editorial staffs of both newspapers, occupied the top floor. It was a relic straight out of *The Front Page*—a maze of paper-strewn desks where reporters and editors labored in a smoke-drenched cacophony of clacking typewriters, ringing telephones, and shouted conversations.[1]

My duties as a night general assignment reporter were seldom arduous, and as the hour grew late I often wandered back to the newsroom's library, or morgue as it was called in those days. It resembled a small public library in some respects, offering magazines, reference materials, and other sources of general information. The library's most important function, however, was to serve as the newsroom's collective memory.

To this day, two unique collections form the heart of the library. The first is a clippings file that, before being supplanted by an electronic data base in the 1980s, held an estimated two million stories. Meticulously cut from the pages of the *Pioneer Press* and *Dispatch* by librarians armed with razor blades, these clippings were carefully folded into thousands of small white envelopes and organized by a system of headings unknown to the Library of Congress or Mr. Dewey and his decimals. To find stories on Charles Lindbergh, for example, an enterprising reporter might have to consult an envelope entitled "Transatlantic Crossings." As the ultimate mother lode of background information (known as "advance" or simply "A matter" in the trade), the clippings file— now used mostly in its electronic form—continues to be an indispensable resource.[2]

As I nosed about the library on those long quiet nights, I soon came upon a second and even more fascinating collection—the newspapers' photographic archives. The sheer size of it astounded me. Tucked away in long rows of filing cabinets were thousands of oversized manila envelopes packed with photographs. By my reckoning there had to be at least half a million images in all (an estimate in the 1950s put the total at an even million), most in the form of 8-by-10- or 12-by-15-inch prints and some going as far back as the early 1900s.

Equally remarkable was the variety and quality of the images. Here was a visual history of the St. Paul area like no other, compiled from the work of professional photojournalists whose everyday job was to document, for better or worse, the life of the times. Yet it was a mostly hidden history because the archives had never been open on a regular basis to researchers or the general public (this is still

the case today). Many of the strangely alluring photographs that caught my eye, I realized, probably hadn't been seen since the day they appeared in either the *Pioneer Press* or *Dispatch.*[3]

On these early tours through the archives I also came to learn, much to my initial frustration, that the collection seldom yields its treasures easily. At first glance, the organizational system seems simple enough. Photographs are grouped by subjects (beginning with "Aardvarks" and ending with "Zytec Corporation"), by names, and by size. There's also a special section just for sports. The most interesting pictures, including almost all of those used in this book, are stored in the large-format subject files. These consist of more than 7,000 envelopes, each containing anywhere from one to 100 or more photographs.

Despite its seemingly logical structure, the archives actually resemble nothing so much as an old, tangled city whose many streets and byways have to be learned by heart. There are many duplicative mysteries (a picture of an old mansion, for example, might be found under "Houses-Historic-St. Paul" or "Historic Houses" or perhaps even "Urban Renewal"). Also common are thick grab-bag envelopes ("Murders-Minnesota-1950s," say, or "Accidents-Automobile-1920-59"), as well as impossibly broad subject headings (an envelope simply labeled "Sex" is my favorite, though its contents are disappointingly bland). Because of these organizational quirks, every envelope in the archives holds the possibility of surprise.

As I sampled the library's photographic wonders over a period of many years, I found myself especially drawn to pictures taken between about 1945 and 1965. I grew up in the 1950s, so photographs from that time were in some sense a way of revisiting my childhood, even though I was raised across the river in Minneapolis, better known to faithful readers of the *Pioneer Press* and *Dispatch* as the domineering and more often than not perfidious "Mill City."

Nostalgia, however, wasn't the only appeal of these pictures from the days of my youth. Many of them were spectacular in their own right. Taken with the legendary Speed Graphic—a large-format, one-shot camera used by many newspapers until 35mm equipment took over in the 1960s—the photographs were direct, unfussy, and often shockingly graphic in their depiction of violence and death. Yet all was not grim in what I have chosen to call the Speed Graphic era. I also found thousands of wonderful pictures recording the sometimes peculiar rituals of daily life. The St. Paul Winter Carnival, which attained a level of delirious weirdness in the 1950s that may never be equaled, proved to be another source of irresistible images.

There was, I discovered, one other feature of the photographs that intrigued me. Taken in almost every corner of St. Paul, they

provide an extraordinary visual record of the city of old. Downtown St. Paul in particular was still a museum of nineteenth- and early twentieth-century architecture as late as 1950. But "urban renewal," as it was euphemistically called, soon began to sweep away much of this history. These were among the strangest of days in St. Paul, a time of wonder and regret as the city remade itself under the seductive banner of modernism. No one documented this transformation more thoroughly, or captured its bittersweet qualities more tellingly, than the *Pioneer Press* and *Dispatch* photographers.

When I retired from the *Pioneer Press* in 2002, I decided the time had come to put together a book of the old news photographs I had come to love. My goal was to create an album of pictures that would highlight the best, most typical, and in some instances, most curious work of the period. It was a daunting challenge because of the multitude of riches available in the archives. In the end, after looking at thousands of images, I settled on about 220 photographs—taken between 1941 and 1966—for inclusion in this book. With the help of a researcher, I then went back through old newspapers on microfilm to confirm when each photograph was published and to learn more about the story behind it.

In all but a few cases, the pictures I selected came with captions identifying the principal people in view, and I have continued that practice in this book. I am well aware that some of the more graphic images in this book may dredge up tragic family memories, but I could not see how to do justice to these pictures without naming the people in them. Much of the value of these photographs, I believe, lies in their specificity. They are not pictures of distant strangers but of people who lived, worked, played, and in some cases died violently in St. Paul and the surrounding areas of Minnesota and Wisconsin. Their names and faces, featured in the public forum of the newspapers half a century ago, now belong to the historical record.

The photographs are organized under eight broad topic headings. Although I've made a point of including a variety of images, readers will quickly discover that there are numerous scenes of violence, death, and disaster. Even with the softening effect of time, some of the pictures—especially when they involve dead children—are hard to look at. I have included them not just because they are powerful and disturbing images but also because it would be bad history to leave them out.

Blood was, for better or worse, the visual signature of news photography in the Speed Graphic era. It can be seen splattered across maimed bodies and corpses, oozing from the wounds of victims in emergency rooms, darkening the floors and walls of murder scenes. The prevalence of such imagery in newspapers like the *Pioneer Press* and *Dispatch* was no accident. Both news-

papers chased spot news ruthlessly in those days, in part because it was what they knew how to do but also because television had not yet become a major competitor. While newspapers today generally shy away from displaying too much gore, no such hesitancy infected the hard-bitten characters who ran newsrooms in the Speed Graphic era.

Although the *Pioneer Press* and *Dispatch* were hardly unique among newspapers in their devotion to graphic mayhem, their front pages—particularly in the late 1940s and early 1950s—could be as bloody as those of even the most sensationalistic tabloids. "There's no question that we were much more willing to be graphic at that time than we are today," said John Finnegan, who started as a reporter at the *Pioneer Press* and *Dispatch* in 1951 and retired as the editor and assistant publisher in 1988. "We were into the reality of what was going on."[4]

That reality could be extremely unpleasant. Consider these images: a decomposed corpse, facial features twisted out of place and one arm gnawed away by animals; a murdered child lying in his coffin; a decapitated body at the scene of an industrial accident; a mass murderer, pictured just minutes after he'd put the barrel of a rifle under his chin and pulled the trigger. These and many other equally gruesome photographs appeared in the *Pioneer Press* and *Dispatch* in the 1940s and 1950s.

On the other hand, the newspapers were downright blue nosed when it came to any kind of photograph with overt sexual content. "One thing we were in those days was a family newspaper," said Gareth Hiebert, the long-time "Oliver Towne" columnist for the *Dispatch*. "We didn't get into sexual stories." Perhaps not, but the newspapers' photographers did love to take pictures of women in poses that would arouse howls of protest today. A favorite was the shot of some young secretary sitting on a desk with her skirt hiked up and legs crossed while her boss leered happily in the background. The newspapers also took an unabashedly salacious interest in any murder case with a sexual angle (or better yet, triangle), and the most sensational murder trial of the era involved a Minneapolis woman accused of killing the married lover by whom she was pregnant.[5]

Still, dramatic images of death and disaster remained the most sought-after pictures during the Speed Graphic era. News photographers were able to obtain such pictures because they had virtually unlimited access to crime, accident, and fire scenes. The press, in fact, maintained a close working relationship with police and fire officials during these years, not only in St. Paul but in most other American cities.

In Minneapolis, for example, reporters and photographers carried special passes entitling them to cross police and fire lines. The passes were signed by the mayor (who from 1945 to 1948 was

none other than Hubert Humphrey). The situation seems to have been more informal in St. Paul, where the photographers knew many police officers on a first-name basis and seldom had any trouble gaining access to a crime or disaster scene. The St. Paul newspapers were also linked to the police through Nate Bomberg, a crime reporter who worked out of the downtown police station for more than 40 years before retiring in the 1970s. Bomberg was such a fixture at the "cop shop," as the station was called, that he even helped young officers write their reports.[6]

This cozy relationship between press and police came with a price, of course. Cooperation breeds complicity, and as a result newspapers seldom challenged the official police version of events. If a suspect got roughed up a bit during interrogation or a cop got into a drunken brawl while off duty, the public was unlikely to hear about it. The newspapers also bestowed plenty of favorable publicity on the police. It was, in essence, a business of exchanges. The cops got their mugs in the newspapers (and plenty of credit for doing the hard work of fighting crime), while the photographers got access.

Like most newspapers, the *Pioneer Press* and *Dispatch* began to wean themselves from blood and guts imagery in the 1960s. Any number of explanations might be offered for why the newspapers gradually gave up on gore. It would be nice to think that the public's taste for blood has abated over the years, but the ultragraphic imagery now offered routinely in the movies and on television belies this proposition.

A more likely explanation is that newspapers simply became more sensitive to reader complaints than they once were. "There was a gradual change," Finnegan said. "By the time I took over as executive editor [in 1970], we had established that we would not show a dead body. I know we had started getting more complaints from people about that kind of stuff."[7]

There were other reasons why newspapers began to cut back on graphic coverage of crime and disaster. Police-press relations cooled in the late 1960s, making it more difficult for photographers to get pictures at tightly controlled crime and accident scenes. The police also became more professional in their investigations by taking steps to ensure that crime scenes would not be contaminated by outsiders. In the 1970s, the Watergate scandal led to a confrontational style of journalism that further discouraged overt cooperation with the police and authorities. "It got to the point where the police didn't want you around any more," said Dennis (Buzz) Magnuson, a photographer at the *Pioneer Press* and *Dispatch* for more than 45 years. At the same time, newspapers began to cede more and more spot news coverage to local television — a trend that continues to this day.[8]

The newspapers' close relationship with the police mirrored in many ways their relationship with the community at large. Although newspapers of the Speed Graphic era had many failings—sensationalism, sexism, racial and ethnic stereotyping, and subservience to authority come immediately to mind—they also had one great virtue, which is that they tended to be much closer to the ground of everyday life than newspapers usually are today, when a kind of imperial distance often separates the media from their audience. It is not going too far to say that the *Pioneer Press* and *Dispatch*—descendants of the state's oldest newspaper, founded before St. Paul itself was incorporated—were woven into the very fabric of the city during the Speed Graphic era.

I think this helps explain why so many news photographs of the time have a kind of intimacy seldom found today. The photographers were, in many ways, taking snapshots of home—a place, to be sure, that could be very ugly at times—but home nonetheless. And even though crime and disaster always received plenty of attention, the newspapers were just as devoted to what might be called "small town" news. Photographers regularly shot everything from neighborhood festivals to church and club meetings to local bowling tournaments. They were seen as part of the community and were welcome almost everywhere. "People wanted their pictures taken," Magnuson said. "They'd say, 'Oh, you're from the newspapers,' and whatever you wanted you could pretty much get. We were loved. Today we're hated. Television did that."[9]

EXCEPT FOR A HANDFUL of pictures taken by freelancers, all of the images in this book are the work of former staff photographers at the *Pioneer Press* and *Dispatch*. During the period covered by this book, about 25 photographers worked at one time or another for the newspapers. The size of the staff fluctuated a bit, but the normal complement seems to have been 10 to 12 full-time photographers. Except for Betty Engle LeVin, who took pictures for a few years during and after World War II, all were men.

They spent much of their time shooting routine pictures of everything from city council meetings to gatherings of church ladies to visiting celebrities. Photographs like these were assigned at the request of editors and reporters who needed pictures to illustrate their stories. Overall, a photographer might shoot ten or more assignments on a single shift—far more than is usually the case today.[10]

All photographers worked under the supervision of a photo editor who controlled scheduling and assignments and oversaw darkroom operations. The photo editor, with the help of staff artists, was also in charge of cropping, highlighting, or otherwise manipulating prints before publication. Because the quality of newspaper photo reproduction was generally so poor in the Speed Graphic era, some prints had to be enhanced (by highlighting the

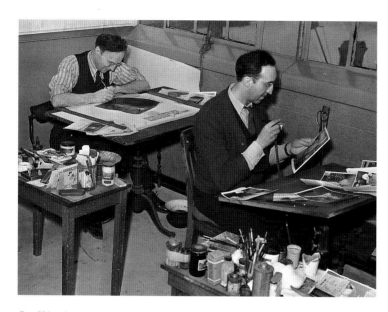

Staff in the newspapers' art department used pen and ink and watercolor in black and various shades of gray to highlight or mask details in photographs.

contrast around a figure, for example). Airbrushing to eliminate unwanted background details was also a frequent practice. The images in this book are presented as they were found in the newspapers' archives, with crop marks and other alterations intact. Nor has any attempt been made to repair tears, folds, splotches, or other damage to the prints caused by time and use.

As they rushed from one assignment to another, the photographers were always on the lookout for "spot news" pictures of the kind that couldn't be scheduled in advance. These photographs of accidents, fires, crimes, and other forms of human misadventure took priority over everything else. When a big story broke, photographers—who were in constant radio contact with the photo desk—could be diverted from other assignments as needed. In some cases, as many as half a dozen photographers might end up shooting a large fire or some other noteworthy disaster.

The photographers worked in shifts around the clock. By the late 1940s, at least one was assigned to overnight duty, which entailed cruising the city in a specially equipped car to chase down police and fire calls. Unlike reporters, photographers didn't work specifically for the morning *Pioneer Press* or the afternoon *Dispatch.* Although feature pictures were typically assigned to one newspaper or the other, spot news photographs appeared in the first available edition of either paper. In practice, this meant that overnight crime pictures often appeared in the *Dispatch,* which generally had more of a tabloid look to it than the *Pioneer Press.*

The photographers themselves were a varied and colorful

lot. Most appear to have been self-taught, and it is doubtful any of them came to the job with a college degree in the fine arts. Hyman Paulinski (better known as Hi, or sometimes Hy, Paul) was typical of the breed. Born in North Minneapolis, Paul got his start in the news business when an editor from the old *Minneapolis Journal* found him playing craps in an alley one day and hired him as an office boy. Paul advanced to a job writing high school sports stories before he got his big break.

As Paul later told the story, "Mr. George Adams, managing editor, came up to me and said, 'Hy, would you like to be a photographer?' and I said I'd never run a camera in my life. He said, 'Take a camera home and shoot your girlfriend.' That's what I did." By some accounts, Paul—who later won a number of awards for his work—never quite mastered the intricacies of the Speed Graphic camera, shooting all of his pictures at the same aperture setting of F8.[11]

In general, however, the photographers hired by the newspapers in the 1950s came on board with considerable expertise (a number had been military photographers). Experience was necessary because there was no time for on-the-job training. "They [the photo editors] didn't give you any information," said Magnuson. "You had to know what you were doing."[12]

There were, in fact, some extremely sophisticated technicians among the photographers. David (D. C.) Dornberg, for example, designed and built a special sequence camera for use at University of Minnesota football games. The bulky camera was known as the "Duck Caller" because of the noise it made as it snapped off one photograph after another.[13]

Many of the photographers were, in every sense of the word, "characters." This is hardly surprising in view of the demands of the job, which has never been for the faint of heart. News photography can be dangerous (Paul, for example, was nearly shot in 1947 by a deranged gunman who'd already killed a police officer), and it's highly competitive. It's also a line of work that offers no second chances. If a photographer misses a key shot, it's gone for good. For these and other reasons, news photographers of the Speed Graphic era tended to be a cheeky group, willing to take chances and flout authority to capture the vital moment.

The rigors of the work were such that alcoholism seems to have been quite common. At least two photographers in the 1950s were fired for drinking. Another committed suicide. Yet many others avoided the demons and enjoyed remarkably long and productive careers. Photographers Jack Loveland and Roy Derickson form an intertwined example of this longevity. When Derickson was born in St. Paul in 1926, he was one of triplets. Since this was considered newsworthy, Loveland was assigned to take a picture of the babies. Twenty years later, when Derickson went to work

at the *Pioneer Press* and *Dispatch* as a photographer in his own right, he met Loveland again—this time as a colleague. Loveland stayed on at the newspapers until about 1970. Derickson also had an exceptionally long career, retiring in 1990 after 44 years on the job.[14]

Most of what is known about the Speed Graphic photographers at the *Pioneer Press* and *Dispatch* is anecdotal. Some of the best stories center on Paul, who was known for his malapropisms (upon seeing the Dionne quintuplets, he is said to have exclaimed, "My God, there's five of them") and who once famously addressed former Archbishop John Murray of St. Paul as "Archie."[15]

ONE OTHER DISTINCTIVE ELEMENT of the era deserves more mention—the Speed Graphic camera itself. Virtually all of the photographs in this book were taken with the Speed Graphic, which served as the standard American press camera for over half a century. The camera was manufactured by Graflex Corporation of Rochester, New York, and is regarded by one devoted photographer as "both the first and the last great American-made camera."[16]

The Speed Graphic was introduced in 1912—a time when photography was becoming increasingly important in American newspapers. Updated versions of the camera appeared in 1928 and again in the 1940s and 1950s. The last Speed Graphic was manufactured in 1973, when Graflex itself went out of business.

The Speed Graphic came in various sizes, but the standard model used at the *Pioneer Press* and *Dispatch* and other newspapers was designed for four-by-five-inch sheet film. By today's streamlined standards, the Speed Graphic was both large (it weighs about six pounds, not counting flash attachment) and complex, featuring two shutters, three viewfinders, a rangefinder (on later models), a bellows adaptable to a variety of lenses, a lateral shifting mechanism, and manual settings for aperture and shutter speed.

The camera, which folded up into a box, had a reputation for strength and durability that made it the favorite of many professional photographers. It was endorsed by no less a figure than Arthur Fellig (1899–1968), better known as Weegee, the celebrated New York street photographer. In his book *Naked City*, published in 1945, he wrote: "If you are puzzled about the kind of camera to buy, get a Speed Graphic . . . for two reasons . . . it is a good camera and moreover, it is standard equipment for all press photographers . . . with a camera like that the cops will assume that you belong on the scene and will let you get beyond the police lines."[17]

The camera's size was its major advantage over the 35mm or digital equipment used by most news photographers today. The Speed Graphic's four-by five-inch format produces a much larger negative than 35mm cameras, and this makes for prints that have tremendous clarity and detail. *Pioneer Press* and *Dispatch* photographers normally made eight-by-ten-inch prints, but would go up to 12-by-15 inches if they felt they had a particularly good picture. Even at this size, Speed Graphic prints remain sharp with little hint of the graininess that can become a problem with smaller film.

The Speed Graphic's biggest drawback was that, as most commonly used, it was a one-shot camera. The photographer couldn't simply snap off a series of pictures on a roll, as with 35mm equipment. Instead, a sheet of film had to be loaded for each shot. The standard holder of the time came with two sheets of film. After taking his first picture, the photographer would have to remove the holder, turn it around, and reload it. Only then could he take his next shot. More pictures would require the use of additional holders in the same fashion.

The process seems cumbersome by today's standards, although a practiced photographer could shoot quite a few pictures in a short time. Even so, there was no way a Speed Graphic could be made to take photographs as quickly as modern cameras. This meant that photographers of the Speed Graphic era, when dealing with any kind of unposed situation, had to be extremely adept at anticipating the action. Good news photographers still must do so today, of course, but with the one-shot Speed Graphic this skill was especially critical. "When you used the old Graphic, you had to be right on," said Derickson. "You really had to watch what you were doing. We used to say it took good eyeballs. You really worked at it."[18]

Another of the Speed Graphic's notable features was its huge flashbulb, which sent out a burst of light powerful enough to illuminate the darkest corner of hell. There was nothing subtle about the light, which added a lurid tinge to even the most innocent images. As a number of historians have noted, much of the look of movies and photography in the so-called "noir era" of the 1930s and 1940s can be traced back to the Speed Graphic's bulb and its unflattering assault of light.[19]

The Speed Graphic was abandoned by photographers at the *Pioneer Press* and *Dispatch* in the early 1960s as the lighter and more versatile 35mm cameras became the industry standard. Most of the photographers whose work is featured in this book had also left the paper by this time, and it is fair to say that by 1970 the Speed Graphic era—in every sense—was over.

THE PHOTOGRAPHS, FORTUNATELY, REMAIN. Today, they still speak to us through their vivid immediacy, their graphic exploration of the dark side of urban life, and their sometimes appalling richness of detail. Stolen from lost moments in the history of the city, they have the power to pull us back through time to a world at once intimately familiar and surprisingly strange.

CRASH
AND BURN

Bad accidents happen all the time, but not to most of us, and the more spectacular the mishap the more we find ourselves drawn into its violation of the ordinary. This seems to have been the basic premise behind the relentless documenting of disaster that characterized newspaper photography in the Speed Graphic era. Local television news—today's prime provider of noteworthy mayhem—was in its infancy in the late 1940s and early 1950s, which meant newspapers still chased "spot" news with everything they had. And even though *Pioneer Press* and *Dispatch* photographers took numerous pictures of everyday life in those days, there is no question that other people's misfortunes fueled the photographic energy of the time.

This emphasis on disaster seems odd because we tend to think of the 1950s as a rather placid era. In many ways it was, but beneath the smooth surface of events life roared on in its usual disorderly way. Automobiles crashed, trucks overturned, streetcars piled into each other, airplanes plunged to the ground in fiery crashes, houses and other buildings exploded, streets caved in, fires turned old brick structures into gigantic ovens, flood waters rampaged, tornadoes swirled down from the sky, and people died, sometimes gruesomely. Death by drowning and accidental suffocation was also a grim reality, with children the most frequent victims. As often as not, photographers from the newspapers were there to capture the scene or its shattered aftermath in pictures that offer an extraordinary range of images and emotions.

Some of the photographs in this chapter, which is devoted to daylight pictures, are momentary but full-fledged dramas snatched from the maw of time. Others have a static, dispassionate quality, as though the photographer found safety by distancing himself from the event. A few of the pictures—most notably Dick Magnuson's image of a house improbably blown to pieces—possess an eerie beauty. Still others are brutally utilitarian, devoted to a strict and merciless accounting of the visual facts.

Newspapers, of course, still send photographers to fires, explosions, and other calamities. Yet coverage now tends to be much more selective—and restrained—than it was during the time when these photographs were taken. The idea of anything like what might be called privacy in public—the right *not* to be photographed at an accident or other disaster—doesn't seem to have existed in the Speed Graphic era. Today, for example, most newspapers shy away from showing graphic images of the maimed and dead, but such pictures were the routine stuff of photojournalism in the 1940s through the mid-1960s.

Whether the new, more sensitive way of approaching the news is better than the seemingly more callous way of old is in many respects a moot point. News photographers today typically have far less access to accident and crime scenes than was true 50 years ago. As a result, some of the photographs that follow probably could not be duplicated now under any circumstances. What is certain is that these pictures offer a distinctive look at a time when life was no more predictable than it is today.

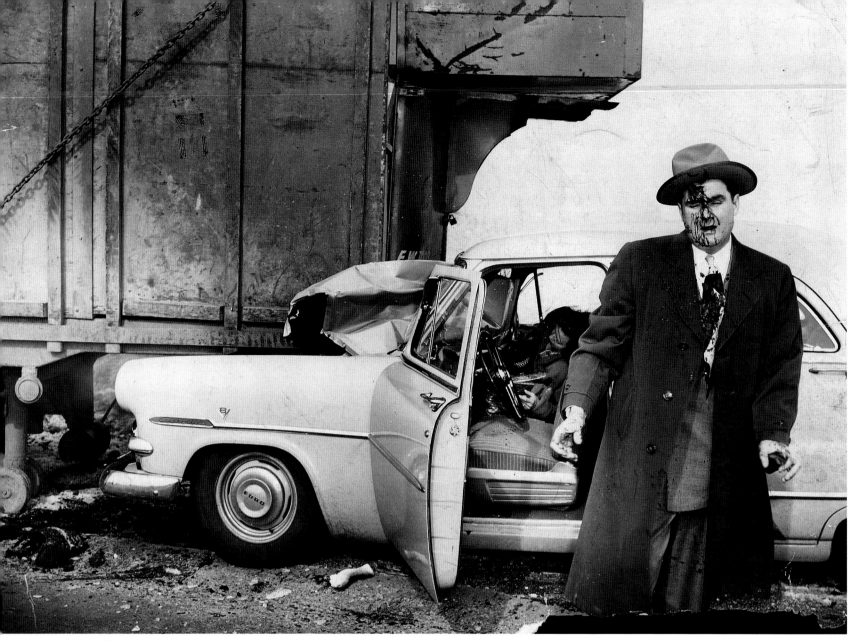

MAR 0 2 1953

THIS STARTLING IMAGE may well be the definitive photograph of the Speed Graphic era in the Twin Cities. In its blunt, bloody simplicity it demonstrates the visceral wallop that the best news pictures of the time delivered. The photographer, Dick Magnuson, was thought by his colleagues to have perhaps the best eye of anyone on the staff, but he also had something better—the knack of being in the right place at the right time.

In this case, he was driving home with his family one day in March 1953 when he pulled up behind a semitrailer rig climbing the long hill out of the Minnesota River Valley near Shakopee on old Highway 169. Magnuson was quoted in the *Pioneer Press* as saying he edged over to pass the truck but pulled back in when he saw a car coming in the opposite direction. Seconds later, the truck's trailer suddenly broke loose

from the cab and swerved across the highway into the path of the oncoming car, driven by a man identified as E. A. Krusemark of Bloomington. Here, Krusemark, blood streaming down his face, staggers from his crumpled car while behind him his wife lies injured in the front seat.

The story that accompanied this extraordinary picture can only be described as amazingly blasé about the Krusemarks' fate, with nary a word about how serious their injuries might have been. Instead, it began as follows: "When news photographers say their prayers, they usually include a fervent plea to be at the scene when a big story breaks. *Pioneer Press* photographer Dick Magnuson got that wish Sunday morning. He was so close to the story, he had a narrow escape himself, but he got a dramatic picture." There was no further mention of the Krusemarks.

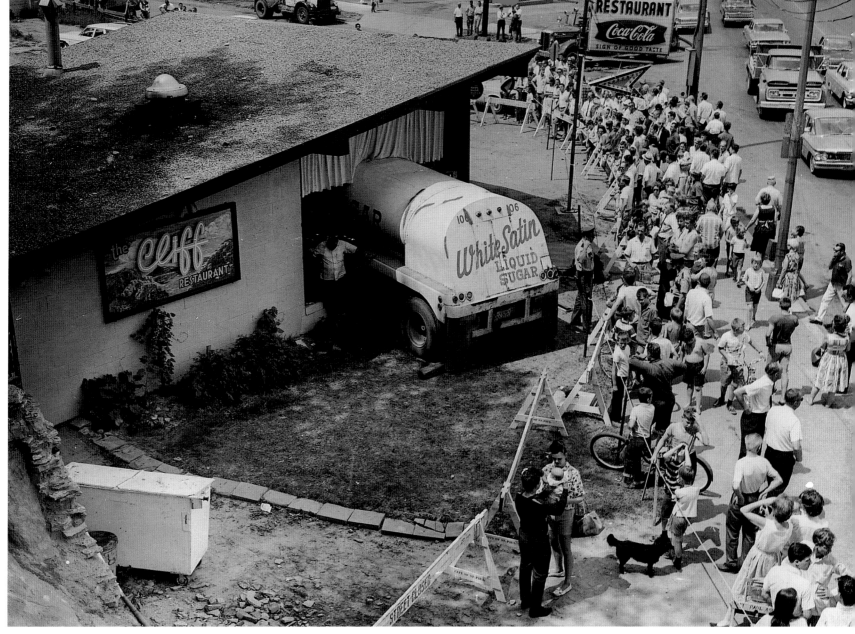

Dispatch / Hi Paul

JUL 2 9 1966

WHAT MUST SURELY RANK as one of the more bizarre vehicular accidents in the history of St. Paul occurred on a July morning in 1966 when a truck driver picked the wrong place to stop for a telephone call. The driver, hauling a tanker full of liquid sugar, parked his rig at a gas station on South Wabasha Street on the city's West Side. He didn't park it well enough, however, because the unattended truck soon began to roll downhill, picking up momentum as it went.

Less than 100 yards away stood Mickelsen's Cliff Restaurant, a small establishment located in front of the old Castle Royal nightclub (now the Wabasha Street Caves). As though guided by some malevolent hand, the big rig and its heavy load of sugar plowed into the restaurant head on, smashing through one side of the concrete-block building and out the other. The force of the impact was like a bomb exploding. "Glass, wood and fixtures were flying through the restaurant," said one survivor. Another reported: "I could hear people screaming, and I went in back and saw two men sticking out of the bricks."

The two—both restaurant customers—died when they were trapped beneath the front wheels of the truck. Eight other people were injured. By the time photographer Hi Paul arrived to take pictures, a sizable crowd was already on hand to view the aftermath of this unlikely disaster.

9

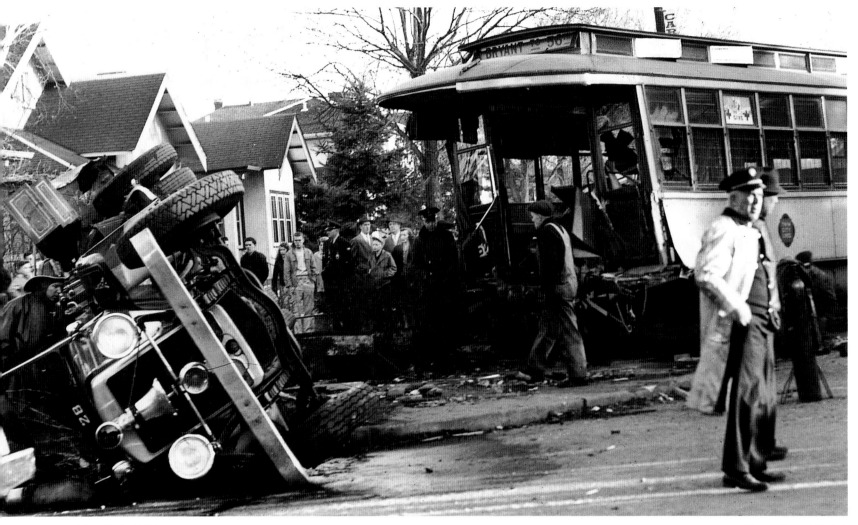

MAR 3 0 1948

Pioneer Press / Hi Paul

TWIN CITIANS HAVE SUCH FOND MEMORIES of the streetcars that it's easy to forget they were as accident prone as any other vehicle, perhaps even more so because they couldn't be steered out of trouble. Here are photographs of two spectacular trolley crashes. Both happened in Minneapolis, a city to which *Pioneer Press* and *Dispatch* photographers rarely ventured except to record the most newsworthy mayhem.

The first photograph shows a nasty collision between a streetcar and a fire truck at 44th Street and Bryant Avenue South in 1948. According to the *Pioneer Press,* the fire truck was on its a way to a call, sirens blaring, when it clipped the streetcar and tipped over on its side. "It hit us almost before we knew it," said the fire truck's driver. The impact tore away the front of the streetcar and pushed it up onto the front lawn of a house, whose owner told

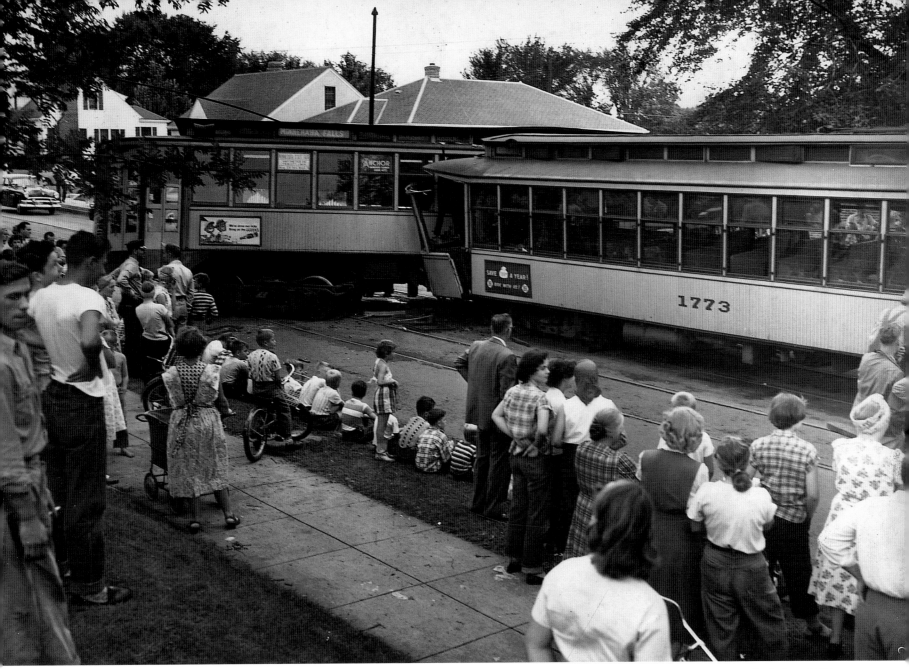

Pioneer Press / photographer unknown, but possibly Jack Loveland

AUG 2 1 1951

the newspaper, "I heard the siren and then an explosion. I thought our house was caving in. . . . People were shouting and screaming and lying everywhere." The motorman, two of the streetcar's 40 passengers, and five firemen were hospitalized with injuries.

A photograph from August 1951 shows a fairly rare type of accident—two streetcars colliding. This also happened in South Minneapolis, on 42nd Avenue South near 53rd Street. In this case, a southbound streetcar on its way to Minnehaha Park suddenly jumped the tracks, straddled the street, and was struck by the northbound trolley at right. Both motormen and six passengers received minor injuries in the accident. Here, people from the neighborhood, including kids with front-row seats on the curb, watch as a Twin City Rapid Transit Company crew (at far right) works to move one of the damaged trolleys.

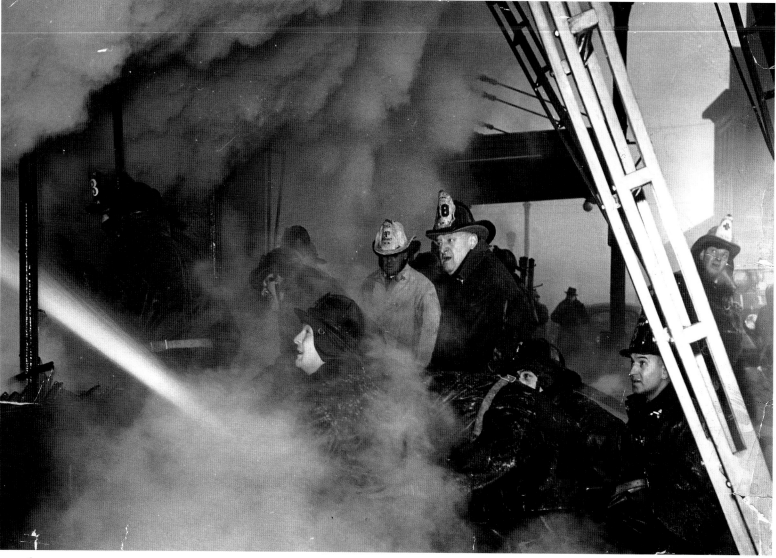

JAN 1 0 1942

Pioneer Press / photographer unknown

ONE FIREMAN IN THIS PHOTOGRAPH is about to die, and that is what makes it an unusually haunting image. The year is 1942 and the scene is Cedar Street, where on a bitterly cold January afternoon firemen are battling a blaze that enveloped a two-story building next to the St. Paul Athletic Club (now the University Club). Because the club was literally next door to the *Pioneer Press* and *Dispatch* building, a photographer was quickly on the scene and snapped this close-up of fire fighters working to douse the stubborn, smoky fire.

As this photograph was taken, smoke was already pouring into the Athletic Club through second-floor doors that linked it directly to the smaller building. There were fire doors to prevent just such a situation, but they were open. Worried that heavy smoke in the club might make it impossible to rescue anyone trapped on the upper floors, four firemen decided to go up to the second floor and shut the fire doors. Among them was Captain Thomas Kell, who stands to the right of the ladder.

Kell and two of the other firemen—District Chief Frank Minogue and Russell Hunt—were overcome by smoke and fumes as they groped their way toward the doors. They died before rescuers could reach them. For the St. Paul Fire Department, it was the worst loss of life since 1900, when five firemen had died in a blazing warehouse in the Midway area.

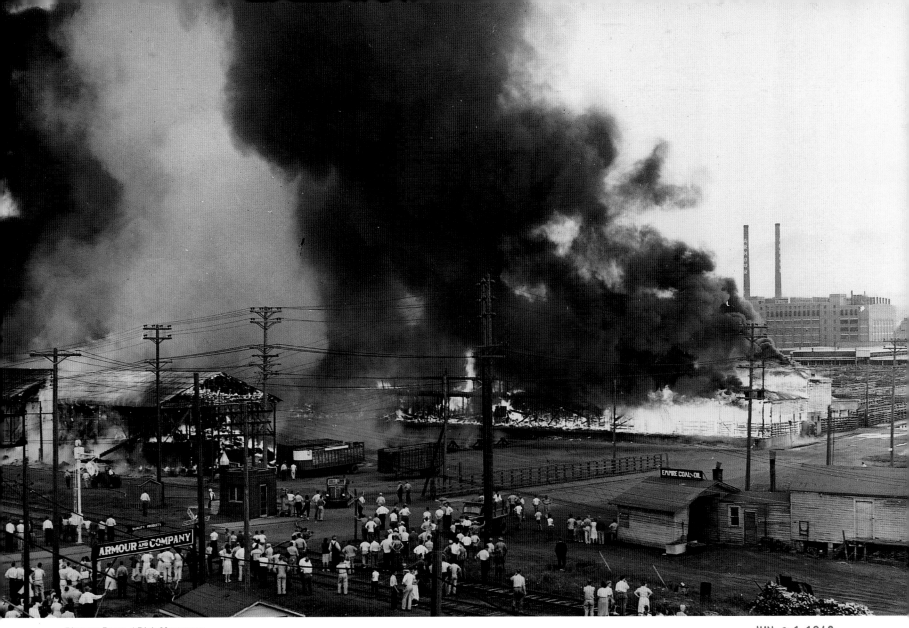

Pioneer Press / Dick Magnuson

JUN 0 1 1948

MEMORIAL DAY OF 1948 was among the most memorable in the history of South St. Paul. Just before noon, a passerby noticed smoke pouring from a hay shed at the southwest corner of the sprawling Union Stockyards near Concord Street and Armour Avenue. Fed by tinder-dry wood, the fire spread swiftly and within 30 minutes had engulfed three square blocks of the stockyards. By the time the blaze was brought under control two hours later, it had destroyed nine blocks of pens, three hay sheds, a scale house, and 88 railroad cattle cars. Thirty-five head of cattle also perished while 2,000 other animals were safely evacuated and then herded into swamplands along the adjacent Mississippi River. Total damage was estimated at $1 million.

Photographer Dick Magnuson found a high perch to take this sweeping picture of the fire as it ate through the stock pens. The huge Armour meatpacking plant, threatened for a time by the fast-moving blaze, is visible to the rear. The *Pioneer Press* reported that the fire sent up a column of smoke 1,000 feet high. A crowd estimated by police at 100,000 people (the number was almost surely inflated) watched the fire from a nearby hill on Camber Avenue. Among those taking in the spectacle was Republican presidential candidate Harold Stassen, who lived in South St. Paul.

The fire marked the end of an eventful month at the stockyards. Just two weeks earlier, National Guardsmen had been called in to maintain order during a bitter strike against Armour and other meatpackers (see page 102). That strike had been over for only nine days when the fire broke out.

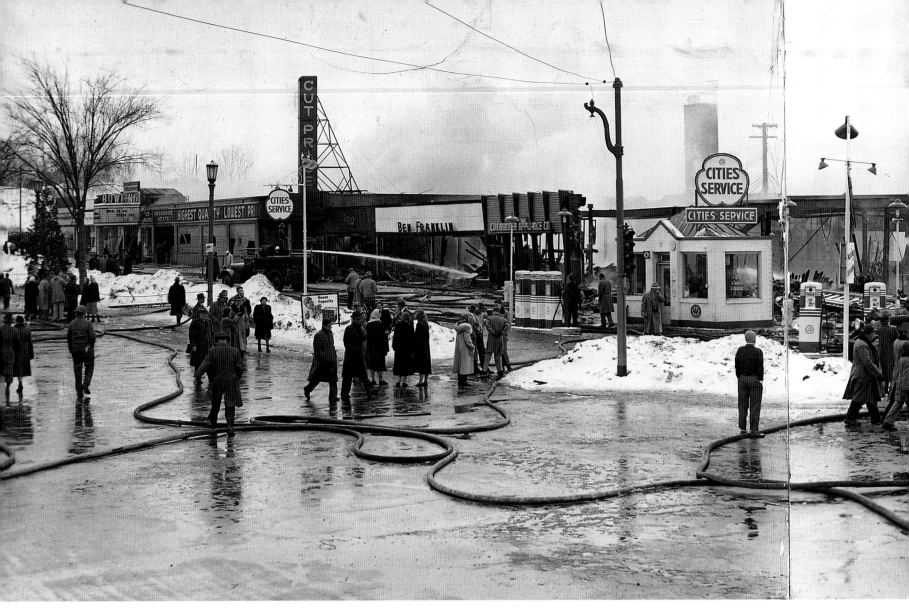

APR 0 2 1951

THE HIGHLAND PARK SHOPPING CENTER,
which opened in 1939, was among the first
auto-oriented malls in the Twin Cities, offer-
ing the novelty of off-street parking in front
of its businesses. The center, however, was
plagued from the start by an old-fashioned
problem—fire. A blaze in 1941 caused exten-
sive damage, but it was nothing compared to
the fire that roared through the center on
April 1, 1951, and left this scene of devasta-
tion behind. The blaze destroyed 12 of the 17

14

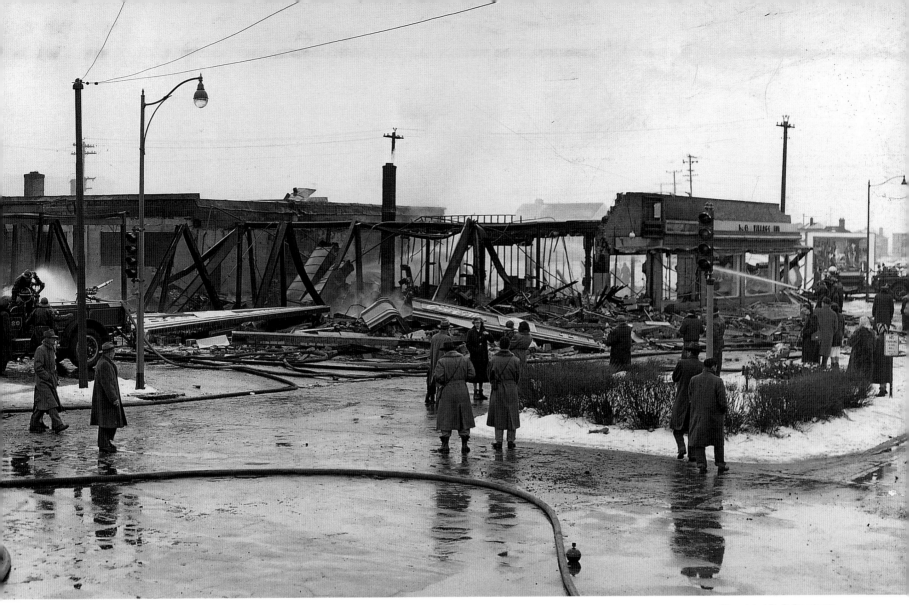

businesses in the shopping center before fire fighters brought it under control. The *Dispatch* estimated damages at $2 million, making the fire the costliest in St. Paul's history up to that time.

This panoramic photograph, looking southeast from the intersection of Ford Parkway and Cleveland Avenue, was taken as the fire still smoldered seven hours after its discovery at three o'clock in the morning. Note the mix of businesses in the center, where chain retailers had already established a presence. The big rooftop sign visible here was for a Cut Price Supermarket that claimed to be the largest food store in the Twin Cities. It even had a bowling alley in the basement. A Ben Franklin variety store and a Cities Service gas station were also part of the center's business mix. The center was rebuilt in much the same format after the fire and still occupies the site today.

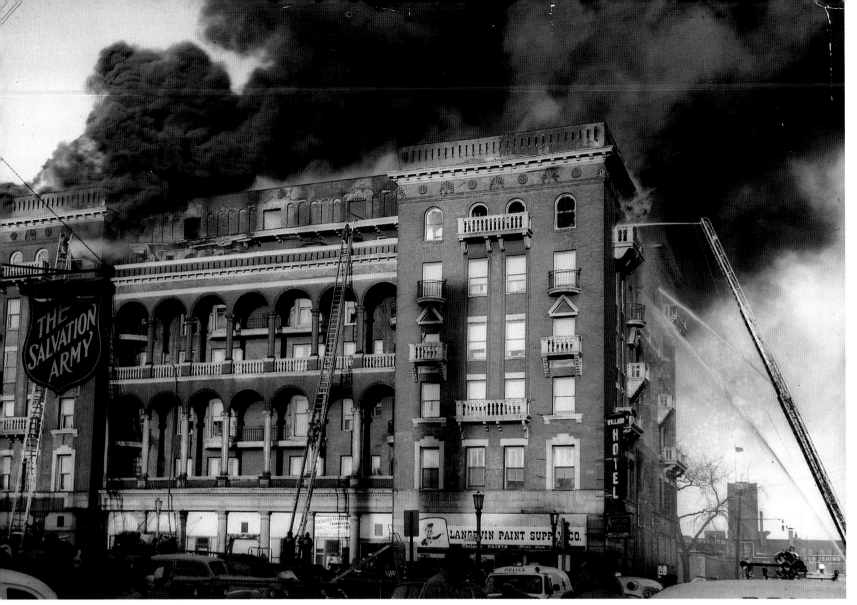

DEC 1 4 1955

Pioneer Press / Dick Magnuson

DOWNTOWN HOTELS AND APARTMENT BUILDINGS rarely burn anymore in St. Paul or elsewhere, a testimony to modern fire safety practices and the impact of urban renewal, which cleared away a good many old structures rightly regarded as fire traps. But in the 1950s and early 1960s, before downtown St. Paul was scoured of much of its Victorian-era architecture, large fires in residential buildings occurred with surprising frequency.

One of the worst was in December 1955 at the Colonnade Building (for many years known as the Willard Hotel) at Tenth and St. Peter Streets. The fire, possibly caused by a worker's carelessly tossed cigarette, broke out on the top (sixth) floor. One witness said flames and smoke spread with "horrible swiftness" through upper floors of the hotel, built in 1889. A 53-year-old maid, Augusta Heasley, died in a stalled elevator as she tried to reach the sixth floor to warn resi-

dents. "We could hear her screaming for help but we couldn't help," said a St. Paul policeman who called in the alarm, then raced through the building to alert occupants.

Most residents escaped on their own, but some, including a man trapped on a balcony, had to be rescued. Photographer Dick Magnuson caught this scene as firemen, working from ladders, poured water into the sixth floor. A few miles away on University Avenue, firemen were fighting a second large blaze—at a car dealership—that had been called in a minute before the alarm at the Colonnade. That fire also took one life. The *Pioneer Press* reported that the simultaneous blazes "emptied every [fire] station in the city."

As for the Colonnade, it's still in use as an apartment building, although its upper two stories had to be amputated after the fire because of extensive structural damage.

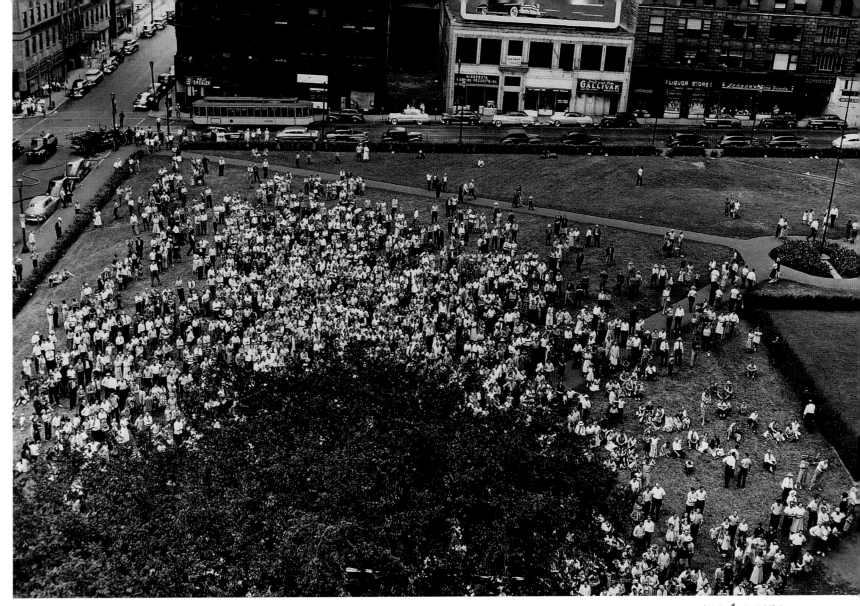

Pioneer Press / Ted Strasser

AUG 1 4 1950

IT'S THE AFTERNOON OF AUGUST 13, 1950, and hundreds of people have gathered in what was then known as Victory Park. The "park" was in fact little more than a vacant downtown block left behind in 1933 following demolition of the old St. Paul City Hall and Ramsey County Courthouse. Normally, the block was not the sort of place to attract a crowd, but on this day something extraordinary is happening. The view is looking south toward the intersection of Fourth and Cedar Streets (today, the *Pioneer Press* Building occupies this

site). As a streetcar moves down Fourth in front of the old Globe Building, the crowd is clearly transfixed by an event occurring behind the camera.

Many people are standing, but others are sitting in the grass and seem ready to stay awhile and take in the show. The fire truck parked at the corner provides an unmistakable clue as to what everyone is looking at. On the next pages are three views of the fire that everyone was watching.

THE FIRE THAT DREW THE MASSES to
Victory Park occurred at the Jewell Hotel,
which despite its promising name was hardly
one of the city's architectural gems. But the
hotel, built in about 1890 and located on Fifth
Street just west of Cedar Street, proved to
be spectacular fuel for a towering blaze that
started on the ground floor, possibly in the
aptly named Flame Bar.

Like other buildings of its vintage, the
five-story Jewell was a fireman's nightmare
because its brick bearing walls were prone
to sudden collapse. Three walls did just that,
one after the other, and by the time the fire
was finally put out, the 107-room hotel was,
in the words of the *Pioneer Press,* "an empty
mask." Four of the 83 guests registered at the
hotel were rescued by aerial ladder, while all
the others managed to escape under their
own power.

The first photograph, taken from a
nearby building, provides a high-level view
of the scene as flames leap through the hotel's
roof. The blaze raced up elevator shafts so
quickly that fire fighters had no chance of
saving the structure. Instead, they concen-
trated—successfully—on keeping the fire
from spreading to adjacent buildings.

Another photograph, one of scores taken
that afternoon by the newspapers, shows the
fire from street level along Fifth. The blaze
required six special alarms and the efforts

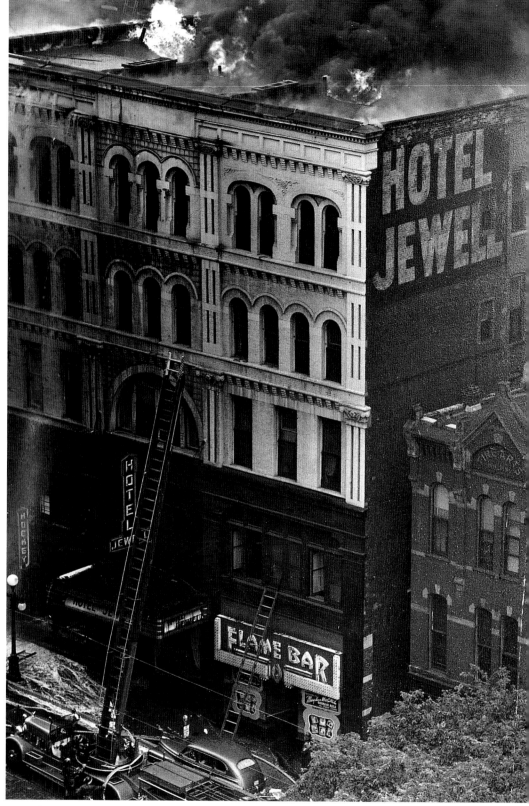

AUG 1 4 1950

Pioneer Press / Chet Kryzak

18

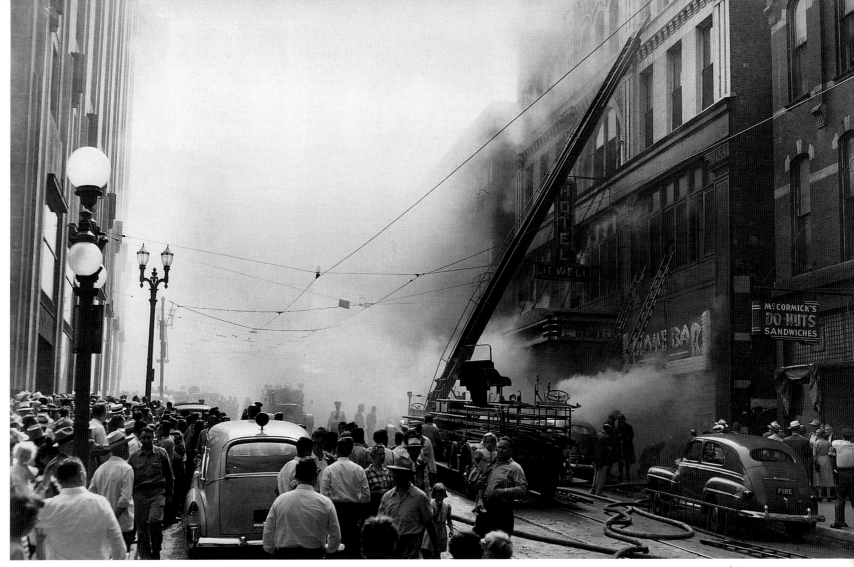

Pioneer Press / Dick Magnuson

of most of St. Paul's Fire Department, plus two squads from Minneapolis, to bring it under control. At one point, 30 fire department hoses were pouring water into the doomed hotel. The *Pioneer Press* noted that "at its height the fire spread a pall of smoke over the entire business district, attracting traffic and crowds that gave the loop a carnival look. People stayed to watch past midnight." The crowds are close to the burning building, despite the threat of falling walls. As always, the fire was a hot and dangerous business for the men fighting it. Fortunately, two Salvation Army men were on hand to provide Cloquet Club soda and Dixie Cream donuts to the weary firemen.

The remains of the hotel were demolished after the fire. Today, Ecolab Center occupies the site.

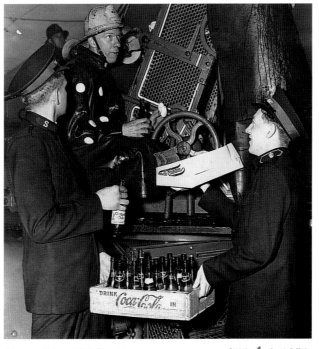

Pioneer Press / Ted Strasser

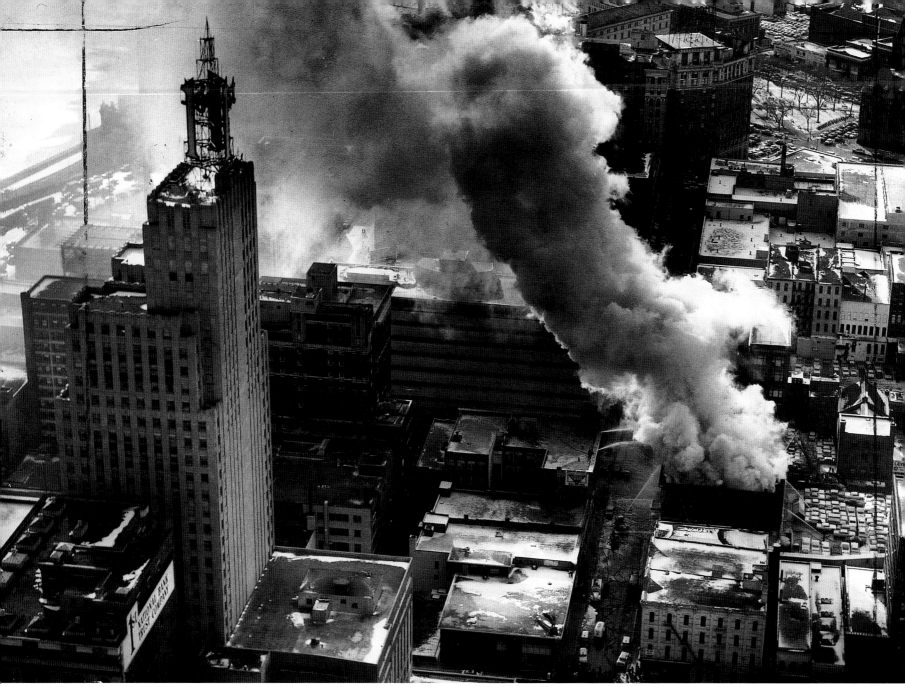

JAN 2 1 1961

ON JANUARY 20, 1961, the day that John F. Kennedy was sworn in as president of the United States, yet another of St. Paul's old downtown hotels went up in flames. This time it was the Frederic Hotel, on the northeast corner of Fifth and Cedar Streets, just a half block away from where the Jewell Hotel had been. The four-story Frederic, built in 1903, was a modest building, but it burned with astonishing speed, looking almost like a volcano that had blown its top in this aerial view, one of a series obtained by photographer Don Spavin. The *Pioneer Press* and *Dispatch* didn't have an aircraft, but in extraordinary cases, editors would rent a light plane

and pilot at nearby Holman Field and send up a photographer to take pictures.

"When [St. Paul Fire Department] retirees gather to reminisce about the 'big ones,'" said a 1998 departmental history, "the Frederic Hotel fire . . . always comes to mind." The eight-alarm fire started in the basement of the 102-room hotel, rapidly moved up through elevator shafts, and exploded from the roof. Fanned by winds of up to 30 miles an hour, the fire hopped across Fifth and ignited window frames in a building that housed the First Federal Savings and Loan Association. Firemen are visible here on the roof of the First Federal

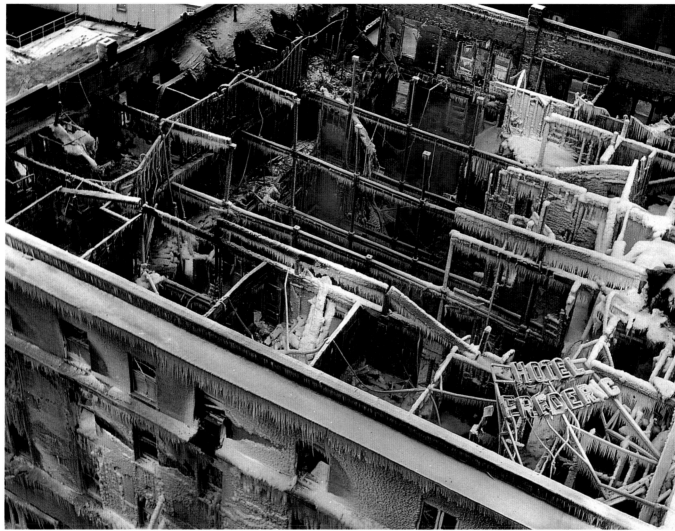

JAN 2 1 1961

building as they send streams of water across Fifth into the hotel.

Five guests on upper floors were trapped by flames until firemen managed to rescue them with ladders. Other fire fighters entered the burning hotel and led occupants to safety. One guest couldn't be accounted for, however. His body was found a week later as workers demolished the remains of the hotel.

Another of Spavin's photographs provides an eerie top-down view of the unroofed, burned-out hotel, which was left coated in ice because the fire was fought in sub-freezing weather. Room and hallway walls are still mostly in place, as are the building's brick exterior walls and interior steel columns. Some furnishings are also in evidence, as is the hotel's crumpled neon sign.

After the Frederic's destruction, there was to be only one more large hotel fire in downtown St. Paul. It happened in January 1966, when the aging Carleton Hotel on St. Peter Street burned. Nine people were killed, and two others later died of their injuries, making it the most lethal fire of its kind in the city's history.

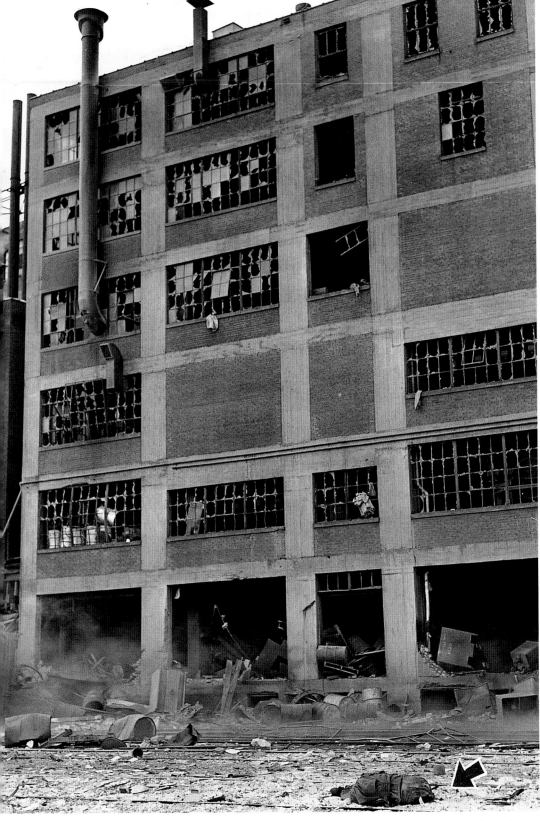

FEB 0 8 1951

Dispatch / photographer unknown

THE DEADLIEST DISASTER in St. Paul's history occurred at just after eight o'clock on the morning of February 8, 1951, when a thunderous butane gas explosion tore through part of the huge Minnesota Mining and Manufacturing Company (now 3M, Inc.) industrial complex along Bush Avenue on the city's East Side. The explosion occurred in a six-story concrete-frame building where minerals were crushed and then heated in huge butane ovens. It left 15 people dead or dying, including a truck driver making deliveries at the plant. Another 54 workers were injured, some with terrible burns.

So powerful was the blast that it knocked over railroad cars on nearby tracks, swept through tunnels into adjacent buildings, and ejected some of its victims through shattered windows while burying others under tons of debris. The first photograph shows the blast-damaged building with the body of an unidentified victim lying on railroad tracks behind it. The man had been decapitated in the explosion, and the *Dispatch*'s editors apparently thought it would be helpful to point this fact out with an arrow. This prominently displayed pointer suggests something like perverse journalistic pride in being able to deliver such a gruesome detail to the public.

Photographers also raced to Ancker Hospital (a predecessor of today's Regions Hospital and located at Colborne Street and Jefferson Avenue in St. Paul). Many of the blast victims were treated at Ancker. Here, a doctor and nurse tend to a critically injured worker, part of whose face had been torn open by the blast. Meanwhile, Father Francis Turmeyer, a hospital chaplain, reads the last rites over the unidentified man.

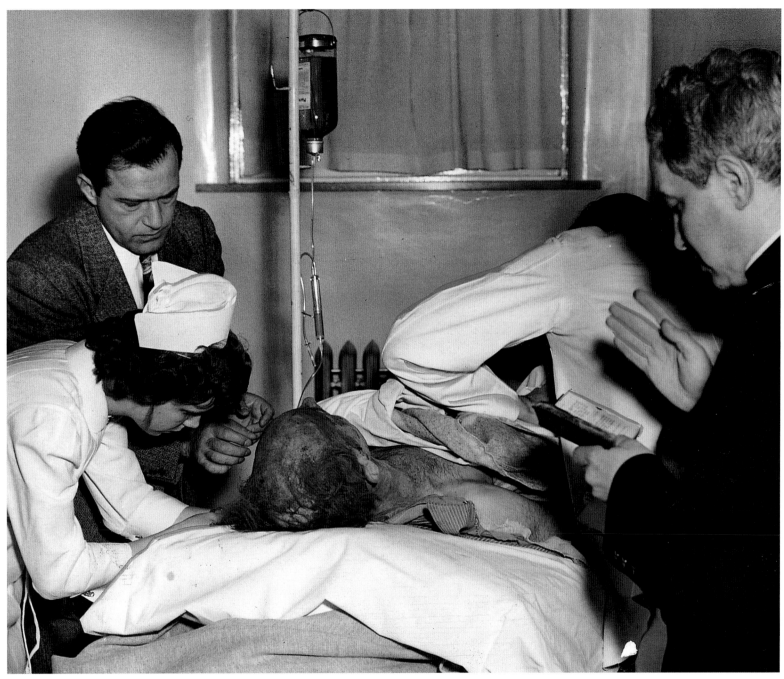

Dispatch / Jack Loveland

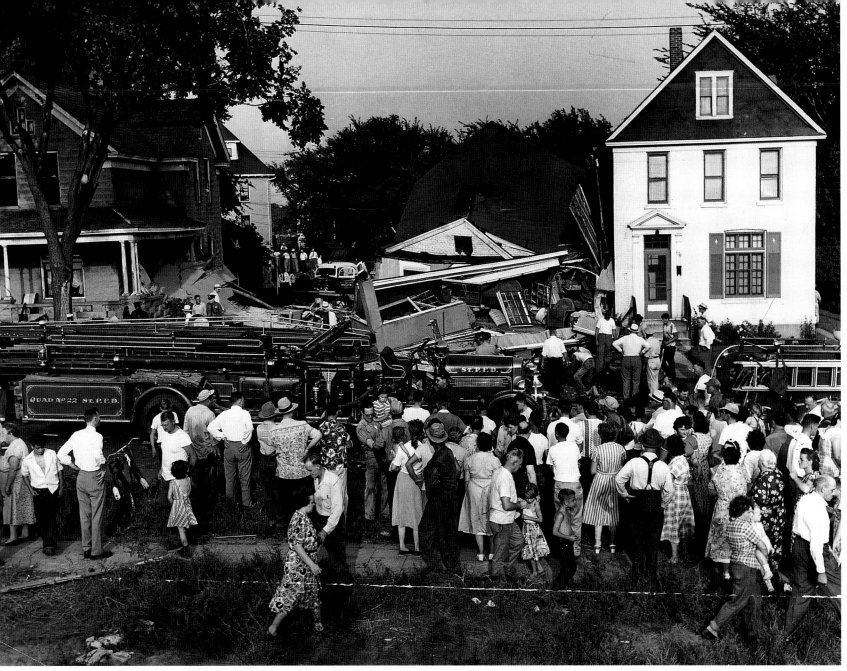

IT IS SOMETIMES POSSIBLE to find unexpected beauty in the midst of disaster. So it is with the first of these photographs documenting a natural gas explosion that, in 1952, destroyed a house on Western Avenue near Minnehaha Avenue in St. Paul. "It sounded like a 500-pound bomb had exploded," said one neighbor, whose specificity as to the size of the blast suggests he had military experience. Another neighbor said, "The house seemed to rise up in the air and fall apart. Then I heard a roar and the ground shook." The *Pioneer Press* also reported, somewhat cryptically, that the explosion was so intense it "reversed" the home's north wall.

Five people were injured—only one seriously—in the blast, which according to the *Pioneer Press* " pancaked" the two-story home. One of the injuries occurred when a woman taking a bath in the house next door was struck by a window frame that came flying her way.

Dick Magnuson's panoramic view of the disaster is striking, largely because of the way his photograph arranges itself into four distinct planes of action—a crowd of onlookers, fire trucks in a perfect line along the street, the destroyed house and its neighbors, and, to the rear, another group of gawkers standing behind

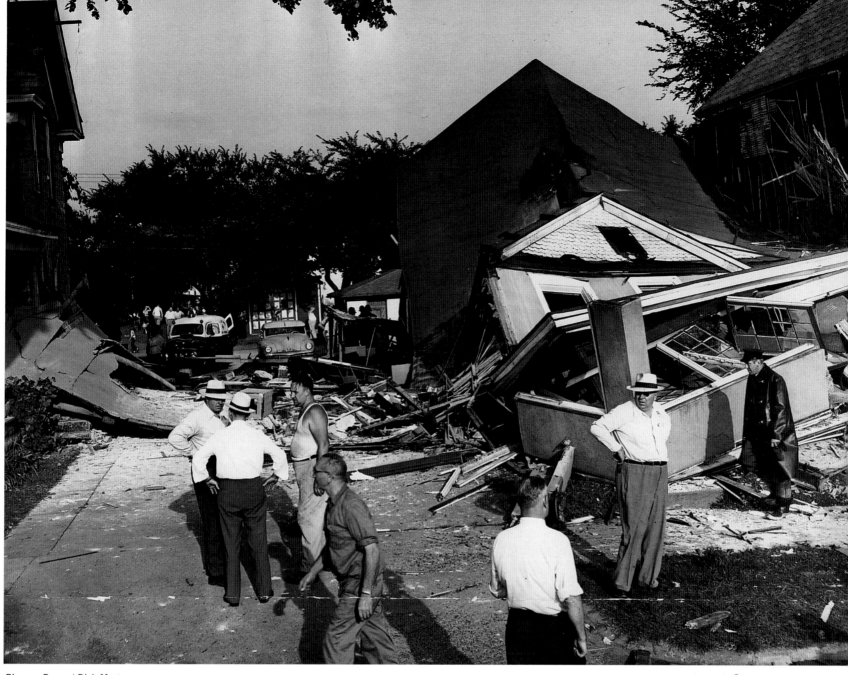

an ambulance. With its deep focus and elevated camera position, the photograph seems to envelop the scene. Like most Speed Graphic pictures, it is also rich with detail. Note especially all of the young children with their parents in the foreground. This was a working-class neighborhood, and the baby boom was obviously well under way.

A second photograph provides a closer look at the house, its roof leaning up against part of the collapsed front gable. The large piece of wreckage resting against the house at left is probably one of the destroyed home's side walls. Aside from the fireman at right, it's not known who the men here are, but the ones in hats and long-sleeved shirts may well have been inspectors from the Northern States Power Company (now Xcel Energy), which supplied gas to the house.

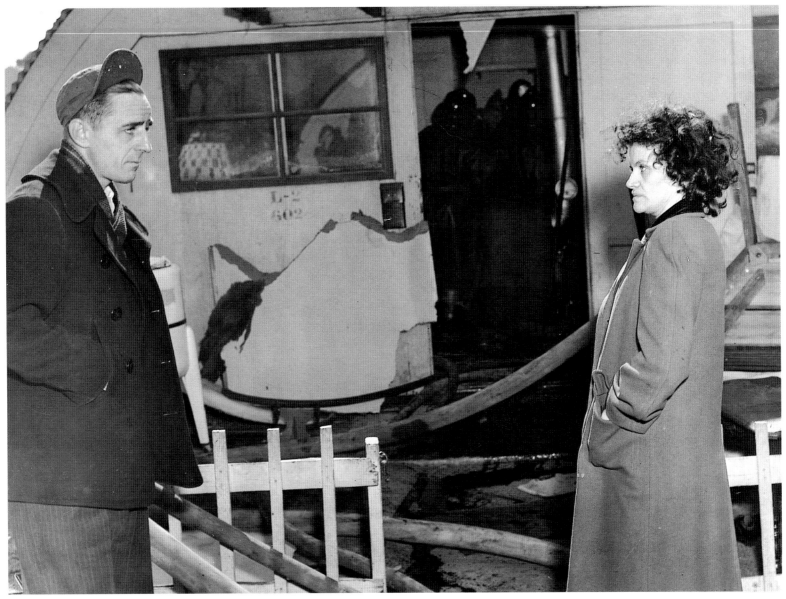

MAR 1 6 1949

AN EXPLOSION DIDN'T HAVE TO BE HUGE to bring out newspaper photographers in the Speed Graphic era. Here's a case of a relatively small event that nonetheless produced this classic I-wonder-what-they-were-thinking picture. The couple here, identified as Mr. and Mrs. Kenneth Nelson, are standing in front of their damaged Quonset hut home in a "veteran's village" at East Fifth and Flandrau Streets in St. Paul. Behind them firemen work to salvage what they can from the hut, one of hundreds erected in the city as "temporary" housing after World War II.

Mrs. Nelson was home with the couple's three children, ages two through seven, when a drum of oil used to fuel heating and cooking stoves suddenly exploded, possibly after coming in contact with an untended bonfire only 15 feet away. She and the children escaped without injury, but the explosion caused a fire that heavily damaged the hut.

The family had no insurance, and the Nelsons, caught in a desperate moment by the photographer, had to be wondering where they would live and how they would put their lives back together.

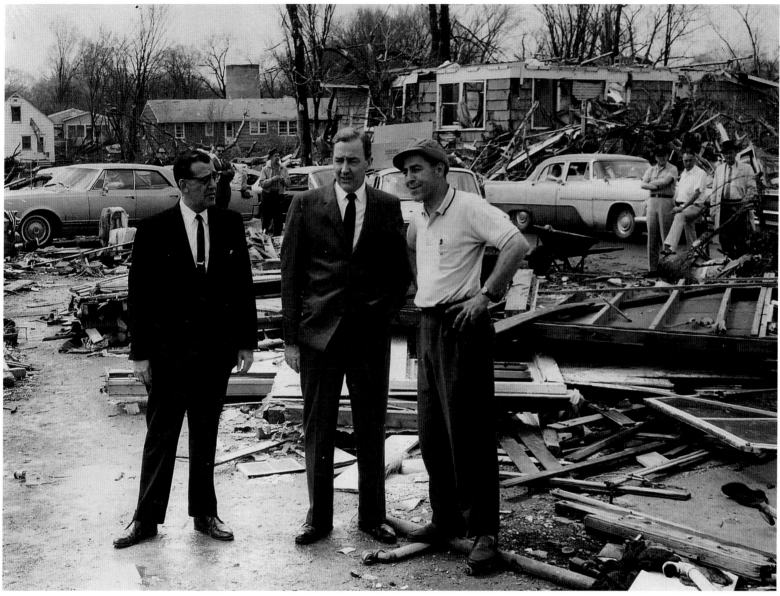

Pioneer Press / Hi Paul

DISASTERS CAUSED BY HUMAN MISADVENTURE weren't the only kind that attracted the Speed Graphic photographers. Natural disasters, including tornadoes, also brought out the men with big cameras. In the Twin Cities, the worst tornado outbreak on record occurred during the afternoon and evening of May 6, 1965. As many as ten twisters, some packing winds of more than 200 miles an hour, struck in the Lake Minnetonka area and also chewed through northern suburbs such as Fridley, Spring Lake Park, and Mounds View. Thirteen people died, hundreds were injured, and well over 1,000 homes, as well as other kinds of buildings, were damaged or destroyed.

Then as now, politicians rushed in to tour the disaster area and pledge speedy assistance. Here, three days after the storms, Senator Eugene McCarthy views the devastation in the Deephaven area at Lake Minnetonka. He's looking at the ruins of a house that belonged to Mrs. S. H. Cargill. With him are an official (at left) from the Small Business Administration and Charles N. Brooks, Jr., son-in-law of Mrs. Cargill, whose relation, if any, to the giant grain firm of the same name is unknown. As is so often the case with tornadoes, this one followed an eccentric path. Note the unroofed home to the rear while just behind it stands a house that appears to have sustained little damage.

Later on the same day, Vice President Hubert Humphrey arrived by helicopter to inspect the damage. Given the state's political clout in Washington, D.C., at the time, it's a good bet that federal aid arrived quickly.

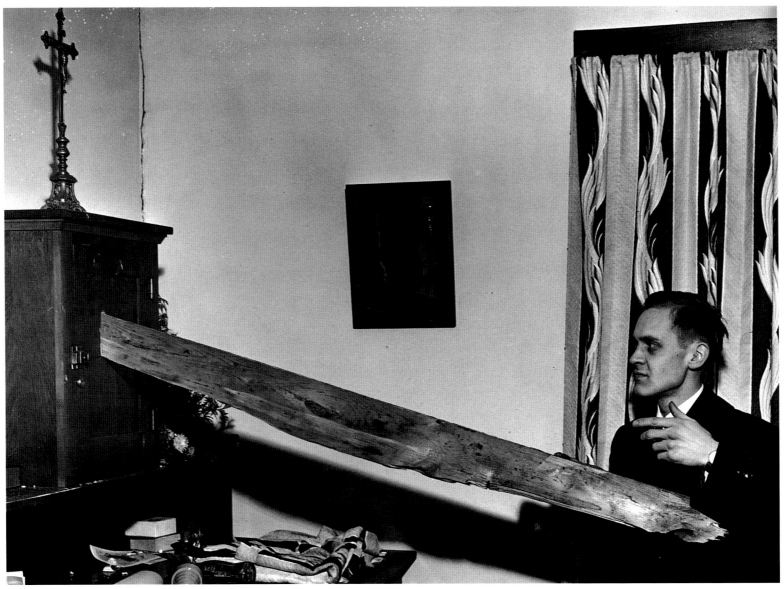

Pioneer Press / Chet Kryzak

28

TORNADOES WERE AS WIDELY COVERED in the 1950s as they are today. But newspaper and television photographers were rarely lucky enough to catch tornadoes in action. Instead, they concentrated on the aftermath, looking for those quirky acts of destruction— boards driven through buildings, feathers plucked from dead chickens, automobiles piled into one another—that are the stuff of tornadic legend. These two photographs show some of the more unusual damage from a rarity in Minnesota—March twisters. Three people died in the storms, which on March 21, 1953, struck in a wide swath extending from New Ulm to St. Cloud.

The small community of Sedan in Pope County was among the hardest hit. The local Catholic church sustained perhaps the strangest form of mutilation when a board propelled by the tornado smashed into the sacristy and buried itself in a wooden tabernacle. Whether this suggested a message of some kind from on high was an issue the *Pioneer Press* chose not to address. But reporter Bob Johnson did pose with the stray board, which narrowly missed a chalice before arriving at its final resting place.

The town's Presbyterian church suffered an even worse fate. The twister picked up the small wooden church and flung it, in large sections, into a nearby lumberyard. The front entryway ended up on its side, where a Sedan resident named Chester Torgeson poses behind the horizontal front doors. The photograph is made even more disorienting by the large wall section, its arched window frame still intact, that angles to the rear like a giant flying arrow.

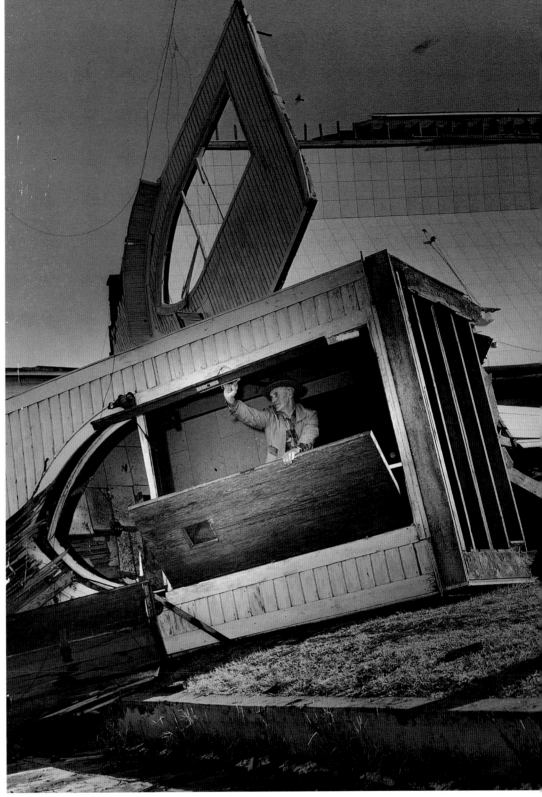

Pioneer Press / Dick Magnuson

MAR 2 3 1953

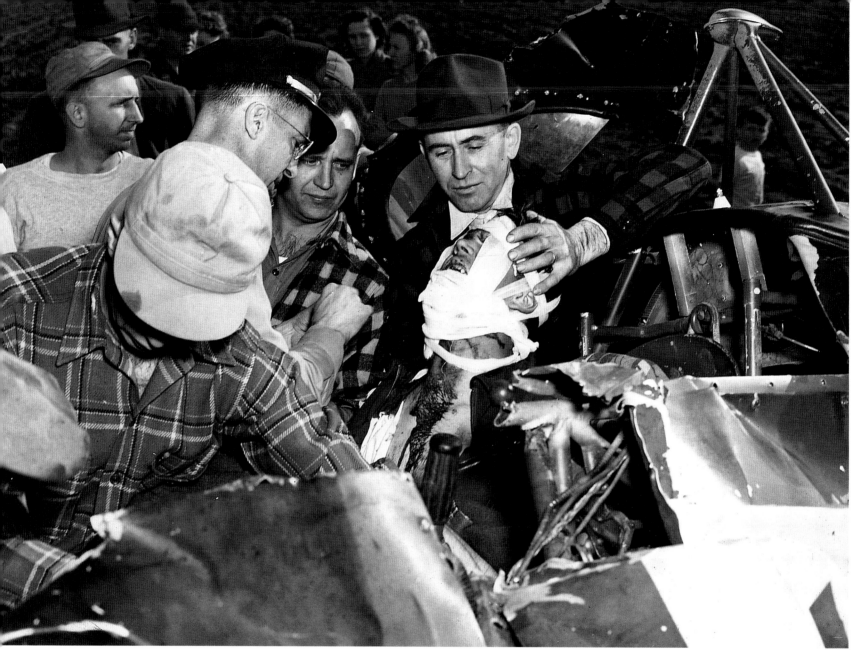

APR 1 1 1949

Pioneer Press / Wendell Wilson

AIRPLANE CRASHES, because they're relatively rare, always attract plenty of attention from news photographers. Here are scenes from two crashes—one small but clearly painful, the other among the worst in the history of the Twin Cities.

In the first picture, taken by a freelance photographer, rescuers work to free 24-year-old Robert Wood from the wreckage of his light plane after it crashed near Tanners Lake east of St. Paul. The *Pioneer Press* reported that Wood and a friend had purchased the aircraft, a Howard D-GA-18 trainer, for $200 and spent months working on it. Wood crashed while trying to make a steep turn on the first day he'd managed to get the plane into the air.

A crowd of about 100 people quickly materialized to watch as a Washington County sheriff's deputy and others tended to Wood. The extrication looks to have been extremely painful, since a fractured jaw and leg were among Wood's injuries. Despite his youth, Wood was all too familiar with danger in the air, having flown 57 bomber missions over Germany as a tail-gunner during World War II. He survived that crucible, but it's not known how he fared after his crash in the quiet fields of rural Washington County.

A far more horrific crash occurred on the morning of June 9, 1956, when a U.S. Navy jet fighter loaded with 1,000 gallons of fuel plowed into a group of houses in South Minneapolis as the

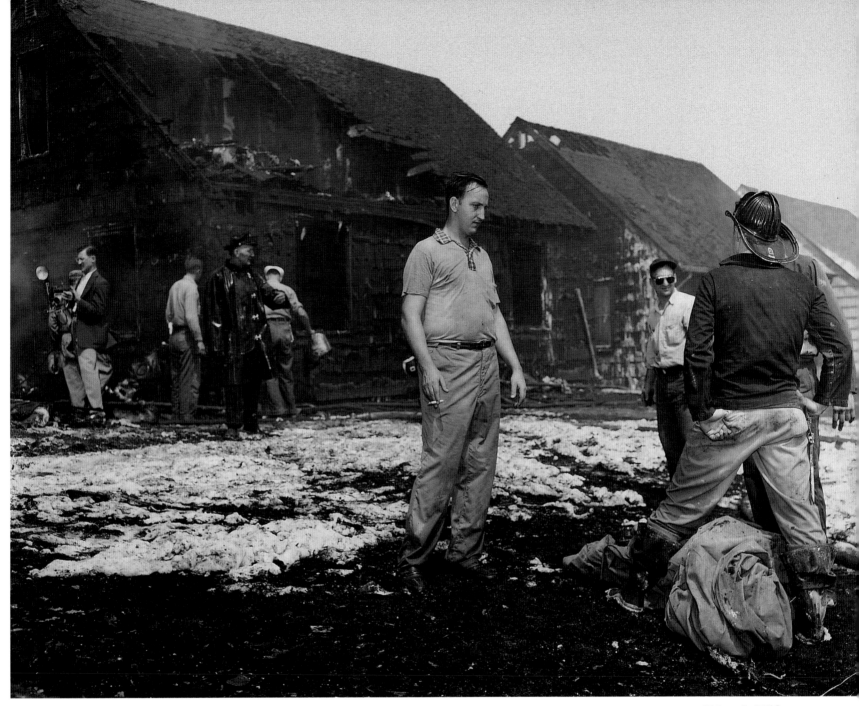

Dispatch / Ted Strasser

JUN 0 9 1956

pilot tried to make an emergency landing at Wold-Chamberlain Field. The pilot was killed, as were four of the five family members (one child survived) living in a house that took the brunt of the impact. A three-year-old girl in another house was also killed. All told, 15 people were injured, and 11 houses were either destroyed or damaged in the crash, near 58th Street and 46th Avenue South. The crash was, of course, a huge news story, and authorities later estimated that 75,000 people (probably an inflated number) tried to reach the scene, tying up traffic for miles around.

In this picture, a fireman straddles the covered body of the three-year-old girl who died, possibly in the burned-out house

behind him. The girl's mother managed to escape the house with another child. Later, the sobbing mother told reporters she'd wanted to go back after the girl, "but I couldn't. I just couldn't get in. Everything was in flames." Note the news photographer at left center. His presence in the middle of a disaster scene would be unheard of today.

The crash was the second air disaster of the week in the Twin Cities. Four days earlier, a U.S. Air Force jet had overshot a runway while landing at Wold-Chamberlain and struck a car on a nearby highway. A mother and daughter in the car were killed in that accident.

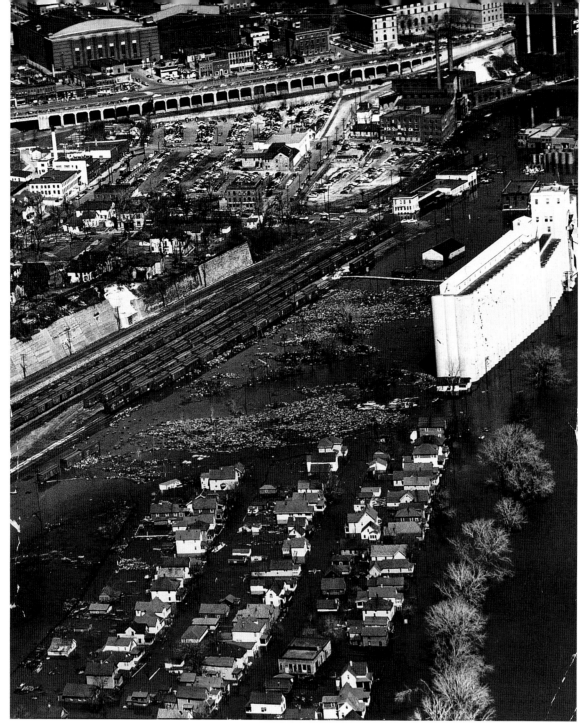

APR 1 5 1952

Pioneer Press / Ted Strasser

TWO PHOTOGRAPHS taken exactly 13 years apart highlight St. Paul's sometimes tempestuous relationship with the flood-prone Mississippi River. Although significant floods have struck in St. Paul as recently as 2001, when the Mississippi crested at its third highest level ever, the city—with new levees and low-lands largely cleared of structures—no longer offers many inviting targets for the river's periodic inundations.

That was not the case in 1952, a year that saw what is still the most disastrous flood in the city's history. Exceeding all previous high-water marks in St. Paul, the river poured across heavily populated "flats" on both sides of the river near downtown. By

the time the waters subsided, more than 5,000 people had been forced from homes that were in many instances damaged beyond all hope of repair.

An aerial view taken on April 14, 1952, shows the Upper Levee area west of Chestnut Street. The neighborhood's modest homes, many owned by Italian immigrants and their descendants, were all inundated by this time, when the river stood at almost eight feet above flood stage. Water also surrounded the huge Farmers Union Grain Terminal elevator and closed off key rail lines beneath the downtown bluffs. Across the river, water flowed "14 blocks deep into the West Side," according to the *Pioneer Press*.

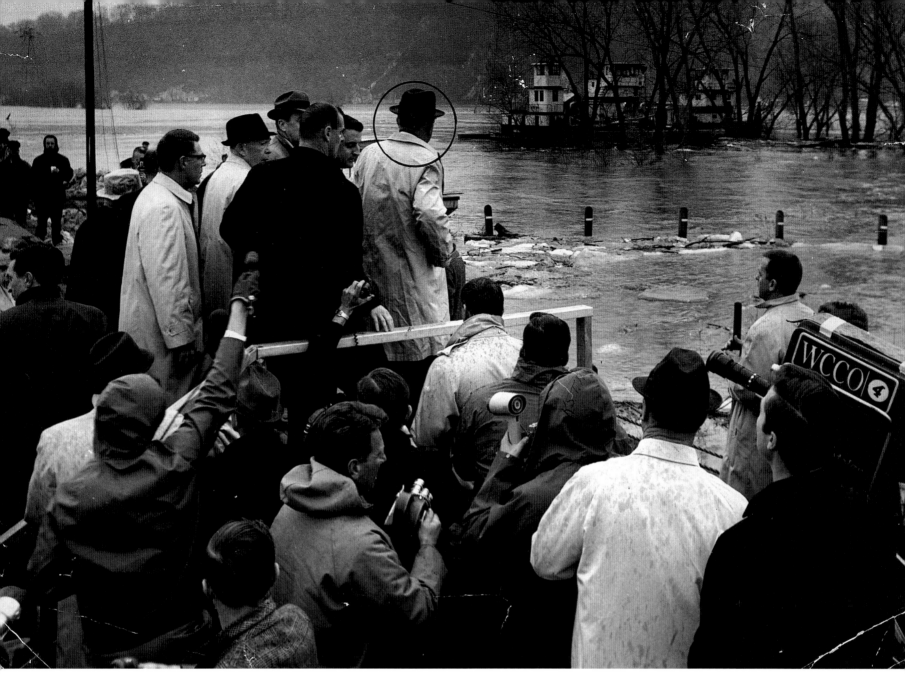

Pioneer Press / Roy Derickson

APR 1 5 1965

The 1952 flood led to enormous changes in St. Paul. Within a decade, the historic Upper Levee and West Side Flats residential neighborhoods would be gone, replaced by roads, industries, and new levees designed to hold back the tempestuous river.

The next big flood to come along, in 1965, proved to be another record breaker, reaching what remains the highest crest—12 feet above flood stage—ever recorded in St. Paul. Rivers across the state also swelled to unprecedented levels that year. The situation was dire enough to prompt a visit from President Lyndon Johnson, no doubt at the urging of his vice president, Hubert Humphrey. On April 14, near Shepard Road and James Avenue in St. Paul, Johnson and a bevy of Minnesota politicians stood within feet of the icy river amidst a scrum of television and newspaper photographers.

Normally, you'd expect the president to be front and center in a photograph like this, but here the focus is on the rampaging river, against which even LBJ (he's the one circled) was powerless. Huddled around Johnson in a light drizzle are, from left, Congressman Clark MacGregor (as the lone Republican at the scene he was left to stand at the back of the group), Governor Karl Rolvaag, Humphrey (in the creased hat), Senator Walter Mondale, and an unidentified Secret Service agent in a black coat. Senator Eugene McCarthy was also on hand but can't be seen here.

During his visit, Johnson pledged what politicians always do in disasters, saying, "We will do everything we can as promptly as we can and will render the maximum amount of federal aid." Then he flew back to Washington, D.C.

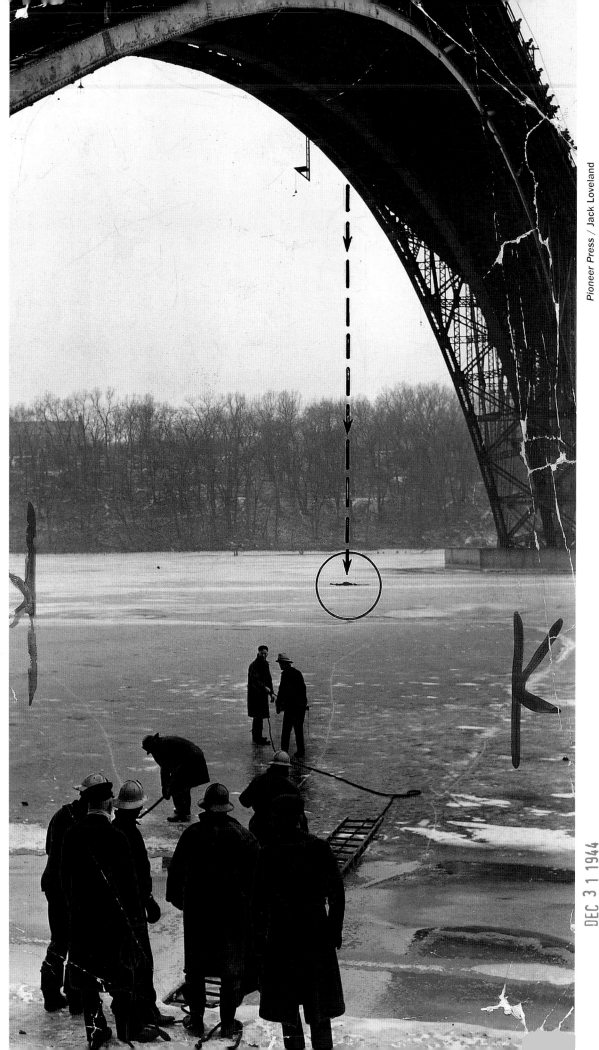

FOR MANY YEARS, SUICIDES—regardless of whether the person was well known or not—received substantial coverage in the press. In the nineteenth century, for example, newspapers like the *Pioneer Press* frequently offered a wrenching narrative of the victim's last days or hours, hoping to make sense of the act of self-extinction. By the Speed Graphic era, suicide was still considered newsworthy, although a photograph and brief story generally sufficed, unless the victim was someone prominent. Here are two suicides recorded by *Pioneer Press* photographers in the 1940s—one done in public, the other very private.

Early in the morning on the last day of 1944, 30-year-old Kathleen Bokuske of South Minneapolis walked out onto the Lake Street– Marshall Avenue Bridge, climbed over the railing near the center of the span, and leaped to her death. Her "crushed body," as the *Pioneer Press* described it, landed on a thin layer of ice coating the Mississippi River, and it took quite an effort by firemen using ropes, ladders, and toboggans to bring the body back to shore. In the manner of the time, the newspaper used arrows and a circle around the body to show exactly how and where Bokuske, who was said to be suffering from a "nervous ailment," had gone to her death.

The photograph is grimly straightforward and very sad. Bokuske's "ailment" would today almost surely be called depression, and as with all suicides, the scene conveys a deep sense of loneliness and loss.

Similar sentiments come to mind when looking at an even grimmer photograph from 1947. Death for this unidentified elderly man came at a seedy rooming house on St. Peter Street in downtown St. Paul. When the house's proprietor came to collect the rent, he found the man hanging in a small closet. It doesn't appear this graphic photograph was actually used in the newspaper, but there was a brief story in the *Pioneer Press*.

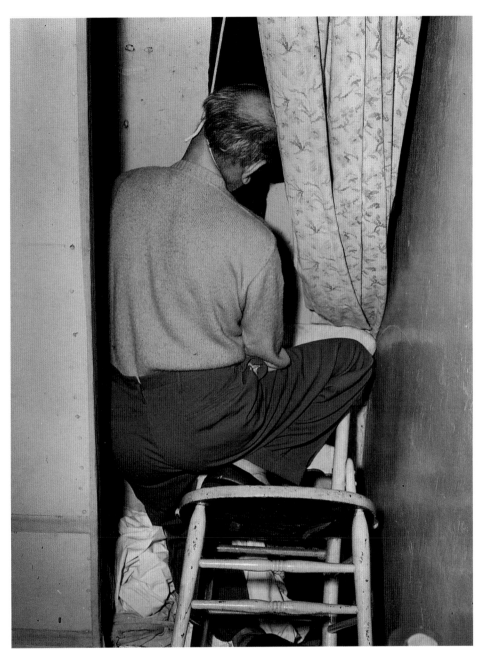

Pioneer Press / Chet Kryzak

MAR 0 7 1947

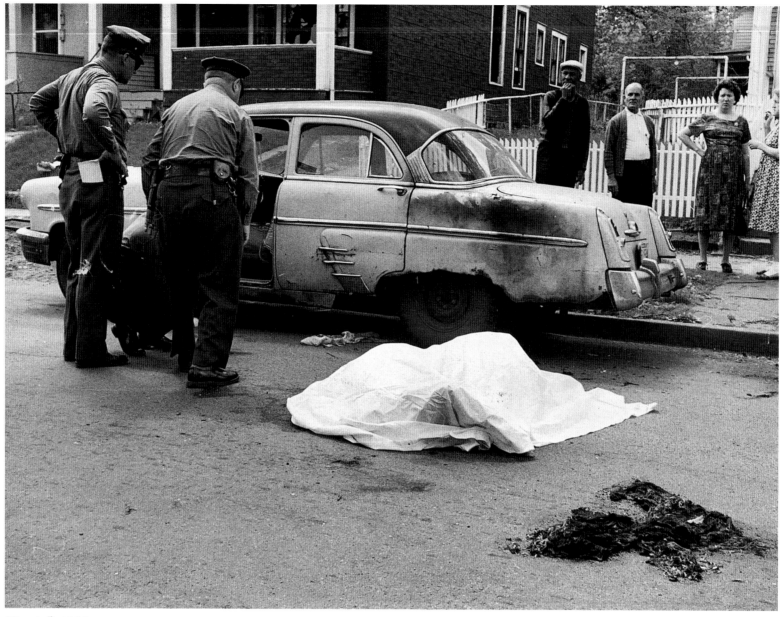

MAY 1 5 1964

Dispatch / Sylvan Doroshow

A FIRE-SINGED CAR, a body wrapped in a sheet, charred remains of clothes on the street, policemen inspecting the scene, a few bystanders gathered to watch. It all makes for a classic spot news photograph and for something of a mystery as well.

Covered by the sheet is a woman identified as Mrs. Frank Risse, age 63. Investigators later determined that she'd burned to death when a bowl containing flammable insect spray ignited and set her clothes on fire as she sat in the car outside her house on Iglehart Avenue in St. Paul. Her body engulfed in flames, she managed to get out of the car and walk a few steps before a neighbor and a passing motorist were able to beat out the fire. She was dead by the time firemen arrived.

Mrs. Risse's son later told police he didn't know why his mother would have had insect spray in the car, which she never drove. Nor could he explain why a pack of matches was found outside the car, since she didn't smoke. But it was learned that she'd walked to a nearby drugstore to purchase the spray, returned home with it, and died in the mysterious fire a short time later.

36

ST. PAUL'S MANY RIVERSIDE CLIFFS have attracted youthful explorers, sometimes with tragic results, since the founding days of the city. In May 1949, however, a three-year-old girl who tumbled over a cliff near Cherry Street in the Mounds Park neighborhood turned out to be very lucky. The girl, Charlotte Pillar, plunged 50 feet down the cliff before a fortuitous ledge broke her fall. Her eight-year-old brother, Dennis, bravely scrambled down to help her but became stuck himself before rescuers arrived.

Here, St. Paul Police patrolman Vern Neihart has the girl in his arms as he prepares to ascend the cliff with the help of a rope around his waist being pulled by firemen above. Dennis, meanwhile, awaits his turn for rescue. One of the striking aspects of this photograph is how primitive the rescue seems by today's standards. Fire departments now come equipped with all manner of special gear to rescue people who find themselves in high and precarious places.

As for Charlotte, she suffered only cuts and bruises in her downhill adventure, but it's a sure thing that her mother, identified as Mrs. Daniel Pillar, had a long talk with her about playing too close to cliffs.

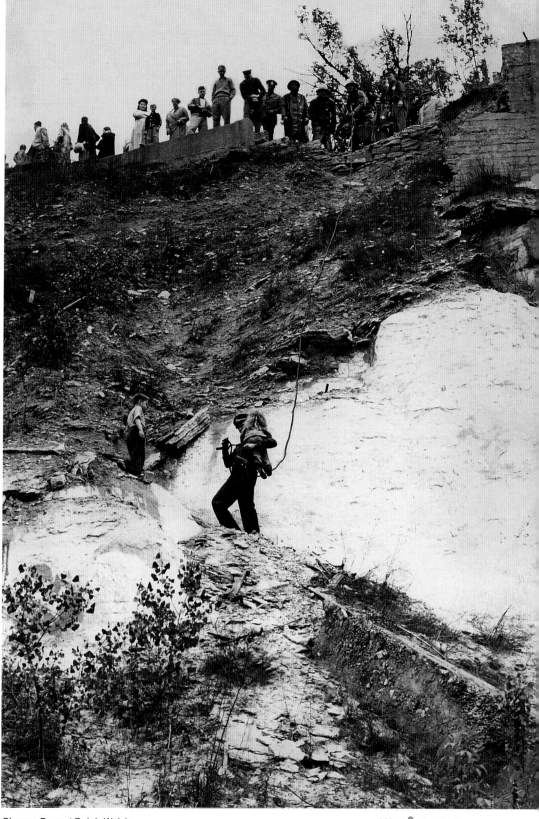

Pioneer Press / Ralph Welch

MAY 2 0 1949

37

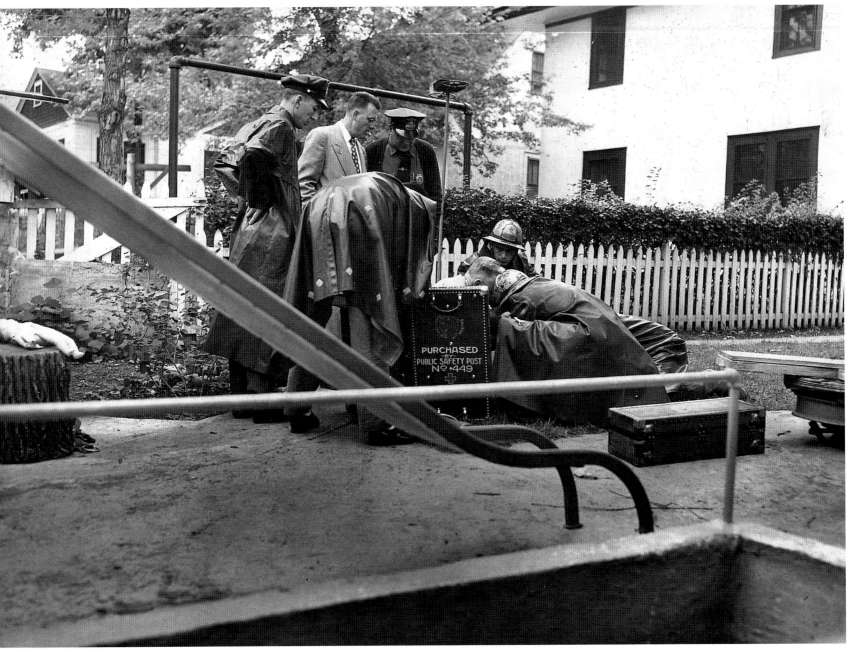

AUG 3 1 1951

Dispatch / Stu Gang

NO EVENT IS MORE TRAGIC or inexplicable than the death of a child, as these photographs (and two more that follow) demonstrate. All are scenes of drownings, which seem to have been more common in the 1950s than they are today.

The first was taken on Sargent Avenue in St. Paul in 1951. Firemen are trying to revive 19-month-old Patricia Morrissey, who wandered away from her playmates and fell into a small homemade wading pool in the yard of a nearby house. There was only about a foot of water in the pool, but it was enough to prove lethal. Part of the pool is visible in the foreground, while the little girl's doll rests on a tree stump at left. A boy found Patricia floating in the pool and summoned help, but all efforts to resuscitate her failed.

Six years later, in the Highland Park neighborhood, another child was lost. This

38

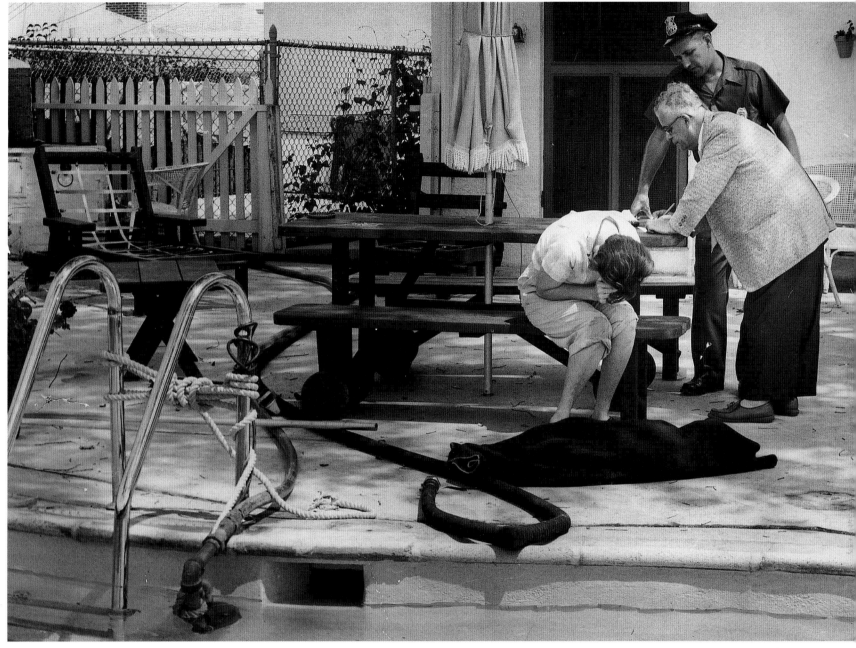

JUL 1 6 1957

time the victim was a four-year-old boy named Charles Simmer. The boy's mother found him in a pool at a neighbor's house, lying at the bottom of the deep end in eight feet of water. She dived in and got him out, but he was pronounced dead after firemen worked in vain to revive him.

In this photograph the aftermath of the tragedy is laid out in a quietly eloquent, almost intimate way. The boy's body, covered with a blanket, lies next to the pool. Mrs. L. Charles O'Leary, a neighbor (but not the pool owner), sits at a picnic table, weeping over the body. The man behind her taking notes is *Pioneer Press* reporter Louis Gollop, who's getting details of the drowning from Robert Kunz, a St. Paul Police patrolman. Gollop's presence at such a tragic scene is an indication of how closely the police and the press often worked in the 1950s.

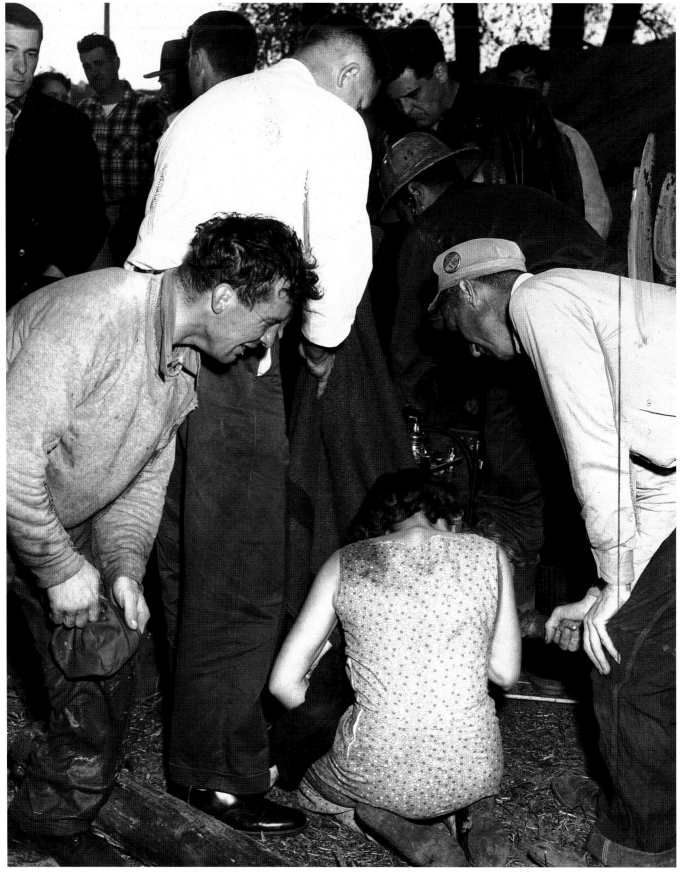

MAY 1 5 1956

Pioneer Press / Leo Stock

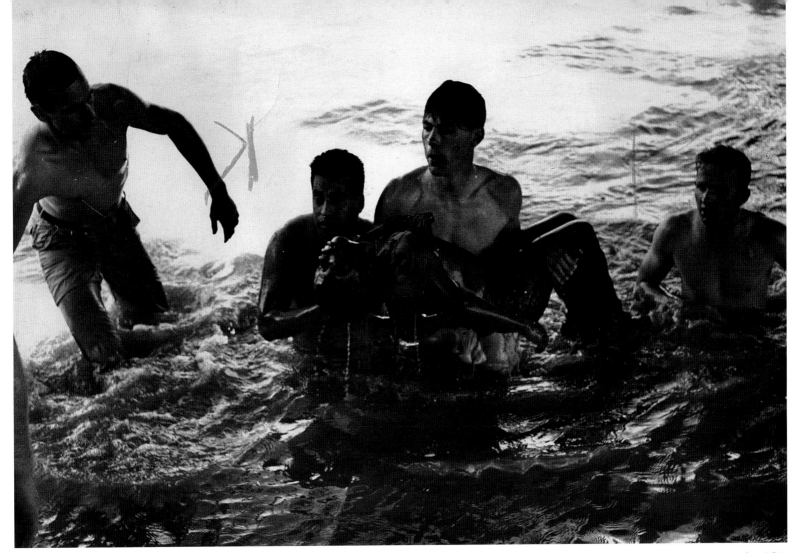

Pioneer Press / Spence Hollstadt

IN MAY 1956, two-year-old Raymond Gorz wandered away from his home on St. Paul's West Side Flats. Riding a tricycle, he went to the steep banks of the Mississippi River just two blocks away. As he played along the banks, he lost his footing and tumbled down into the treacherous current. When the boy couldn't be found, his father, Robert Gorz, went searching for him and came across the abandoned tricycle. He also saw a tiny body floating downstream. Gorz jumped in, fully clothed, to rescue his son, but efforts to revive the boy, first by an uncle and then by firemen, proved futile.

Here, the boy's mother, whose first name isn't given in the newspaper story, holds him in her arms. To her left the boy's sobbing father, his clothes still drenched from his plunge into the river, looks on. The uncle, Walter Gorz, holds one of the dead boy's hands. By this time it appears firemen have given up their resuscitation efforts. The *Pioneer Press* reported that the mother "picked up the body, unbelieving, refusing to let police cover the boy with a sheet. . . . [The father] held onto a small, limp hand, kissing it and weeping uncontrollably and beating upon the earth with his fist. An officer took the body from the mother's arms.

The parents walked away toward their home. . . . They walked arm in arm, sobbing."

On a warm June evening in 1960 another tragedy played itself out in St. Paul when eleven-year-old James Green and his nine-year-old brother, Henry, built a makeshift raft and went navigating in a pond near their home. The pond was actually a ten-foot-deep, rain-filled pit beneath a bridge being constructed along the Interstate 35E corridor at Arlington Avenue. Another brother, aged seven, later told police that a boy standing on the uncompleted bridge threw a firecracker down toward the raft. "They [the two brothers] got scared and fell off," the younger brother reported. James and Henry never made it back to their raft, disappearing into the murky waters.

A policeman arrived and was about to go in after the boys when four volunteers offered to help. The men dived into the pit and are shown here bringing one of the brothers back to shore. The other boy was quickly found as well, but both were pronounced dead at the scene. Residents of the area were angered by the deaths, according to the *Pioneer Press,* and demanded that the pit be drained "before others drown."

41

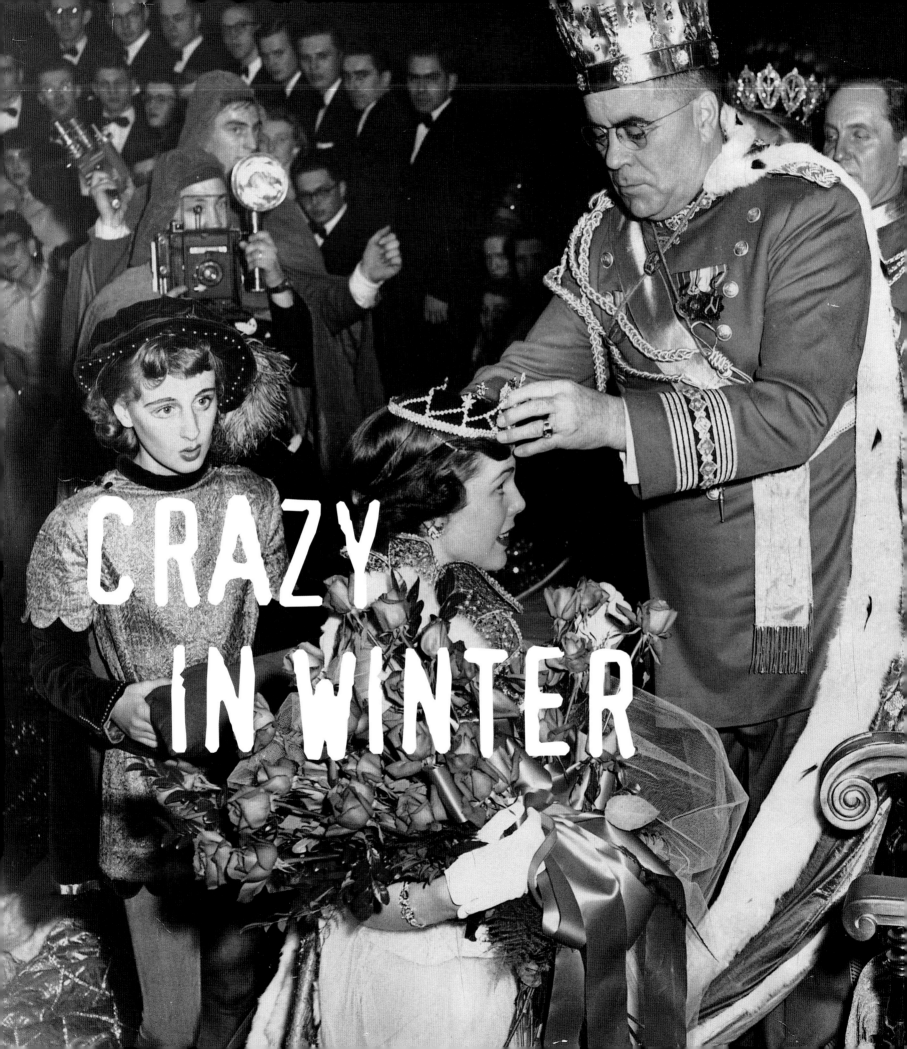

The St. Paul Winter Carnival goes back to 1886. Legend holds that it was created to disprove the notion, advanced by some pansy of a newspaperman from New York, that Minnesota's climate is as inhospitably frigid as Siberia's. At least one historian, however, has suggested that the carnival was launched for that most fundamental of reasons in St. Paul—to compete with Minneapolis, which was planning a huge industrial exposition in the summer of 1886.

Whatever inspired St. Paulites, they went out that January to build the city's first ice palace. They also staged the inaugural Winter Carnival parade on a night when the temperature was a mere 14 degrees below zero. Although the festival has gone through fits and starts over the years, it continues to cast a strange spell over the city every winter. In some ways, it functions as an alternative reality, a fantasy world populated by kings, queens, princes, and princesses, all of whom are required to do battle with nefarious Vulcans and, on occasion, wear outlandish costumes. It is all very peculiar in an endearing sort of way.

The Vulcans, a far more aggressive lot in the 1950s than they are today, were the carnival's id, a group of masked men who careened around town in an old fire truck and delivered smudgy smooches to any females they happened to run across. These unsolicited kisses were not considered to be improper behavior in the 1950s, at least by the Vulcans themselves. The ceremonial unmasking of Vulcanus Rex and his "Krewe" was always a much-anticipated event, memorialized by a photograph in the newspaper.

As an all-absorbing civic celebration, the carnival may well have reached its apogee in the late 1940s and into the 1950s, even though no mammoth ice palaces were constructed during these years. The day and night parades often attracted 100,000 people (if police estimates are to be believed), while lavishly staged events like the crowning of the Queen of the Snows packed them in at the old St. Paul Auditorium.

Out at White Bear Lake there was also the "World's Original Ice Fishing Contest," an event first held in 1947. The contest quickly snowballed into a huge affair that, among other things, featured what might be called aerial art. It's not clear how it happened, but someone came up with the bright idea of arranging the contestants and their cars in such a way that they formed distinctive geometric patterns when viewed from above. One year, in a grim comment on the polio epidemic of the early 1950s, the outline of a gigantic lung was created on the ice. Most years, however, the image was a bit more upbeat.

Naturally, the *Pioneer Press* and *Dispatch* devoted an enormous amount of ink to the carnival and also sponsored perhaps its most remarkable event—the treasure hunt (now known as the medallion hunt). Inaugurated in 1952, the hunt was elegant in its simplicity. The newspapers' promotion director secured a small metal treasure chest, put a certificate inside entitling the finder to up to $1,000, hid the chest in Highland Park, and wrote up rhyming clues that appeared daily in the *Pioneer Press* and *Dispatch*.

The first hunt was wildly successful, though it nearly got off to a shocking start. In their frenzy to find the treasure, one group of hunters broke into an electrical vault inside King Boreas's small ice palace in Rice Park and came close to electrocuting themselves. Other would-be winners brought fake treasure chests to the newspaper offices in hopes of claiming the prize.

The photographs that follow highlight some of the more memorable moments of winter madness in St. Paul during the Speed Graphic era.

FEB 0 8 1948

Pioneer Press / Hi Paul

BUILDING SNOW FORTS and snowmen has forever been the pre-
rogative of youth in Minnesota. In 1948, however, kids in St. Paul
got the chance to do something even more creative. That year
the Winter Carnival sponsored a citywide contest to see who
could build the best miniature ice palace. Top prize was $50, a lot
of money to a youngster in those days. The contest was so well
organized that it had two levels for youngsters, based on age. In
early February, as the carnival drew to a close, judges roamed
the city to select winners. It isn't known how many mini-palaces
the judges saw, but eight prizes were awarded in all.

Bertie Lou Mathison, champion in the age 12 and under
category, looks justifiably proud as she poses behind the palace's
angular walls. Bertie and ten fellow Camp Fire Girls spent five
weeks creating the icy wonder in the yard of her home on East
Ivy Avenue in St. Paul. As a design, it's a work any modern archi-
tect would envy for its directness and its ingenious use of a
"found" material—in this case, coffee cans—as pillars.

Pioneer Press / Ralph Welch

THE OFFICIAL 1948 ICE PALACE was in Como Park in front of the lakeside pavilion. It was more of a stage than a true ice castle, but it did feature sculpted figures and decorative flags atop its stepped-up walls. The scene here was taken on the night of the "storming" of the palace by Vulcanus Rex, referred to by the *Pioneer Press* as a "self-styled people's king." This event traditionally marks the end of the ten-day Winter Carnival and is also supposed to carry with it the promise of warmer weather to come.

Warmth, however, was in short supply on this particular night. The temperature was 11 degrees below zero, and "the extreme cold affected the traditional ceremonies," according to the newspaper. "It started when Jean Kellenberger, Morris Fire Queen, slipped on ice and fell while leading the retinue of Queens to the ice throne. She was not hurt." Things only got worse after that. An unlucky drum and bugle corps on hand to provide music "sometimes lost normal brass volume because of the cold instruments," while King Boreas (Edward C. Hampe) risked frostbite by going without earmuffs. The *Pioneer Press* also reported that the king's "blond consort, Queen of the Snows Maxine Emerson, was almost white" due to the extreme cold. One hopes she didn't have to sit on the ice throne for too long.

Despite the arctic weather, police estimated that between 10,000 and 20,000 people turned out to watch all of this frigid foolishness during a 45-minute ceremony that must have felt like an icy eternity.

JAN 0 6 1949

THE WINTER CARNIVAL was for many years something of an oversized boys' club, whose members (mostly local businessmen) got a chance to cut loose and have a little naughty fun. This was especially true of the Vulcans, masked marauders who've always had the best part—they're the villains—in the carnival's well-crafted fantasy. The Vulcans still cut a smudge-strewn swathe through St. Paul during the carnival, but they've toned down since the freewheeling days of yore. Unburdened by any notion of women's rights, the Vulcans for many years did their best to plant a kiss on virtually any female within reach, an activity that, according to one *Dispatch* article, earned them many a slap.

This photograph from 1949 shows George Heleniak, reigning Vulcan King, on the receiving end of a kiss and a practical joke. The kiss is being delivered by a woman named Lee Mantoen. Heleniak, according to a caption, "receives said smooch with obvious enjoyment." Ah, but there is trickery afoot. Note the Vulcan with folded arms standing directly behind the kissing pair. Who could this impatient, frowning, grease-stained figure be?

You guessed it—it's Mrs. Heleniak in disguise and doing her best to look upset about hubby's indiscretion. It was, of course, all a practical joke, one that was arranged as part of Heleniak's installation as president of the Exchange Club in St. Paul. Corny photographs like this—once a regular feature of the newspapers' carnival coverage—are today an all-but-extinct journalistic species.

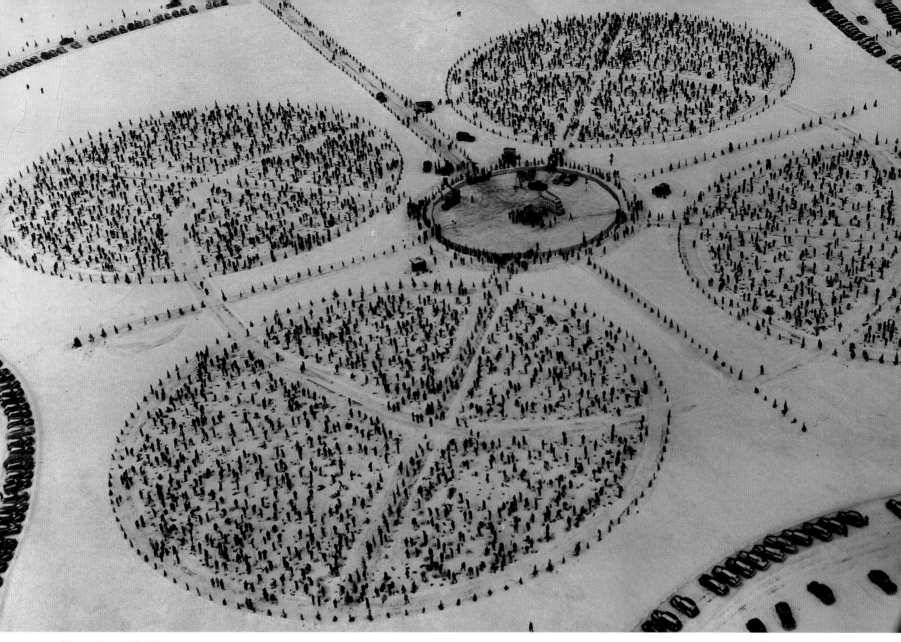

Pioneer Press / Ted Strasser

FEB 1 3 1949

LONG BEFORE CROP CIRCLES and Christo, there was ice fishing art. The idea appeared as early as 1948, when the World's Original Ice Fishing Contest at White Bear Lake began to draw notice for its unique appearance from the air. That year, 3,000 hardy contestants showed up for the event—cosponsored by the Winter Carnival—forming a big circle in the center of the frozen lake orbited by a dark ring of parked cars. The *Pioneer Press* sent its aerial photograph of the scene out on the Associated Press wire, where it proved to be quite a hit. The picture appeared in newspapers all over the United States and even a few in Europe. One can only imagine what the French made of it.

Be that as it may, in 1949 the organizers of the ice fishing contest decided to do something even more spectacular in the way of design. This pleasing clover-leaf, featuring five circles marked out by rows of "planted" evergreens and surrounded by an undulating double ring of vehicles, certainly made for a memorable photograph.

The contest itself drew an estimated 5,000 participants, perhaps not as amazing as the fact that there were 7,000 spectators, which if nothing else suggests that excitement may have been in short supply in those days. Still, the big event did offer a dramatic and stirring conclusion. Just 30 seconds before the time limit expired, a St. Paul man landed a five and three-quarter pound Northern pike and was immediately pronounced the grand winner. Alas, the World's Largest Ice Fishing Contest gave way to competition from similar events in the 1980s and is now a winter memory.

47

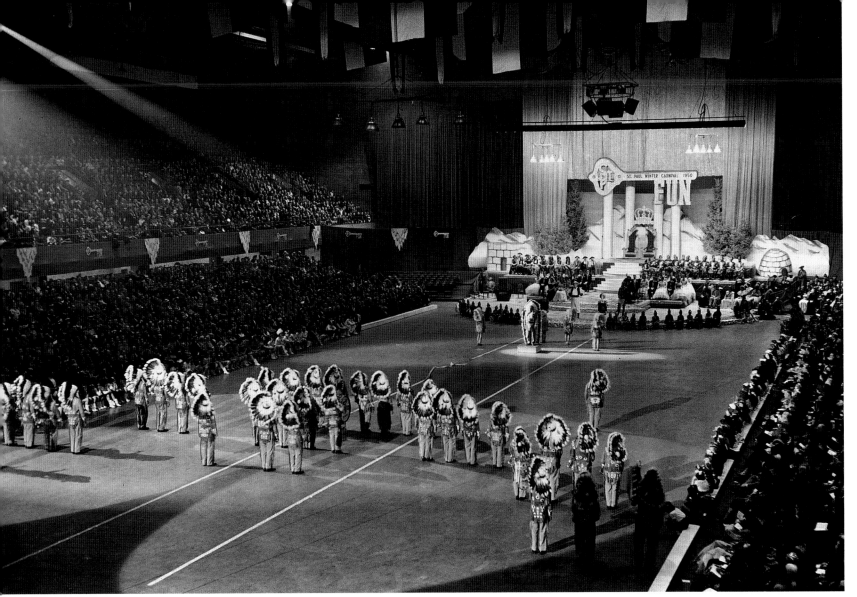

FEB 0 2 1950

Pioneer Press / Jack Loveland

THE OLD ST. PAUL AUDITORIUM was the scene of many Winter Carnival events, including this well-attended ceremony from 1950. The occasion was the coronation of the Queen of the Snows, an affair that featured, among other things, the grand entrance of carnival "royalty." Here's the arrival of the Prince of the West Wind, who wore a ten-gallon cowboy hat and was escorted by the ever-popular Schmidt's Post 8 American Legion Indians. The 18 Queen candidates were already on stage, waiting like everyone else for the arrival of King Boreas, whose throne stands ready for his regal presence. According to the *Pioneer Press*, 8,000 people showed up to watch these royal proceedings—a testament to the carnival's hold in those days on the public imagination.

The Schmidt's Indians were a drum and bugle corps formed by an American Legion Post in St. Paul and sponsored by the brewery. They appeared at all manner of parades, celebrations, and public functions. St. Paul's other big brewer at the time, Hamm's, sponsored a similar organization. These groups, whose members wore buckskins and warbonnets, were typically all white. The sight of white people dressing up in ersatz "Indian" garb was so common in the 1950s that it drew little attention or controversy. That would come later.

Incidentally, on the same day that the *Pioneer Press* reported on all of this foolishness, another front-page story disclosed that the United States had already begun work on a hydrogen bomb, which an Associated Press dispatch memorably described as a device "that could be the most horrible engine of destruction ever devised by man." This unsettling news, however, didn't merit nearly as large a headline as the coronation story.

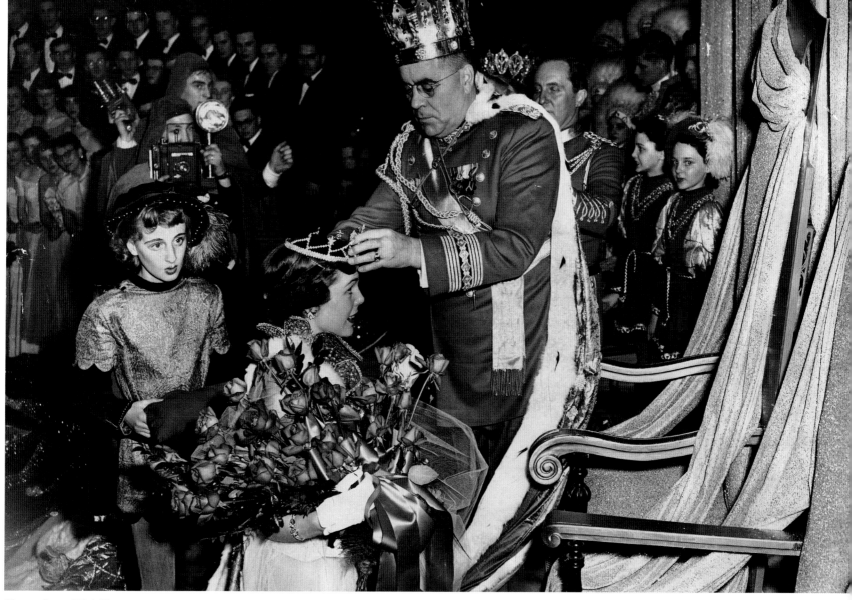

FEB 0 4 1953

TRADITIONALLY, the coronation of the new Queen of the Snows was among the most lavish of all Winter Carnival events. This 1953 photograph shows the magic moment as 18-year-old Carole O'Grady is crowned by King Boreas XVIII, alias J. Russell Sweitzer. The sheer pageantry of the event is impressive by today's standards, as is the fact that 10,000 people showed up at the St. Paul Auditorium to watch.

The most fascinating faces in this picture belong to the young pages dressed in tunics and fancy hats. Note the page at far right sneaking a look at the camera. Speaking of cameras, that's a Speed Graphic held by one of the caped photographers at left.

As for the new Queen of the Snows, the *Pioneer Press* reported that she was "brushing a joyous tear from her eye" as she was crowned. O'Grady was sponsored by 3M, where she worked as a private secretary. The newspaper went on to describe the new queen as a "109-pound, auburn haired lassie who stands 5 feet, 4 inches tall and owns a pair of warm, liquid brown eyes. Other important statistics: 34-24-34 for bust, waist and hips." It should be noted that newspapers in the 1950s routinely provided this sort of female anatomical detail to their readers, presumably in the spirit of public service.

FEB 0 5 1953

Pioneer Press / Dick Magnuson

WHEN PHOTOGRAPHERS of the Speed Graphic era couldn't be at the scene of a big story, they would sometimes resort to the next best thing in the form of a loosely staged reenactment. This example of the genre, courtesy of *Pioneer Press* photographer Dick Magnuson, depicts what, for any true-blue St. Paulite, is that most sublime of moments—discovery of the Winter Carnival treasure.

The year is 1953 and the woman at center with a hoe is Mrs. Catherine Harmon, who after two days of "methodical hunting" unearthed the treasure, worth $1,000, in Cherokee Park on St. Paul's West Side. A man named Fred (Bud) Croft, Jr., was hunting next to Mrs.

Harmon and reported that when her hoe struck the chest she reacted at first with disbelief. "The woman said, 'Someone is pulling a gag on me. This is too easy,'" Croft quoted her as saying. "She was so stunned and spellbound I gave her my name as a witness." The identities of the dozen or so reenactors shown here (including one fellow peeking out from behind the tree at left) aren't known, but they all seem to be having a fine time, especially the kids at right. Incidentally, Mrs. Harmon, whose husband was president of Webb Publishing Company in St. Paul, donated the $1,000 prize to charity.

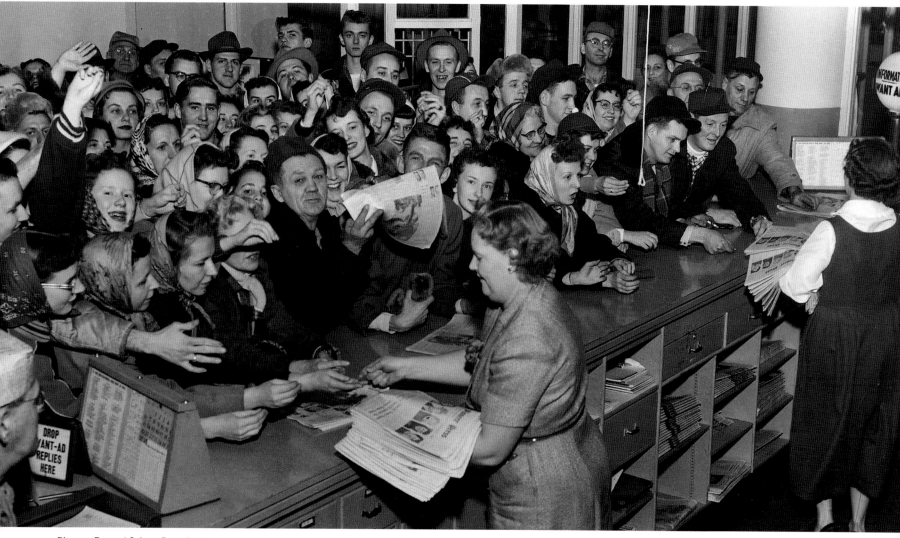

Pioneer Press / Sylvan Doroshow

FEB 0 3 1955

Another photograph, from 1955, shows just how frantic the hunt could be. Before cell phones and the Internet, the only way for treasure hunters to stay on top of their game was to show up at the offices of the *Pioneer Press* and *Dispatch* as soon as each new edition of the newspaper appeared with the latest clue. The *Pioneer Press*'s first edition usually came out at about eight o'clock at night, and that's when hordes of treasure seekers showed up in the lobby of the newspaper's building on Fourth Street to secure a copy of the paper, which in those days still sold for a nickel.

The people at the counter look remarkably eager and excited, keeping clerks Inez Ferguson (left) and Norma Elmquist busy. So many people showed up to get the latest clue that a traffic jam bottled up the intersection of Fourth and Cedar Streets for nearly an hour. What none of these hopefuls had yet figured out was that the treasure lay just five blocks away, beneath a mailbox at Seventh and Robert Streets.

A quaint feature of the hunt in these years was the use of smoke bombs—set off from the roof of the *Pioneer Press* and *Dispatch* building—to notify searchers that the treasure had been found. As soon as the bombs exploded, the newspapers' switchboard "was swamped by eager inquirers, asking for confirmation of the signal."

WOMEN'S WORLD

THE SPEED GRAPHIC ERA offered a limited range of images when it came to women. *Pioneer Press* and *Dispatch* photographers, like their cohorts elsewhere, were fond of shots showing women in mildly seductive poses. Pictures displaying a well-turned leg were perhaps the favorite. However, most photographs showed women performing tasks—cooking, modeling clothes, tending to children—thought to be appropriate to their station in life. Now and then, however, a picture that defied the stereotypes would sneak into print. Here are four photographs that typify how women were presented in the St. Paul newspapers in the 1940s and 1950s.

This might be called the "ogle shot," and it was standard for the time. The young women here took part in a "bathing beauty" contest held during a regional convention of the American Taxicab Association in St. Paul. The man doing the ogling was a contest judge from Chicago.

Pioneer Press / June 23, 1948 / Dick Magnuson

Women were rarely seen in any kind of professional role in newspaper photographs of the time. This is a notable exception. Jean Kusnerek (left) and Nancy Lasley were identified as "aeronautics career girls" at the University of Minnesota's Rosemount Research Center in 1948. A story noted that they were "up to their pretty necks" in wind tunnel research.

Pioneer Press / May 26, 1948 / Jack Loveland

A movie about the exploits of Depression-era gangster "Baby Face" Nelson was playing in St. Paul in 1957. For reasons hard to fathom, some editor thought it would be a scream to pose this woman—Gloria Nelson, 18, apparently known since childhood as "baby face"—as a bank robber. So here she is, "armed only with a tube of lipstick and a compact," at the American National Bank in St. Paul.

Dispatch / Dec. 6, 1957 /
Sylvan Doroshow

These young women are co-winners of the Miss Print title at an event sponsored by the University of Minnesota School of Journalism in 1956. Carol Goral came as a printer's devil while Nancy Fournier posed in an oversized cigarette pack as "Miss Tattoo." Oh, those crazy college kids!

Dispatch / May 12, 1956 /
Sylvan Doroshow

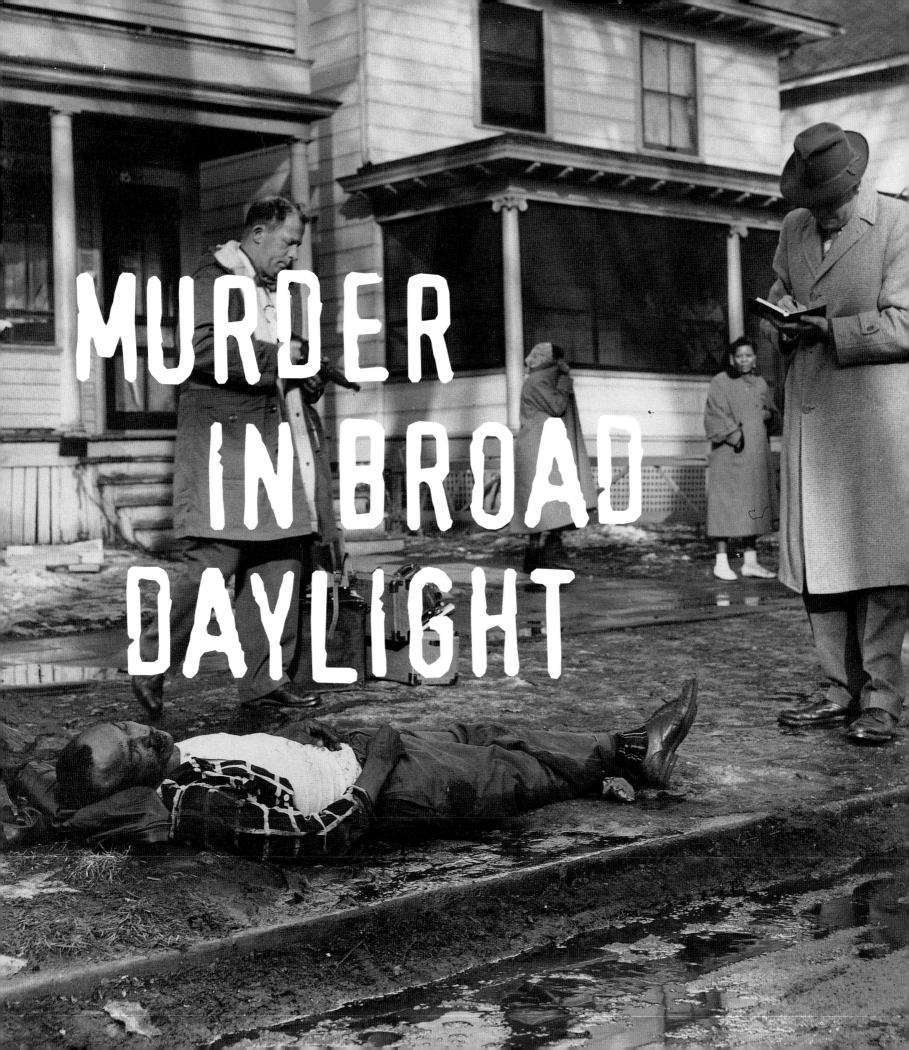

A taste for lurid, violent imagery is one of the most unsettling features of much "respectable" journalism in the 1940s and 1950s. Though violence remains an omnipresent reality in human affairs, the mainstream media today—with some exceptions—tend to approach gore cautiously, fearful that too many explicit depictions of violent death will produce a backlash among readers and viewers. No such internal governor appears to have been in place at the *Pioneer Press* and *Dispatch,* or at most other newspapers, during the Speed Graphic era. Pictures of shot, stabbed, burned, beaten, mutilated, and even decomposed corpses regularly appeared in the newspapers as a sort of grisly side dish to the other, more readily digestible, events of the day.

The strangeness of these photographs, at least to modern eyes, lies in their almost hypnotic proximity to violent death and to those accused of dealing it out. Today, murder as presented in the media is generally a distant affair, the body unseen behind a cordon of police tape and ranks of emergency vehicles with flashing lights. The immediate crime scene is a world apart, as closed to outsiders as the sanctuary of some mystic religion, and very rarely do news photographers have a chance to enter the inner sanctum.

It was a much different world 50 years ago. The crime scene was as often as not a quasi-public place, open to the news photographers and reporters who were in some rough sense representatives of the people. Murder then was not merely a crime but a kind of public tragedy, played out before anyone who had a nickel for a newspaper and the stomach to look at photographs of the dead.

Yet media coverage wasn't limited only to the crime scene and its mute victims. There was also in the Speed Graphic era something like a culture of public investigation that permitted the press to be on hand for arrests, interrogations, confessions, and even, in some cases, the administration of polygraph tests. This culture is still with us, of course—the O. J. Simpson extravaganza is perhaps its crowning recent example—but in the 1940s and 1950s even far less sensational crimes tended to be followed in closer detail, especially by the newspapers, than is usually the case now.

The dangers of a cozy partnership between the press and the justice system are all too obvious in retrospect. At the national level, Senator Joseph McCarthy's meteoric rise as a hunter of Communists was made possible by a compliant press that had largely forgotten how to think for itself. In the case of local crime coverage, cooperation produced a kind of dependency on the part of the press, which was seldom inclined to challenge cops, prosecutors, politicians, and judges, none of whom were above manipulating the newspapers for their own purposes. Nor were the rights of defendants very secure in an overheated media atmosphere in which the presumption of innocence was never allowed to get in the way of a good story.

Still, there is no denying that the access to crime scenes and criminals once enjoyed by the press in St. Paul and elsewhere produced a marvelous body of everyday news photography. The pictures in this chapter are devoted to daytime photographs of criminals and crime scenes. The even richer world of the night is the focus of another chapter.

MAR 1 6 1956

PHOTOGRAPHS OF CORPSES were routinely published in the *Pioneer Press* and *Dispatch* during the Speed Graphic era, and no one—at least no one at the newspapers—seems to have had many second thoughts about the practice. The three bodies shown here are typical of this bloody photographic harvest.

The first comes from 1956 and shows a woman lying dead outside a shack along the Mississippi River on St. Paul's West Side. The woman was identified as 57-year-old Sarah Ackerman, a resident of the impoverished community. Some of Ackerman's clothes, including a pair of stockings and jeans she wore as an undergarment, were discovered 100 feet from her body. Her shoes were never found. Despite these suspicious circumstances, her death was attributed to alcoholism and exposure. This raw, unpleasant photograph may well have been her only appearance in the St. Paul newspapers.

Although there is no way of knowing for certain, it is likely that almost every homicide in St. Paul and its suburbs in the Speed Graphic era attracted a photographer from the *Pioneer Press* and *Dispatch*. Many of them were hardly what would today be called high-profile cases.

The dead man on the boulevard is one such example from 1960. His name is Dave Williams, and he had gone to the house of his elderly former father-in-law on Iglehart Avenue to confront him about some obscure dispute. The two men had been feuding for years, according to police. Their last argument ended when Williams, 44, took a blast from a 12-gauge shotgun at close range, staggered across the street, and died before help could arrive. The ex-father-in-law, 76, claimed he fired in self-defense.

A photographer arrived not long after the shooting and took this picture of a police officer preparing to cover Williams with a sheet. Meanwhile, two plainclothes investigators process the scene, which even from a distance of almost half a century conveys the lonely chill of death.

Another picture depicts death in literally frigid circumstances. The body of a man lies in a frozen field, not far from a building at East Seventh and John Streets in St. Paul that advertises itself, with a certain ironic

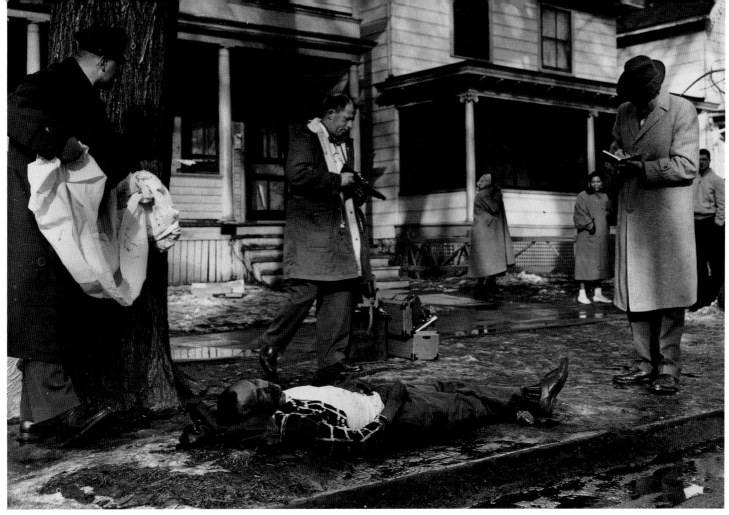

Dispatch / Sylvan Doroshow

flourish, as a "terminal" warehouse. Two uniformed policemen and a detective seem to have spotted something suspicious and point toward tracks in the snow.

Under the heading, "Man's Mystery Death Probed," the *Dispatch* reported that the unidentified man, possibly in his seventies, was discovered after an anonymous caller told police that someone had "left a dummy" in the vacant lot. The man wore work clothes and had a box of snuff in his pocket. In his notes, photographer Ted Strasser wrote that the man was "believed murdered," but the *Dispatch* story said only that police were "trying to determine if there was foul play."

There appear to have been no more stories about the man in subsequent issues of the newspaper. Who he was and how he died remain a mystery, one of many to be found in the photo archives.

Dispatch / Ted Strasser

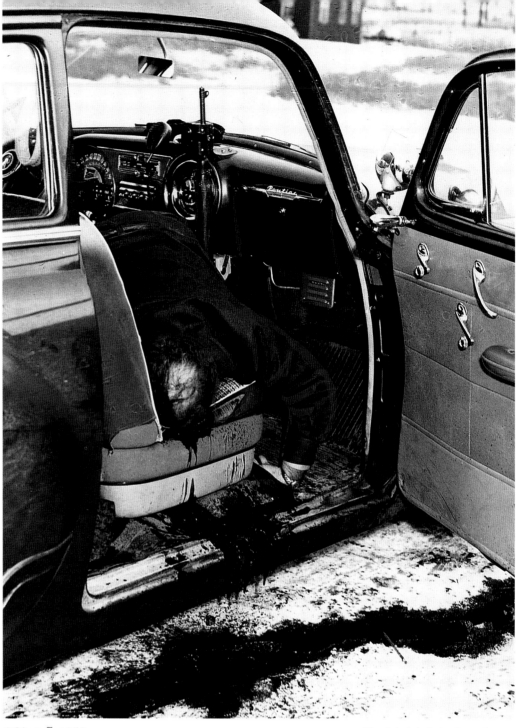

DEC 0 7 1953

THERE WAS AN UNDENIABLE STREAK of cruelty in the news coverage of the era. Very little in the way of public tragedy was out of bounds for the news photographers and their editors, and sensitivity toward the families of victims does not seem to have been much of a factor in selecting pictures to be published. Perhaps that is the way it should be—news is news, after all, no matter how bad or bloody—but that doesn't lessen the pain of seeing a loved one dead on the front page of the newspaper.

Two photographs related to the murder of an Anoka County sheriff's deputy in December 1953 demonstrate the unblinking style of the times. The deputy, Ernest Zettergren, was shot and killed with his own gun after struggling with a burglar he'd surprised at four o'clock in the morning outside a tavern in Fridley. His body, slumped over in the front seat of his squad car above a pool of blood, wasn't discovered until three hours later by two boys on their way to school.

It's not surprising that the photographer took this picture, but it is something of a surprise that police investigators permitted one of their own to be so cruelly depicted in death. The photograph ran in at least one edition of the *Pioneer Press* the next

Pioneer Press / Dick Magnuson

DEC 0 8 1953

morning but did not appear in the final city edition. Perhaps someone had second thoughts.

However, this photograph of Zettergren's wife and six children did run in the *Pioneer Press*. It shows the grieving family looking at a newspaper account of the murder. Family members were also interviewed for a story in which they described their pain and loss. One can only wonder whether the family saw the bloody photograph of Zettergren published in the early edition and what their reaction might have been.

Zettergren's killer was found within hours of the murder. The deputy had called in the license plate number of a car parked near the tavern moments before his death. The auto was quickly traced to an ex-convict named Francis W. Anderson, of Minneapolis. Anderson soon confessed, saying he'd shot Zettergren point blank after grabbing his revolver. "It was a cold-blooded killing. It was no accident," Anderson supposedly told the police. His own days were numbered. After being convicted of first-degree murder, Anderson hanged himself in his cell at Stillwater State Prison on January 31, 1954.

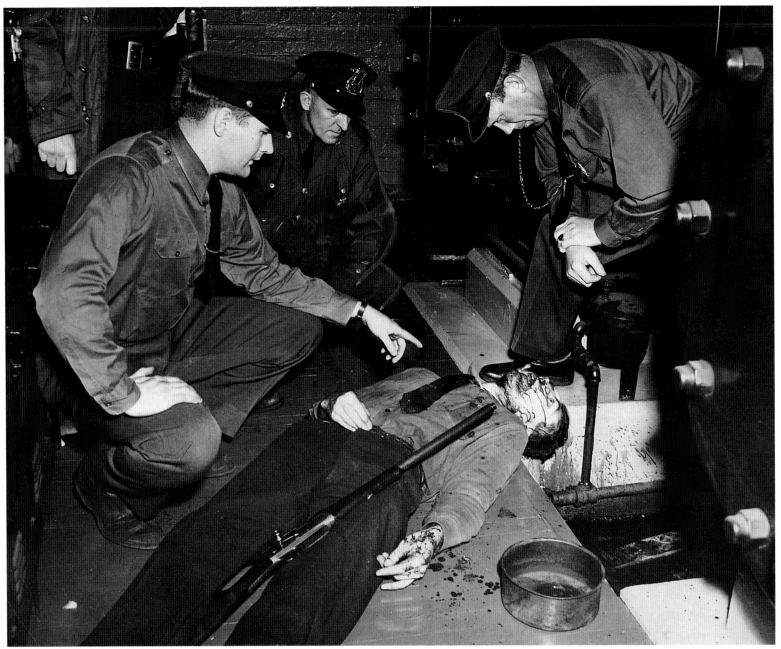

DEC 1 0 1948

Pioneer Press / Jack Loveland

ON DECEMBER 9, 1948, a man named John J. Hill, a longtime employee in the power plant at the Northern Pacific Railroad's sprawling Como shops in St. Paul, got into an argument with coworkers just before quitting time. The argument was apparently over who should clean some boilers, but behind it lay a long and troubled history of conflict. Hill, age 54, had been passed over for promotion and nursed a deep grudge.

What happened next has a familiar ring to it. Hill got out a .30 caliber hunting rifle, either from his locker or the trunk of his car, and started shooting. There were five other men in the building, and Hill killed four of them. It was St. Paul's worst mass murder up until that time. A fifth worker escaped by ducking behind a steel post, which deflected the bullet intended for him. After his brief killing spree, Hill walked into another room, put the gun barrel under his chin, and fired.

This extremely graphic photograph of Hill, taken as three St. Paul police officers examined his body, appeared the next morning on the front page of the *Pioneer Press*. It was one of a dozen pictures from the murder scene printed in the newspaper that day.

Pioneer Press / photographer unknown

WHEN A REAL MURDER SCENE wasn't available to be photographed, a reenactment would sometimes do. That's the case here, where four men—including a couple of law officers—are reenacting the scene of a "torch" slaying near Danbury, Wisconsin.

The victim was a 21-year-old Minneapolis woman named Lorraine Edin, who may have been acting as an informant for the police and FBI in their investigation of what the newspaper described as a "white slavery operation." Edin's badly burned body was found in an abandoned shack near Danbury. She'd been shot before her body and the shack were set on fire. The man in the checkered shirt is a farmer who was out searching for a missing horse when he saw a man carry Edin into the shack and then heard the sound of a grave being dug. Doing the acting honors are the county sheriff, a constable, and, in the grave where Edin's body was discovered, the owner of the property.

Exactly what this reenactment accomplished isn't clear, but St. Paul police were initially interested in Edin's death because they thought it might have connections to a celebrated 1937 murder in St. Paul. In that case, a woman named Ruth Munson was found shot and burned in the vacant hulk of the Aberdeen Hotel (demolished in 1944). One theory, according to the *Dispatch,* was that both women had been part of a Chicago-based "white slave ring." An arrest warrant was later issued for a St. Paul man in connection with Edin's murder, but it's not known whether the suspect was ultimately captured and charged with the crime.

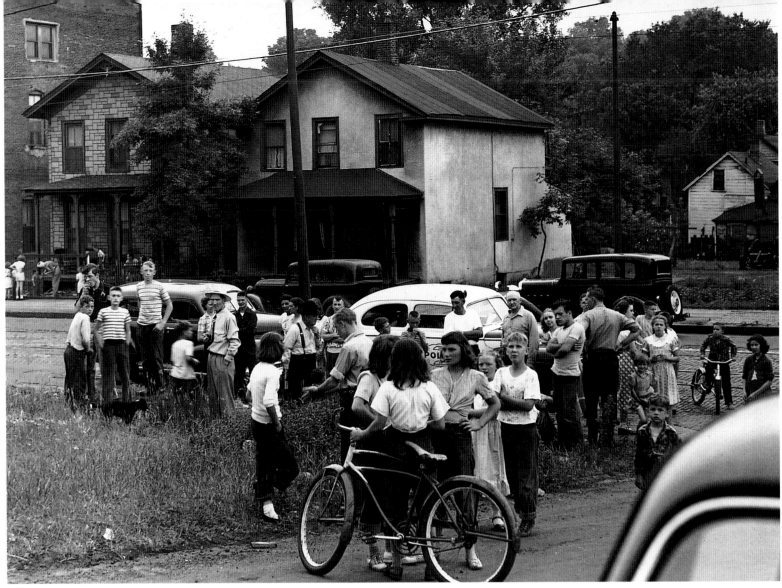

JUN 2 0 1949

Pioneer Press / Ted Strasser

JUN 2 3 1949

Dispatch / D. C. Dornberg

AMONG THE MOST HORRIBLE—and highly publicized—crimes of its era in St. Paul was the molestation and murder of a seven-year-old boy named Harlow O'Brien in 1949. Photographers for the *Pioneer Press* and *Dispatch* took scores of pictures in the days, weeks, and months after the boy's death. These pictures are not only a chilling documentation of murder but also serve as a virtual catalog of the Speed Graphic style. Here are three of those pictures.

The first, taken a day after the murder, shows Harlow's neighborhood along Mississippi Street just northeast of downtown St. Paul. The boy lived in the house at left (next to the brick apartment building) with his parents, Mr. and Mrs. Jack M. O'Brien, and seven siblings. The old houses and cars leave no doubt this was not a well-to-do neighborhood. In fact, the area was sometimes called "the badlands" because of its reputation for crime and disarray. Note all the children pres-

Pioneer Press / Bud Martin

MAR 2 0 1950

ent and the police officer, his back to the camera, who's talking with people near his squad car.

Harlow's body was found beneath a railroad bridge about a block away, near what is now the Williams Hill Business Center. He was "the victim of a sex maniac who strangled him to death," the *Pioneer Press* reported. The bridge was near a shantytown occupied by hoboes and derelicts, who became initial suspects in the case. Yet despite furious efforts by police and a steady drumbeat of publicity, the investigation soon foundered.

In the meantime, funeral services were held for Harlow. His family proved to be remarkably cooperative with the press, to the point of allowing an extraordinary photograph of the boy in his coffin, published by the *Dispatch* on June 23, 1949. The caption reads in part: "Playmates of Harlow O'Brien, 7, slain by a sex maniac, gathered at the O'Brien home this morning to

see his body prior to funeral services. Two of his closest friends are shown with Harlow's pet dog, Brownie." One wonders if the photographer "encouraged" the boys in their choice of a play area.

In March 1950, nine months after the murder, the police finally got their man. A convicted sex offender named Alexander Narr, who lived only a few blocks from the boy's house, confessed to the crime after being arrested for exposing himself. Narr's confession drew as much publicity as the murder itself. There was even a photograph (now apparently lost) that showed Narr pointing to the spot where he'd murdered Harlow.

The case came full circle the next day when the *Pioneer Press* published this picture of Mr. and Mrs. O'Brien reading all about their son's killer. Mrs. O'Brien, however, looks more sad than relieved, for even the most austere justice is cold comfort in the case of a murdered child.

FEB 1 3 1950

Pioneer Press / Ted Strasser

THE DRAMA OF CRIME AND PUNISHMENT was often very brief in the 1950s, as these photographs demonstrate. The first was taken at one o'clock in the afternoon as a crowd gathered outside Barisof's Grocery at St. Anthony Avenue and Kent Street in St. Paul. An hour earlier, a bandit armed with a shotgun had robbed the store, seriously wounding the proprietor, Morris Barisof, and killing his 16-year-old son, Nathan.

By three thirty that afternoon, the police had arrested a suspect, Harold McGruder, based on a description provided by a girl who'd seen him leave the store. By five o'clock, when this picture of McGruder and his interrogators was taken at police headquarters, the 34-year-old ex-convict had confessed to the crime. Among those posing for the camera is Police Chief Charles Tierney, sitting next to

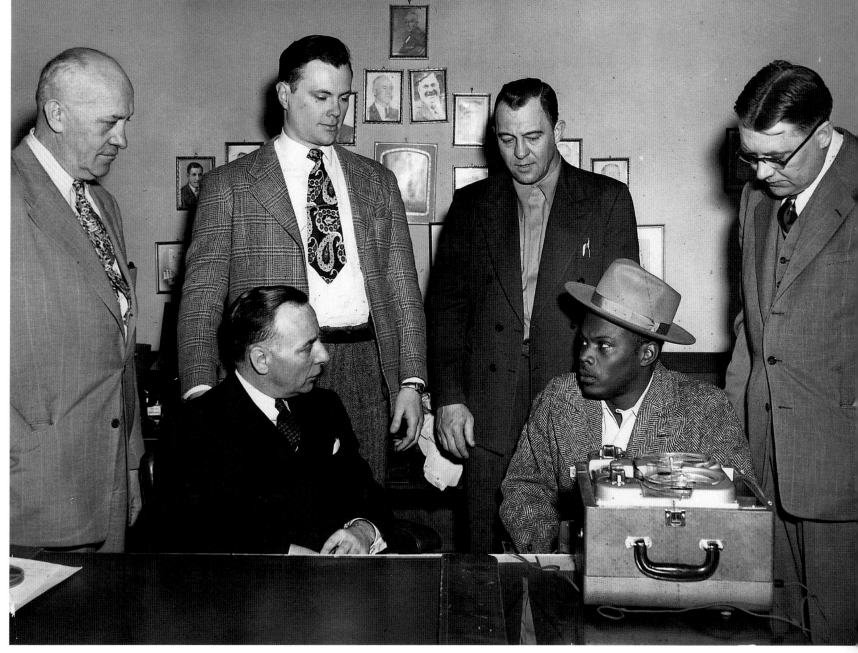

Pioneer Press / Bud Martin

FEB 1 3 1950

McGruder, who'd apparently just delivered his confession to the tape recorder in front of him. No defense attorney, it appears, was on hand to slow the quick march of justice.

McGruder, who two weeks later pled guilty to first-degree murder and was sentenced to life imprisonment, told authorities he shot the elder Barisof after the storekeeper started to throw a can of peaches at

him. McGruder then went to the back of the store and shot down young Nathan, who was working at the meat counter, before walking out with $152 from the cash register. Police found the money and the shotgun when they arrested McGruder at his apartment a half block away from the store.

OCT 1 8 1951

Dispatch / Jack Loveland

OF THE MANY BIZARRE AND BLOODY STORIES of the era, none was stranger than the tale of the "whipping cult" in, of all places, the quiet St. Paul suburb of Lauderdale. It was the kind of story that even today would send the press into a state of collective salivation. In addition to accounts of murder and flogging, there were also allegations of unspecified "sex perversion," adding yet another delectable feature to the story.

The tale actually begins in the late 1940s when a half dozen or so people coalesced into a quasi-religious cult that took corporal punishment—administered with heavy leather whips—to the extreme. Several of the cultists lived at a house in Lauderdale, where on October 15, 1951, a man named Curtis Lennander delivered such vicious whippings to his wife and another woman that both subsequently died. One of the women was all but flayed and had other injuries severe enough to shock even the county coroner. Lennander was arrested, and the media carnival, which included long interviews with some of the cult members, began.

Here's Lennander, standing bare backed for the camera in front of a painting of Jesus, as he shows off wounds to Ramsey County Sheriff Thomas Gibbons. Lennander, who claimed he'd been beaten by another member of the whip-happy household, later denied any religious motivation in the fatal beatings. "I just had to do something," he told police, claiming he'd whipped the women "in a frenzy."

The crime so disturbed local sensibilities that the Ramsey County attorney later felt compelled to announce, despite one victim's testimony to the contrary, that the whippings had "had no connection with religious activities."

66

JUVENILE DELINQUENCY IN THE 1950S
seldom involved the kind of lethal crimes
all too common today, but youthful killers
did make news now and then. This stunned-
looking but very photogenic 17-year-old
named Dennis Weis is being paraded through
police headquarters in St. Paul in May 1957
following a day of murderous violence. Note
the film photographer, presumably from
a local television station, stationed behind
Weis while a nearby police officer directs
the media traffic.

Weis, who had a long juvenile record,
admitted killing his 90-year-old great-
grandmother at their home in West St. Paul
by wrapping a belt around her neck and
strangling her. The motive: She'd seen him
with a gun, and he thought she might ruin
his plans to kill his father, who lived else-
where. After the killing, Weis took a bus to
a home in Maplewood where his family had
once lived and where he had friends. Two
Ramsey County sheriff's deputies spotted
him, and one was critically wounded in a gun
battle before Weis surrendered. Police said
his head cuts occurred when he "resisted
arrest."

"Tender-hearted enough to free a lady-
bug trapped in the kitchen sink . . . brutal
enough to strangle his 90-year-old great-
grandmother. That is the strange personality
of Dennis Weis," the *Pioneer Press* later wrote
in a character profile based on an interview
with his mother. A reporter also interviewed
Weis in a jail, where among other things, he
supposedly offered this advice to other teen-
agers: "Tell the kids to wise up and stay out
of trouble. Tell them to think twice before
doing anything."

Pioneer Press /Sylvan Doroshow

MAY 2 5 1957

NOV 1 4 1946

Dispatch / D. C. Dornberg

THE WOMAN IN BLACK—there was always one lurking around and possibly up to no good in the noir era—is Dorothy Sweeny of Shell Lake, Wisconsin, and she's a suspect in the murder of her husband. Ellis Sweeny was ambushed and shot dead on October 9, 1946, in "the back woods in Wisconsin," according to the *Dispatch*. A man named Gilbert Dickerson, described as Mrs. Sweeny's "paramour," was charged with the murder, which in the news shorthand of the time was invariably described as "a triangle killing." Dickerson soon went to trial where, to the surprise of the press and prosecutors, a jury found him not guilty.

Even so, authorities still suspected Mrs. Sweeny, who in this photograph appears to have her grief well in check, of complicity in the crime. After Dickerson's acquittal in November, she was then brought to St. Paul for a polygraph exam. Among those gath-

ered around the table to watch a criminologist administer the test are the sheriff and district attorney from Washburn County, Wisconsin, and, at right, St. Paul Police Chief Charles J. Tierney.

Mrs. Sweeny, a blood pressure cuff around one arm, looks perfectly collected in this photograph, telling a reporter, "I am not a bit worried." As it turned out, she had no need to be. She passed the polygraph and was later freed from jail with credit for time served after agreeing to plead guilty to being an accessory to murder. Under Wisconsin law, she could be charged with that crime even though her supposed accomplice had been acquitted. "And so," said the *Pioneer Press* in a story late that November, "the 29-year-old woods man's widow walked out of court a free woman."

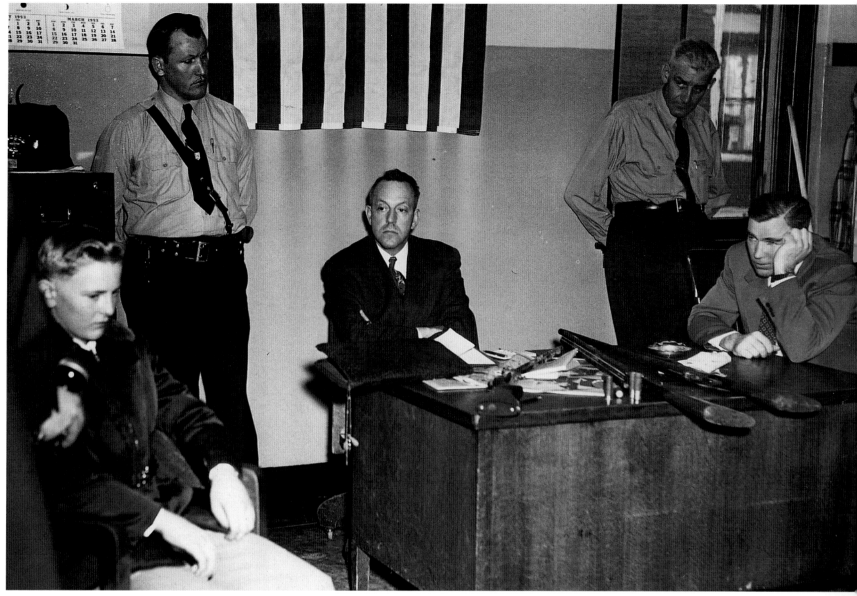

FEB 0 4 1953

THE SCENE IS A CORONER'S INQUEST in Hutchinson, Minnesota, convened after a 26-year-old farmer named Arthur Melichar went berserk one morning and started shooting people. His lethal weaponry—two shotguns and a rifle—lie atop a desk where the McLeod County coroner and attorney are seated. They're questioning a young witness to the mayhem as the Hutchinson police chief and county sheriff stand in the background.

Everyone in this photograph looks grim, and with good reason, since the crime was one of the worst in the county's history. By the time police cornered Melichar in a granary and lobbed in tear gas to subdue him, he'd killed his mother, his bedridden brother, and a 16-year-old boy who—by a stroke of terrible luck—happened to be driving past the farm on his way to school. Melichar also critically wounded another man and set fire to buildings and vehicles on his farm before he was finally taken into custody after a brief gun battle with authorities.

As with so many news photographs of the time, what is remarkable here is how close the viewer seems to the workings of the criminal justice system. Even today's televised coverage of court proceedings rarely achieves the sense of intimacy this photograph provides.

Justice moved swiftly in the 1950s. Less than a month after the murders, Melichar was declared legally insane and committed to the state hospital at St. Peter.

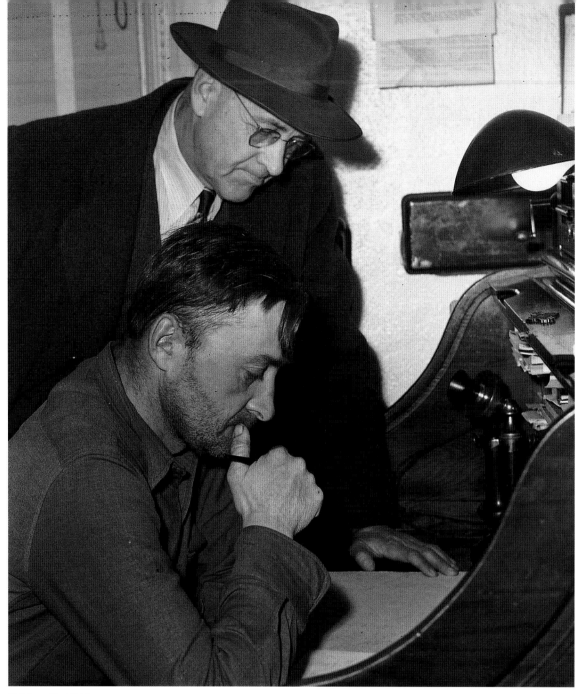

DEC 0 7 1946

Pioneer Press / Jack Loveland

ONE OF THE CONTINUING RITUALS of American law enforcement is the presentation to the media of defendants in particularly heinous or high-profile crimes. Today, this is usually accomplished via the so-called "perp walk" in which the accused is paraded before television cameras on his or her way to court. In the Speed Graphic era, however, there really was no need for a "perp walk." That's because when a big criminal case came along news photographers in St. Paul and elsewhere seemed able to roam at will through police stations, courthouses, and jails, so long as the arresting authorities received credit for their investigative brilliance and got their pictures in the newspaper.

An especially popular photograph was the "confession shot," which pictured the miscreant at the moment of signing his admission of guilt. The scene was almost always the same. The suspect (usually someone charged with murder) sits at a desk or table, either reading or signing his confession. Hovering nearby—and sure to be included in the picture—is the lawman who brought the killer to bay.

Here Edgiton Johnson, 38, is poring over a statement in which he confessed to gunning down his brother and aunt on a farm near Darfur, Minnesota, in December 1946. Chiding from his younger brother about Johnson's failure to serve in World War II apparently prompted the shooting, although Johnson never explained why he killed his 75-year-old aunt as well. Standing beside Johnson—and no doubt offering helpful tips on grammar and syntax—is Sheriff I. M. Berg of Watowan County. The "con-

Pioneer Press / Don Spavin

fession shot" is now an extinct species of photojournalism, at least in the United States, and probably anywhere else where criminal defendants have the benefit of legal representation.

Another multiple murderer appears in a photograph from 1954, taken at the police department in St. Joseph, Missouri, by *Pioneer Press* reporter-photographer Don Spavin. Spavin went to Missouri to interview Richard Wisdorf, 15, the rather soulful-looking youth seated in the custody of two unidentified lawmen. Only a day earlier, Wisdorf had shot to death his mother, father, and grandmother at the family home in Sherburn, Minnesota. His parents' refusal to let him use the family car to attend a wrestling match apparently sparked the triple homicide. After the murders, Wisdorf took in the wrestling show, then set off in the family car for Texas, where he hoped to become a cowboy. He got as far as St. Joseph before the law roped him in.

Later, he gave a long interview to Spavin in which he offered a chilling account of the killings. "I shot to kill all three of them. I shot them in the back of the head because dad taught me to shoot rabbits that way. None of them said anything after I shot them." When he was returned to Minnesota, he signed a confession. He eventually pled guilty to three counts of murder and was sentenced to 90 years in prison.

Dispatch / Roy Dunlap

THE YEAR 1950 saw two sensational murder trials in Minnesota involving women accused of killing, or trying to kill, the men in their lives. One of the defendants was also pregnant, allegedly by her lover. The press, it would be fair to say, was interested.

The lesser of the two cases—at least in terms of publicity—centered on Viola Gavle, a 33-year-old farm wife from Emmons, Minnesota, accused of killing a man with a bottle of strychnine-laced whiskey intended for her husband. Here she is with two of her lawyers and her husband in May 1950 as her trial began in Albert Lea. Truman Gavle, second from the left, stood by his wife throughout the trial, although he appears to be looking rather suspiciously at whatever beverage may be in the cup on the table.

A farmhand with whom Viola Gavle was allegedly having frequent "trysts," as the newspapers delicately put it, was also charged with murder. Both were ultimately convicted, even though Gavle claimed at trial that she hadn't tried to poison her husband but only to cure him of his drinking habit. Death will usually do that. Gavle served more than ten years in prison before being paroled in 1961.

An even more lurid trial took place in Glencoe, Minnesota, where a 23-year-old Minneapolis stenographer named Laura Miller stood accused of shooting to death her lover, a prominent local lawyer, on January 30, 1950. Gordon Jones, 36, married father of two, was found dead in his office, where police also discovered Miller. She was lying on the floor and screaming,

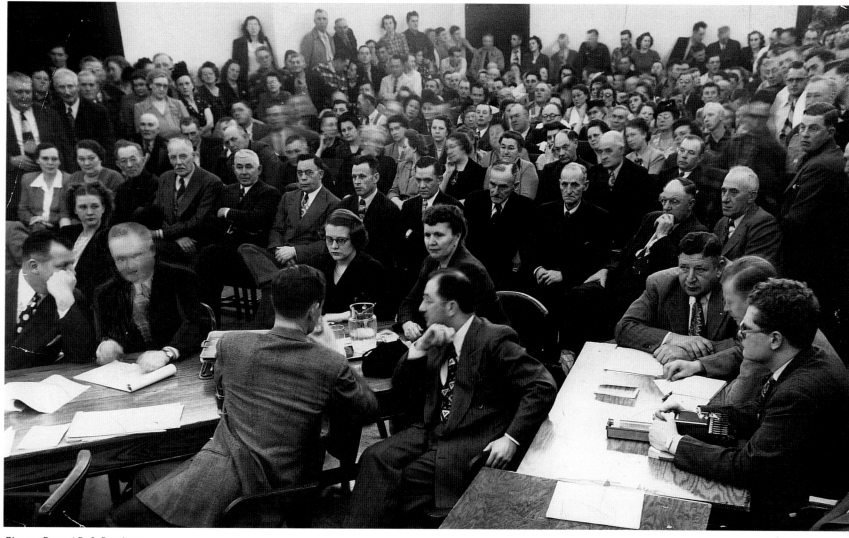

Pioneer Press / D. C. Dornberg

MAR 2 6 1950

"My honey. My honey. For God's sake talk to me. I don't want to live. Let me be with him." At least, that's how the *Dispatch* reported it.

Miller, said to be carrying Jones's baby, was charged with murder, and her trial proved to be the event of a lifetime in Glencoe. Not surprisingly, the press was obsessed with every feature of the lusty saga. The trial was covered in gleefully prurient detail, with Miller variously described as "a buxom brunet" or simply as being "husky." A photograph shows the packed courtroom with Miller (the woman in glasses and swept-back hair at the defense table) clearly the center of everyone's attention.

The highlight came when Miller herself took the witness stand, saying she had brought a pistol to Jones's office with the intention of killing herself but accidentally killed Jones instead. The *Pioneer Press* reported that Miller then "burst into high-pitched cries and bowed forward, burying her head in her lap, uttering sharp cries mingled with unintelligible words."

Her dramatic testimony must have been convincing because the judge later directed her acquittal, saying the state hadn't proved its charge of first-degree murder. Not long after her release, Miller moved to Omaha, where in July 1950 she delivered a baby boy.

Dispatch / Spence Hollstadt

THE T. EUGENE THOMPSON MURDER CASE of 1963 was in many ways the high point of the age of newspaper sensationalism in St. Paul. Thompson, a 35-year-old St. Paul lawyer, was accused—and later convicted—of arranging the "murder for hire" of his wife, Carol, in order to collect more than $1 million worth of life insurance. The case garnered an enormous amount of publicity, in part because the investigators needed months to build their case against Thompson.

He was finally arrested on June 21, 1963, more than three months after his wife—described as an "attractive 34-year-old mother of four"—was bludgeoned and stabbed to death in their Highland Park home. Police arrested Thompson at his summer home in Forest Lake and then took him to the jail at St. Paul police headquarters, where news photographers were ready and waiting when Thompson (right) arrived with St. Paul police detective Ernie Williams. Note that Thompson is not handcuffed. Today, of course, cuffs are a required accessory for every "perp walk."

Thompson's trial was held in Minneapolis (where presumably no one cared about events in St. Paul) and was just past its midpoint on the day of John F. Kennedy's assassination. After six weeks of testimony and a day of deliberations, the jury convicted Thompson of first-degree murder. Although there have been sensational crimes in St. Paul since 1963, few if any have produced as much newspaper coverage as the Thompson case, which remains unique in the annals of the city for its complexity and intense level of public interest.

ONE OF THE INESCAPABLE TRUTHS of tabloid journalism, which is what was being practiced in St. Paul in the 1940s and 1950s, is that the biggest stories of the moment are often those most likely to be forgotten. The brighter the light, it would seem, the faster it burns out. Harlow O'Brien's murder, which once shook St. Paul as have few other crimes, is now an obscure footnote in the history of the city.

Yet St. Paul did try to remember what had happened to the little boy. After his death in 1949, a playground built and equipped by volunteers from all over the city was dedicated near the scene of the crime. It was called the O'Brien Memorial Playground and included Harlow's full name and the dates of his brief life carved into the base of a flagpole.

By 1961, however, the playground was already a ruin, as this photograph indicates. The boys reading the inscription were undoubtedly posed by the photographer to add a note of pathos to the picture. It works, the sadness of the scene intensified by long shadows and slanting sunlight. The playground fell into decay because the neighborhood itself was by this time all but gone, its families forced elsewhere by urban renewal. The flagpole and playground would soon disappear as well under Interstate 35E, which by the late 1960s had obliterated all physical traces of the place where Harlow O'Brien died.

Dispatch / Buzz Magnuson

MAY 0 9 1961

DREAMLAND

There was, of course, an alternate reality to the world of misfortune, murder, and madness depicted with such numbing regularity in the newspapers of the era. St. Paul in the 1950s wasn't just *Peyton Place* with guns, and the *Pioneer Press* and *Dispatch* published thousands of photographs devoted to showing off the positive side of everyday life.

For many people—and particularly the early baby boomers who grew up during the decade—the 1950s still seem like the "good old days." In many respects they were. Violent crime was less common than it is now, which is why murder was always such big news. The economy was humming, especially by the middle of the decade, leading to an era of unprecedented wealth. There was also genuine optimism in the air, based on a boundless faith in progress that seems touching, and more than a little strange, in retrospect. Of course all manner of problems— from atomic brinkmanship to fears about the corrupting influence of rock and roll—lurked at the edges of this dreamland, but even the Garden of Eden had its snakes.

The photographs in this chapter are intended to offer a small, sunny antidote to the grim images of mayhem that appeared so frequently in St. Paul's newspapers in the 1950s. Here you'll see wholesome mothers, lovingly clueless fathers, smiling children, even the mayor of Minneapolis happily preoccupied with a Hollywood sex goddess. Elvis is also on hand, making an appearance in St. Paul early in his career.

Yet for all of their qualities as a kind of visual comfort food, these images have their own haunting resonance because the world they depict was rapidly changing. In the 1950s, for example, most people still lived in the city as opposed to the suburbs (St. Paul, in fact, reached its maximum population of 309,000 people at the end of the decade). Freeways and drive-up shopping malls were only beginning to arrive on the scene, and many people still got around by trolley (at least, until the big yellow cars disappeared in a giant cloud of smoke and scandal in 1954). Kids walked to neighborhood schools and busing was a rarity. And except for historic but small black and Mexican American communities, St. Paul remained an overwhelmingly white city where a visit from "Aunt Jemima" (see page 86) qualified as an experience in diversity.

Some of the photographs here also convey a striking sense of the power that traditional institutions—especially churches—retained right through the 1950s. The Roman Catholic Church, always a force in St. Paul, annually staged huge prayer events that brought together thousands of the faithful in uniform formations of astonishing, almost military precision. Some 100,000 Lutherans, meanwhile, rallied at the State Capitol in 1957 for what may have been the largest religious gathering in state history.

In general, it is fair to say that the old verities—God, family, country—were largely unchallenged in the 1950s, although the rising problem of "juvenile delinquency" hinted at the tumult to come. For a majority of white Americans, life in these times was, if not perfect, comfortable in a way it would never quite be again.

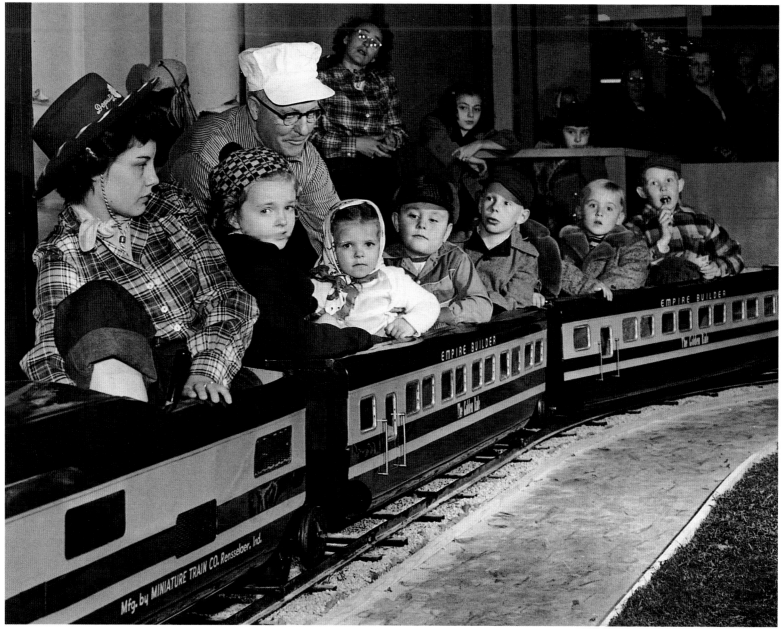

NOV 1 2 1950

Pioneer Press / Don Spavin

IN 1950, the downtown department store still ruled the world of Christmas shopping, and then—as now—retailers understood that if you could get children through the door, parents would inevitably follow. Retailers then—as now—also believed in getting an early start on the season. A photograph taken on November 11, 1950, in the toy shop of the Golden Rule Department Store, shows children enjoying (or maybe, in some cases, merely tolerating) a ride on a miniature version of the Empire Builder, the Great Northern Railway's most famous passenger train. Madonna Peterson (in the cowboy outfit) is guiding the train under the expert eye of Frank O'Neill, whose railroad hat is no prop. O'Neill was senior engineer of the real Empire Builder, and all the riders were his grandchildren.

In other words, this was a "photo op," 1950s style. The photograph was used to illustrate a Christmas toy preview written by a *Pioneer Press* reporter. Naturally, department stores—among the biggest of all newspaper advertisers—received prominent mention. Among other things, the story noted that "the craze for western toys continues, with guns and holsters of all types" and "shooting galleries" especially popular with boys. As for "little girls who don't wear guns," the story said, "there are kitchen cupboards, ice boxes, stoves, miniature furniture for dolls and the traditional small girl toys."

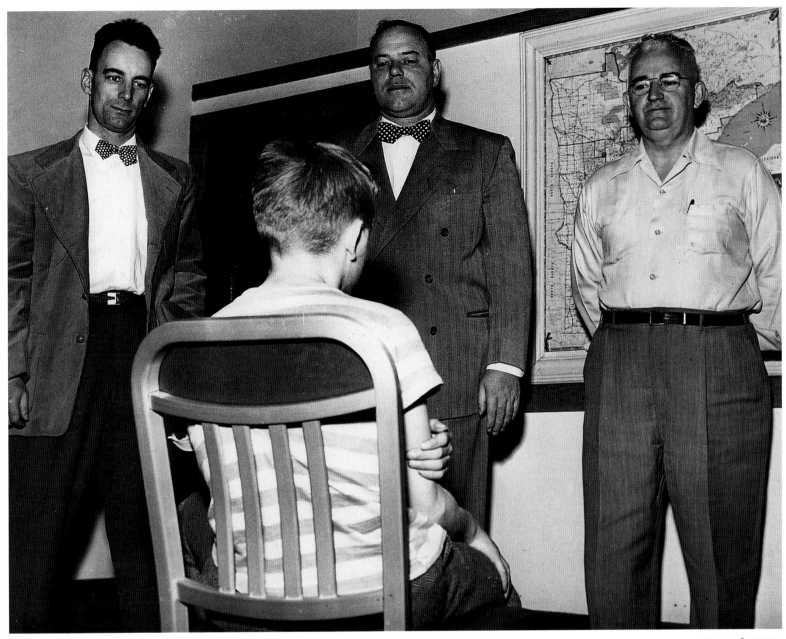

JUN 1 0 1951

HE'S BEEN A BAD BOY, and now the wise yet sympathetic adults in charge are going to set the wayward lad straight. That's pretty much the theme of this photograph, taken in 1951 at the Minnesota Training School for Boys in Red Wing. Commonly called the reform school (today it's the Minnesota Correctional Facility–Red Wing), the institution was founded in the nineteenth century with the idea of turning juvenile offenders away from a potential life of crime. It certainly must have been a daunting place to the unidentified boy shown here, as the *Pioneer Press* noted in its caption: "Directors of the school appear big and tough to the frightened youngster. Actually, Robert Spille, left, principal of the academic school, Supt. [R. E.] Farrell, and W. H. Maginns, guidance supervisor, are not as tough as they seem."

To modern eyes, the picture appears terribly contrived, and it's easy to imagine how the photographer, much like a film director, worked to get just the right look (stern, but not overly so) from the three men. Yet for all its fakery, there's something appealing about this image. It suggests (as does the Sunday magazine photo essay of which it was a part) that juveniles caught on the wrong side of the law can—with proper discipline, guidance, and education—be "reformed" so as to become productive and law-abiding citizens. Tough love, in other words, can remake lives gone wrong. That sort of optimism is not nearly so evident in today's "do the crime, do the time" correctional philosophy.

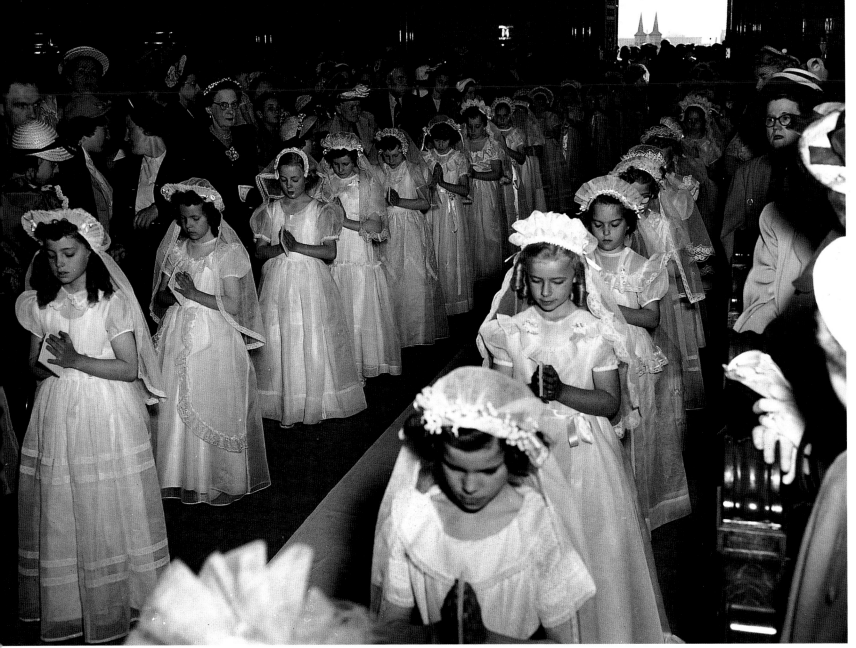

APR 2 7 1952

Ted Strasser

THE ROMAN CATHOLIC CHURCH has always been a force in St. Paul, and that was certainly the case in the 1950s when the huge baby boom generation filled schools and churches. The local parish in those days was a complete religious, social, and educational center, and the church's sway in matters of faith and morality seldom came under question. Two photographs show the church at what may have been its high tide (at least in terms of the sheer number of faithful) in St. Paul.

Photographer Ted Strasser's picture of a first communion ceremony at the St. Paul Cathedral in 1952 is a perfect time capsule of the era. The girls in their veils and white dresses march serenely down the aisle, eyes lowered and hands clasped in prayer. Family members and other churchgoers—mostly women in spring hats—crowd along the aisle to watch the girls pass. Note the twin towers of another Catholic monument—Assumption Church—visible through the Cathedral's open doors.

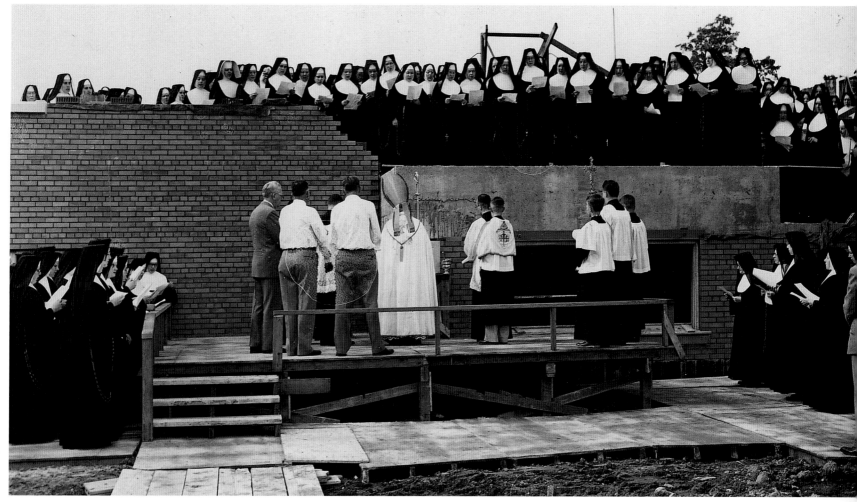

JUN 2 9 1953

It's a sure bet that it required rigorous rehearsals, overseen by the Cathedral School's nuns, to produce such a disciplined First Communion procession. Nuns were in fact the foundation of the entire Catholic educational system in the 1950s, working without pay as teachers and administrators in parochial schools large and small. In a photograph from June 1953, hundreds of nuns have gathered at the College of St. Catherine as Archbishop John Murray officiates at a cornerstone-laying ceremony for Bethany Hall, a retirement home for older nuns. A distinctive feature of this picture is that it shows many of the nuns standing *above* the archbishop and his priests—a rare sight in the traditional Catholic hierarchy.

According to a brief caption in the *Pioneer Press,* the ceremony drew about 350 nuns, in full habit, from several different orders. Bethany remains in use today, but the ranks of the remarkable women who once powered a huge private educational system have thinned greatly in the half century since this photograph was taken.

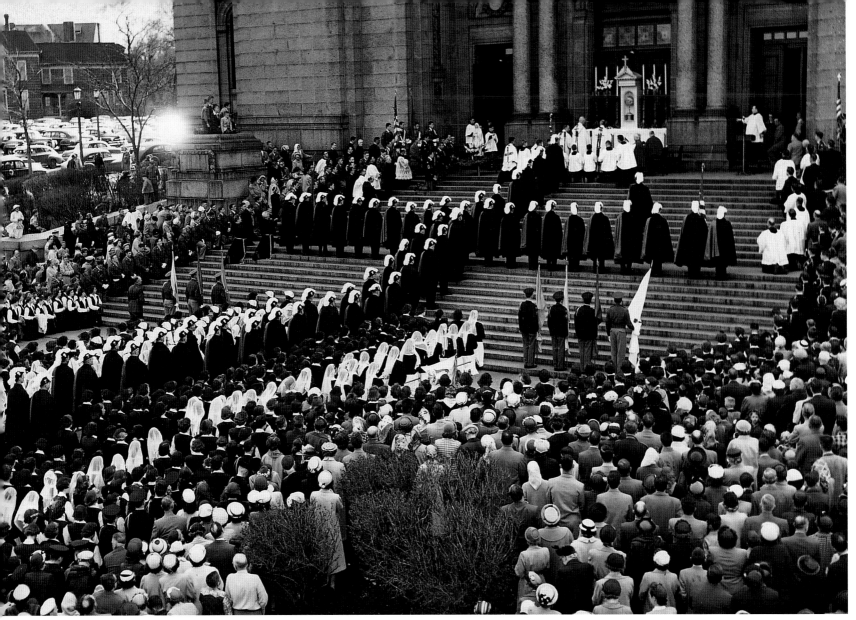

MAY 0 4 1953

IN THE 1950S the Catholic Church held an annual May Day rosary procession in St. Paul that drew thousands of the faithful. These elaborately staged events always culminated with ceremonies at the St. Paul Cathedral.

A photograph from 1953 shows members of the Knights of Columbus, a Catholic lay organization, in all of their caped, sworded, and plumed splendor as they form a human cross on the steps of the Cathedral. Students from nine Catholic girls schools, as well as cadets from St. Thomas Academy and Cretin High School, flank the Knights while Auxil-iary Bishop James J. Byrne delivers the benediction. The procession, or "rosary parade" as it was often called, had started near Laurel and Western Avenues and then doubled back along Summit to the Cathedral. An estimated 30,000 people, organized into seven divisions, took part in the event on a warm Sunday afternoon. Its purpose was to pray for people under Communist rule and for peace in general, much needed at a time when the Korean War still raged. Two months later, on July 26, those prayers were answered when the war in Korea finally ended.

MAY 0 2 1955

In 1955 the annual procession took place on a rainy day, but that didn't put any kind of crimp into the proceedings. With the aid of a long rope, uniformed girls from Our Lady of Peace High School formed a human rosary in front of the Cathedral while the rest of the student body marched behind in perfect formation. The wonder is how so many adolescents could be organized with such rigorous precision, but as any veteran of Catholic schools in the 1950s would readily attest, nuns could be very persuasive people.

AUG 2 6 1957

LUTHERANS DIDN'T STAGE REGULAR PARADES, but they did put on quite a spectacle in St. Paul in 1957. The event was the third Lutheran World Federation assembly, and a crowd estimated at 100,000 people gathered at the State Capitol on August 25, 1957, for concluding ceremonies. This photograph, which appears to have been taken from the roof of the newly completed Minnesota Highway Department (now Transportation Department) Building, gives a marvelous view of the crowd, said at the time to be the largest assembly of its kind in the history of American Lutheranism. The ceremonies included music (a 5,000-member choir was on hand) and a series of addresses by Lutheran leaders from Hungary, France, Sweden, Germany, and the United States.

A *Pioneer Press* article marveled at how flawlessly the huge event, which required five years of planning, was staged.

The Twin City Rapid Transit Company dispatched 500 buses (virtually every vehicle in its fleet not on a regular route) to help transport people to and from the meeting, while parking was arranged nearby for an estimated 10,000 cars. Remarkably, everything seems to have gone off without a hitch.

Note the huge banner with a cross draped from the front of the Capitol. It's unlikely that such an overt religious symbol would be allowed on a public building today, but in the 1950s nobody seemed to mind (though state and national flags were taken down from the Capitol before the banner went up). One especially telling feature of this disciplined and dignified gathering is what happened when it was over. According to the *Pioneer Press,* "only a light litter of paper cups, bottles and other debris" was left behind, and it took crews just 90 minutes to clean up the entire mall.

HERE'S A CLASSIC PHOTOGRAPH of its kind showing the overwhelmed and hopelessly ignorant male of the species trying to cope with prospective fatherhood. The father-to-be in this case is Eugene Tate of St. Paul. He's being tutored in the finer points of infant care by instructor Ruth Kruger at a course offered by a city health agency in 1952.

The story accompanying this carefully choreographed photograph begins by noting, with what sounds like just a dash of regret: "The guy who used to decline changing, feeding or bathing his new son on the grounds that he 'might hurt him' just hasn't got a chance any more. Modern science and St. Paul's Family Nursing service have combined to take the 'fragile' label off Junior and leave Dad with no recourse but to grab a pin and search around for a place to put it."

To illustrate the awful complexities of the task facing Tate, the photograph shows him in a state of apparent befuddlement as he reads a book about how to use the tableful of equipment in front of him. All of the pots, pans, bottles, glasses, jars, and cleaners spread out on the table were required in those days to prepare and sterilize infant formula. *Pioneer Press* reporter (and later executive editor) John Finnegan wrote that "formula making . . . may seem only a little less complicated to the average prospective father than the formula for the hydrogen bomb."

Tate, by the way, was a U.S. Navy Reserve fighter pilot—a job as difficult in its own way as parenthood—and he was facing a call-up to active duty. Asked what he'd do if he and his wife had triplets, he said, "That doesn't worry me. Triplets would be an automatic deferment."

Pioneer Press / Jerry Lundquist

DEC 0 7 1952

MAR 0 2 1954

Dispatch / Jack Loveland

AUNT JEMIMA was an advertising icon concocted in the 1890s to sell a brand of pancake mix. By the 1950s, the mix was being marketed by the Quaker Oats Company, and the figure of Aunt Jemima was embodied by an accomplished blues singer and actress from Chicago named Edith Wilson. Complete with her trademark bandana, Wilson visited youngsters at Shriners Hospital in Minneapolis in March 1954 as part of a promotional tour. Interestingly, she wasn't identified by name in a caption accompanying the photograph in the *Dispatch*, though all of the children were.

Wilson portrayed Quaker's version of Aunt Jemima on television and radio and in personal appearances between 1948 and 1966. However, there appear to have been several other actresses who also played the role during this time. Images of the black "mammy" were still popular in the 1950s, a period not renowned for its sensitivity to racial and ethnic stereotyping. It's not known what Wilson, who died in 1981, thought of her Aunt Jemima role and the image it conveyed, but one can only hope that it paid well.

Pioneer Press / Chet Kryzak

MAY 1 4 1955

THIS DELIGHTFUL PHOTOGRAPH from 1955 shows the winners of a citywide music contest at Monroe High School in St. Paul. Sponsored by the city's recreation department, the contest drew 99 entrants aged 7 to 18. Union musicians served as judges while local music stores handed out prizes.

The musician who really lights up this picture is Bonita Jasper, at right front, playing her accordion. She's obviously having a grand time, as are the other youngsters, who all look impossibly wholesome by today's ragged standards. The accordion, incidentally, was a ubiquitous childhood instrument in the 1950s, so much so that front-porch accordion schools were a fixture in many neighborhoods. The result was a generation of children who either grew up playing "Lady of Spain" on the accordion or were slowly driven mad by the sound of it.

JUL 2 2 1955

Pioneer Press / Sylvan Doroshow

WHILE SHE WASN'T QUITE MARILYN MONROE, Mamie Van Doren ranked fairly high in the pantheon of Hollywood sex goddesses in the 1950s. In July 1955 she and two other stars— Tab Hunter and Sheree North—took part in a show for the Minneapolis Aquatennial. Second-tier Hollywood celebrities in those days were regularly sent out to the provinces to make appearances and probably weren't very happy about it. Still, it's a good bet that the Aquatennial was considered a better gig than having to endure a frigid ride in the Winter Carnival parade across the river in St. Paul.

Van Doren's arrival at Wold-Chamberlain Field sent a *Pioneer Press* writer into uncharacteristic spasms of descriptive prose: "A hot wind was blowing across the field. As photographers approached, Mamie was blown into an S figure. Her pink dress fitted the S, too. She carried a matching pink long-haired fur, a large half-circle of a pink summer bag, and her pink shoes with heels that looked four inches high had pearls on strings for straps and flowers across the open toes."

That night, when Van Doren appeared at the show, Minneapolis mayor Eric Hoyer—dressed in his official Aquatennial sailor suit—was among those on hand to greet the sex symbol. Judging by this photograph, he was quite pleased to meet her.

Dispatch / Leo Stock

MAY 1 4 1956

BEFORE HIS LATER ADVENTURES in drugs and bad eating, Elvis Presley was a slender, sultry, and devilishly handsome young singer who became an unrivaled sensation in the mid-1950s. In May 1956, the 21-year-old Presley was in the Twin Cities for two days, appearing at the St. Paul and Minneapolis Auditoriums for shows attended by wildly adoring mobs of teenagers. Or, as a *Pioneer Press* reporter described the crowd in Minneapolis: "They screamed, they cheered, they clapped and they cried. Then they fought like demons for a touch or close-up glimpse of their king."

At least one girl—12-year-old Theo Schneider of New Ulm, Minnesota—didn't have to fight to gain an audience with the king. Instead, she was invited to Presley's St. Paul show by the promoter, T. B. Skarning, after she'd sent him a letter saying she couldn't attend. In her letter, Schneider had enclosed a dollar and asked for an autographed photograph of Presley. Skarning—no doubt sensing a publicity windfall—invited Schneider to the concert and arranged for Presley to sign his autograph as a photographer snapped this picture of the girl and her idol.

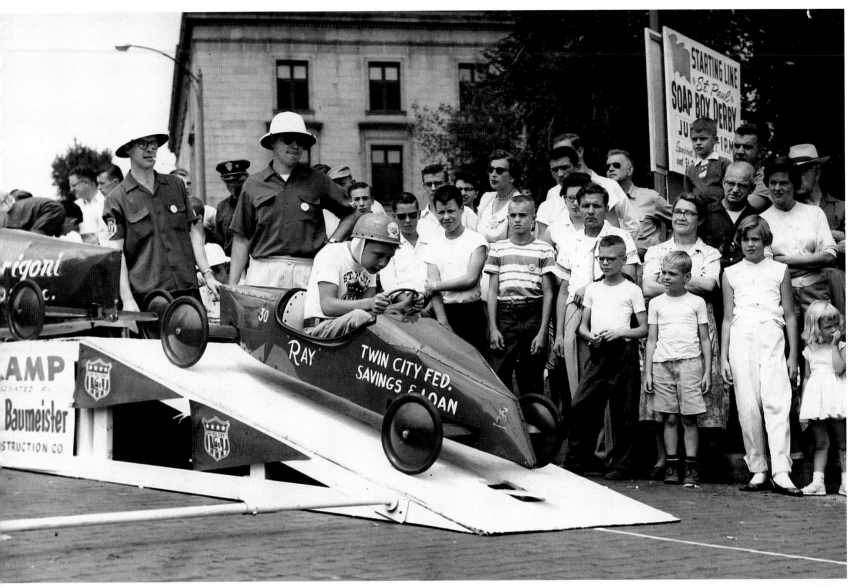

JUL 2 9 1956

Pioneer Press / Hi Paul

THE SOAP BOX DERBY has been around since 1933, when it was created by, of all people, a newspaper photographer. His name was Myron Scott, and he worked for the Dayton (Ohio) *Daily News.* Legend has it that he thought up the idea after watching three boys race homemade cars down a hill. By the late 1930s, crowds of 50,000 people attended the national championship race, known as the All-American, in Akron, Ohio.

In Minnesota, derby fever appears to have peaked with the baby boom generation after World War II. Here's a scene from St. Paul's championship race in 1956. The event, held on the Cedar Street hill in front of the State Capitol, attracted 34 competitors. Among them was 12-year-old Ray Palme of St. Paul. Hunched intently over the steering wheel of his racer, he's just beginning his run (against an unseen opponent to his right) as part of a crowd estimated at 5,000 people looks on.

A *Pioneer Press* reporter on the scene noted that a "rhubarb occurred when several disgruntled fathers whose sons did not win in elimination heats contended that all the racers in the left-hand lane won. A check proved they were correct." New runs were ordered, and the starting ramps were adjusted to provide a fair race, ultimately won by a 15-year-old boy from Spring Lake Park.

The Soap Box Derby nearly ran out of gravity, so to speak, in 1973 after the original winner was disqualified for cheating (he used an electromagnet to juice his racer). At the last minute, a new sponsor stepped in to save the event. The All-American is still held every July in Akron, with racers in three categories, but the crowds aren't what they used to be.

Pioneer Press / Jack Loveland

MAY 0 4 1958

NO COLLECTION OF PHOTOGRAPHS from the 1950s would be complete without at least one image of the stereotypically perfect middle-class family that defined the era. So here is Betty Bach, of Columbia Heights, photographed at home with her five children after winning the title of Mrs. Minnesota in 1958. She and her daughters are enjoying a "songfest" (that's what the caption says) accompanied by son Brian on the inevitable accordion. This photograph is one of several of Mrs. Bach, her husband, Alvin, and their family taken for a Sunday Pictorial Magazine cover story in the *Pioneer Press*.

The story itself was just a tad old-fashioned in its depiction of Mrs. Bach's life as a housewife. It said: "The career of house-

wife and mother is one which the pretty 32-year-old brunette has been following for the past 14 years. Her attractive, spic-and span modern house . . . her five vivacious, well-mannered, neatly-dressed children and the mouth-watering aromas which float from her kitchen testify to success in all departments of the field." The writer added that "Mrs. Bach's slim figure, personal grooming and sunny responsive personality give plenty of evidence that she hasn't let the glamour parade pass her by, either."

As a grace note to this account of domestic bliss, the story included Mrs. Bach's recipe for "drop donuts," which, judging by the amount of butter, sugar, milk, and eggs involved, must have been spectacularly caloric and delicious.

ANIMAL INSTINCTS

NEWSPAPERS HAVE ALWAYS LOVED ANIMAL PICTURES. For years, in fact, the *Pioneer Press* and *Dispatch* made a habit of photographing virtually every new animal born at the Como Zoo, the cuddlier the better. Pictures of weird animals, or animals doing weird things, were also popular, as were shots of animal "heroes" who'd managed to alert their owners to some grave danger. However, one type of imagery—the hunter showing off his trophy—isn't used nearly as frequently today as it once was, perhaps reflecting the delicate sensibilities of our era.

No, this isn't "Buffalo Bill" come back to life. Instead, it's a fellow named LaRue Olson, from South Dakota. He's riding "Pat," alleged to be the world's only trained buffalo. Olson and his talented bison, said to be able to "do anything a horse can and then some," were in St. Paul for a Shrine "Showdeo" at the Minnesota State Fairgrounds when this picture was taken.

Pioneer Press or *Dispatch* /
Sept. 21–25, 1961 /
Sylvan Doroshow

A suitable caption for this picture might be "Dead Turkey Walking." Gwendolyn Schepers of South St. Paul leads the bird from a food market where she'd just purchased it a few days before Thanksgiving in 1947. It's not clear whether turkey on a leash was a common practice at the time or whether this event was staged for the photographer's benefit.

Pioneer Press /
Nov. 24, 1947 / Bud Martin

This photograph records the solemn moment in 1964 when Chico the Chihuahua was honored by the St. Paul Humane Society for alerting his owners to a house fire. Chico, looking confidently into the camera, received a certificate as well as something called the Golden Nylabone Award for his timely outburst of barking. Two officials from the society are shown presenting the awards to 15-year-old Cheryl Baller, Chico's proud owner.

Dispatch / Oct. 23, 1964 / Hi Paul

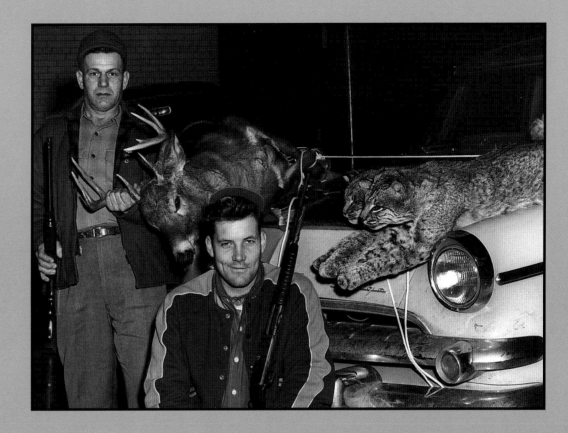

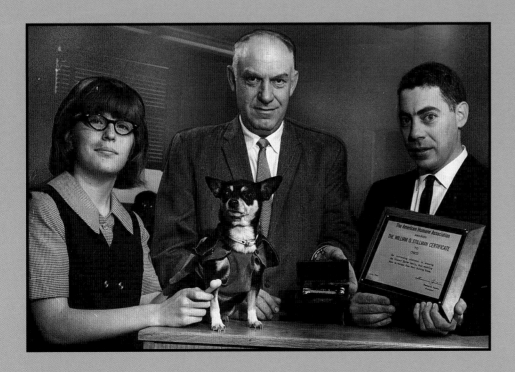

Successful hunters in the old days often brought their kill to the newspaper office to be memorialized in a photograph on the outdoor page. Here, Al Maurer (left) and Bill Johnson pose with a buck and a pair of 40-pound bobcats mounted like ornaments on the hood of their car. The deer and the cats were shot near the Canadian border. Johnson, it is fair to say, looks mighty pleased with his haul.

Pioneer Press / Nov. 22, 1955 / Sylvan Doroshow

The two decades after World War II often call to mind an idyllic era of peace and prosperity. The Fifties in particular tend to be washed in an amber glow of recollection that conjures up images of ranch houses and ramblers occupied by *Leave It to Beaver*–style families, gaudy tail-finned cars equipped with rumbling eight-cylinder engines, and thin-legged blond furniture sufficiently hideous to be prized by contemporary collectors.

The reality was more complicated, and far stranger, than such memories suggest. Mounting racial unrest, anti-Communist hysteria, a bitter war in Korea, the persistent threat of nuclear annihilation, and an epidemic of polio were also part of the times. The photographs in this chapter offer a wide-ranging view of the conflicts and anxieties of the period, as well as a look at some of the stranger moments of everyday life as captured by the indefatigable photographers of the *Pioneer Press* and *Dispatch*.

The chapter begins with photographs from the late 1940s, a period that saw one of the worst housing shortages in the nation's history. *Pioneer Press* and *Dispatch* photographers did some of their best work documenting the crowded, even sordid, conditions in which people were forced to live. They also took many intriguing pictures of the federally funded Quonset hut villages that were one response to the housing problem. By 1946 hut villages were springing up all around the Twin Cities to house veterans and their families. Many of these instant communities, located in parks or undeveloped public land, remained in operation until the early 1950s, when new home building finally began to catch up with demand.

The photographs here also highlight just how precarious the economy was in the immediate postwar years—a time of almost continual labor strife. As wartime wage and price controls were lifted, strikes broke out all across the country in key industries such as steel, meat-packing, and railroading. St. Paul made labor history of its own at this time, when the city's public schoolteachers staged an unprecedented strike for higher wages in 1946. The gigantic meat-packing complex in South St. Paul was the scene of some especially bitter walkouts beginning just a year later.

The late 1940s and early 1950s also was the last age of poliomyelitis, a paralyzing and sometimes fatal disease that especially haunted parents, who feared their children might be the unlucky ones to end up in an iron lung, or worse. Polio anxiety was at especially high levels in the early 1950s, when the *Pioneer Press* and *Dispatch,* like many other newspapers, kept a running total of each week's new cases as reported by public health officials. There was something like a collective sigh of relief when Dr. Jonas Salk's vaccine became available in 1955.

Besides capturing images of the era's big news stories, the newspapers' photographers also found time to take pictures of some of the weirder moments of everyday life, from a "fat men's race" to a group of rooftop exhibitionists known as the "Sons of Sol" to a society woman and her most peculiar "poodle." The ordinary, it might be argued, is always strange, especially when viewed from the safe distance of time.

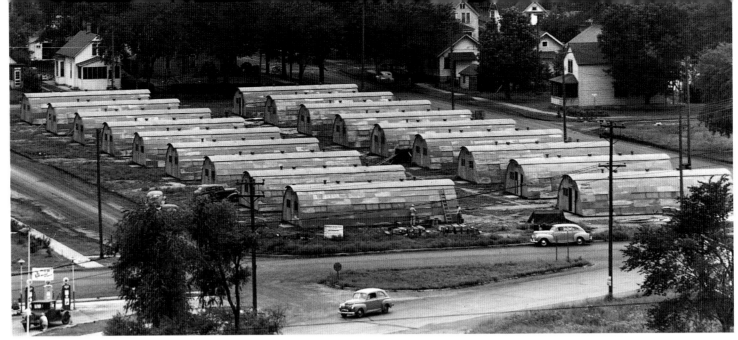

Dispatch / Jack Loveland

Pioneer Press / Chet Kryzak

MANY OF THE VETERANS who came home after World War II faced a new challenge: finding somewhere to live. Little new housing had been built during the war, and the sudden influx of veterans overwhelmed the limited housing stock available in St. Paul and most other cities. The crisis became so acute that in 1946 St. Paul, Minneapolis, and other cities began building temporary settlements for veterans and their families under a federal housing program. St. Paul established eight of these "veterans villages" on city playgrounds, providing homes for 480 families.

The housing itself consisted entirely of Quonset huts—lightweight, prefabricated structures that took their name from the city in Rhode Island where they were made. Developed for the military at the outset of World War II, the hut consisted of a plywood floor over a concrete slab, an easy-to-assemble frame of semicircular steel ribs, and a corrugated metal roof. About 170,000 huts, in various sizes, were produced during the war and later sold for around $1,000 each. By one estimate, as many as 50,000 people nationwide were living in Quonset huts in the immediate postwar years.

The villages in St. Paul were typically laid out in the manner of military barracks, as seen in a photograph from July 1946 showing a hut community nearing completion at Jefferson Avenue and Victoria Street. Those lucky enough to rent a hut didn't enjoy an expansive or luxurious lifestyle, judging by

Pioneer Press / Ted Strasser

JUN 2 1 1947

them did their best to add a touch of warmth and individuality. Mrs. Clayton Le Febre is shown tending to a window box on a hut in the village at Jefferson and Victoria. Her son, Robert, helps with the hose while his little sister, Patricia, looks on.

A photograph taken six years later, in 1953, offers a view of yet another village at Ivy Avenue and Kennard Street on the East Side. The man at the center of the activity is Oscar Lindeman, identified simply as a "hut dweller." He's supervising a sand castle project with a crowd of youthful assistants, all residents of the village behind them. Given the typical size of families at the time, it's likely that several thousand kids in St. Paul alone spent some part of their childhood in Quonset homes. From today's perspective, the huts look to have been cramped and uncomfortable at best, but one suspects that for many children life in the funny little metal houses was a great adventure.

a picture taken in February 1946. It shows Mrs. Arnold E. Anderson and her five-year-old daughter, Ellen, as they inspect the oil-burning stove inside their heavily insulated Quonset hut at Belvidere playground on the West Side. Note the tall cabinets behind them that divide one end of the hut into two make-shift "bedrooms"—something not otherwise provided by the hut's wide-open layout.

The Andersons (Arnold was a navy veteran) had three children in all and were the first of many families to move into the new settlement, known as Camp Belvidere. According to the *Pioneer Press,* the move "brought a successful finish to Mr. Anderson's long search for a home. He had sent 300 postcards to apartment owners and realtors, asking for a place to rent, but with no avail."

Because the huts were the ultimate in look-alike housing, the families that occupied

Dispatch / Bud Martin

APR 0 3 1953

Dispatch / Jack Loveland

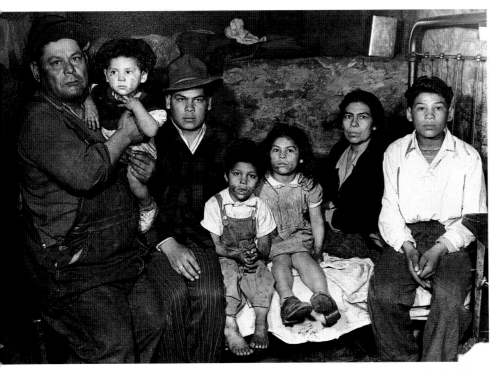

Dispatch / Roy Derickson

RETURNING VETERANS weren't the only ones caught in the housing crunch after World War II. With so much demand chasing so few housing units, the poor faced an especially bleak housing situation. The condition of St. Paul's housing stock aggravated the problem. The city's poorer neighborhoods were full of old houses and apartments that had sagged into something approaching terminal decrepitude. Much of the impetus for urban renewal efforts developed at this time as social reformers, public officials, and the newspapers constantly hammered home the need to replace blighted housing.

A photograph taken in January 1946 shows six children from a 14-member family gathered around a heating stove in a dilapidated house at L'Orient and Fifteenth Streets (near what is today the site of Regions Hospital in St. Paul). The house was "typical of many in the . . . district," said the *Dispatch* in a caption headlined "Drab Housing Picture, Fire Hazard Here Told by Camera." Three other photos detailed living conditions in the five-room house, which had numerous broken windows stuffed with paper or covered with cardboard to keep out the cold. The family

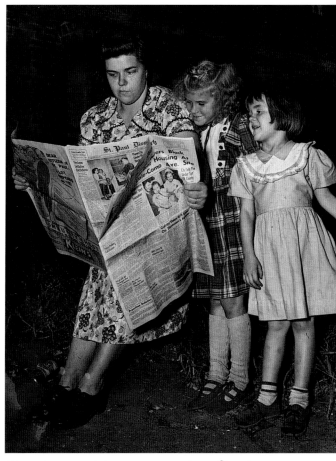

Pioneer Press / Jack Loveland　　　　OCT 1 6 1950

Pioneer Press / Bud Martin　　　　OCT 0 2 1951

isn't identified, but the youngsters look clean, well fed, and reasonably well dressed. Still, it's clear this wasn't a household with a lot of money.

Living conditions could be equally bad for members of the city's Mexican American community on the West Side Flats. Seven of the nine members of the John Briseno family in April 1948 lived in what the *Dispatch* described as "a damp, dark, dirt-floor basement at 99 State St. that has neither water nor toilet facilities. They sought refuge there from the cold last November after their arrival from Texas, hoping they would be able to locate better living quarters." Besides lacking a bathroom, the family's home had no cabinets or closets, no kitchen, and only a large stove for heat.

Other families didn't even have the semblance of a home. In October 1950 three adults and eight children were found camping by their disabled car at Round Lake in Maplewood. The family included 40-year-old Dorothy Richards and her six young children, plus Richards's 23-year-old daughter and her husband and their two children. All had been living out of the car for two weeks after arriving in St. Paul from Chicago via Milwaukee. Their only income was $4 a day that Richards's son-in-

law, Jay Clarke, earned as a pinsetter. "It was the same story everywhere," Clarke told the *Pioneer Press*. "I could find a job but not a place to live."

A sympathetic policeman took up a collection for the combined family, which was relocated to temporary quarters in the Ramsey County jail. In this picture, Richards, her younger children, and one grandchild are enjoying a breakfast of cornflakes served by a jail matron. It's not known what ultimately happened to the family.

Another mother in search of housing is the focus of a photograph from 1951. The woman, identified as Mrs. C. H. Johnson, is shown with two daughters as they pore over "for rent" ads in the *Dispatch*. Although the picture was almost surely posed, Johnson's dilemma was real. Her family (which included her husband and three other children) had just received a final eviction notice from their apartment building, condemned by the city as "dangerous to life and limb."

"We all realize that this place is practically unlivable," Johnson said of the apartment building where she and her family had lived for four years. "The problem is finding another home."

Dispatch / Hi Paul

THE BASEMENT HOUSE was a fairly common sight in the Twin Cities in the years after World War II. Unlike later earth-sheltered homes built to conserve energy, the typical basement house was built to save money. The idea was to construct a basement, put a roof on it, install the usual utilities, and then live underground until there was enough money to complete a full house above. But in some cases, the owners of such houses were so impoverished that they never managed to move upstairs.

That appears to have been the situation with this basement house, photographed in 1952. Located on North Dale Street in Roseville, the 400-square-foot dwelling was home to Mr. and Mrs. Raymond Poole, both in their thirties, and 11 children (a 12th was on the way). The house looks to be a handmade affair, with a plywood front attached to concrete-block side-walls and a nearly flat roof. It had four rooms, cold running water, electricity, and a heating stove. However, the *Dispatch* said there was "no cesspool." The place must have been damp, dark, cold, and cramped. Even so, there was somehow enough room for a 14th person—a roomer who lived with the Pooles.

Raymond Poole, a *Dispatch* story said, earned $34 a week as a window washer. He paid $40 a month for the house, which he and his wife had purchased a year earlier. They didn't have it for long. By the time this photograph was taken, Roseville building inspectors had already condemned the place as unhealthy and unsafe. "We thought at first we could just add another door to make the place safe but now we know that isn't enough," Mrs. Poole told a reporter. "We'd like to add a couple of more rooms or dig a new basement for a new house but we just don't have the money."

Dispatch / Roy Derickson

DEC 1 1 1946

ON NOVEMBER 25, 1946, more than 1,100 St. Paul public schoolteachers, all members of the Federation of Women Teachers Local 28, did the unthinkable: They went on strike, shutting down all 77 city schools. It was the first organized teachers' strike in American history. The reasons for the walkout weren't hard to fathom. St. Paul's public schools—then run by the city rather than an elected board—had been underfunded for years, in part because of a charter limit on educational spending. Classrooms were overcrowded, students had to buy their own textbooks, and teacher pay was notoriously low.

Among the protests inspired by the strike was this march on December 11. Led by a pair of motorcyclists, 100 or so high school students paraded down Cedar

Street near the State Capitol to call for an end to the strike. The big banner with the cryptic message, "36 WEEKS OR CLASS OF 48," refers to the fact that without at least 36 weeks of school in 1946, seniors wouldn't graduate until 1948.

A *Dispatch* story reported that the protesters displayed "a rather hilarious attitude," but the strike itself was anything but amusing. It finally ended on December 27 following the city charter commission's approval of an amendment raising the per capita expenditure for schools. Other changes followed the strike, including a 1947 state law requiring school districts to provide textbooks. However, it was not until 1965 that another of the strikers' goals—the creation of an independent school district for St. Paul—became a reality.

MAR 0 6 1947

LABOR UNREST WAS ENDEMIC in the days after World War II as America adjusted to the novelty of peace. Prices and wages had been controlled during the war, with considerable success, but once hostilities ended, an economic free-for-all ensued. Strikes in the steel, coal, and railroad industries dominated the headlines in 1946, and the next year wasn't much better. In Minnesota some of the biggest postwar strikes occurred in South St. Paul. There, more than 6,000 union meat-packers, earning an average of about $9 a day, worked in plants operated by the Swift, Armour, and Cudahy companies next to the sprawling Union Stockyards.

South St. Paul was at this time a place like no other in the Twin Cities area—a tough old blue-collar town of 16,000 people that seemed like a small (albeit unusually hilly) corner of Chicago. When the United Packinghouse Workers struck for higher wages on March 6, 1947, picketers with handmade signs appeared well before dawn at the corner of Grand Avenue and Concord Street near the entrance to the Swift and Company packing plant. Two hours later, at about 6:30 A.M, the crowd around the intersection had grown substantially, as a richly atmospheric photograph taken from a nearby building shows. By this time policemen appear to have cleared the intersection, where a streetcar and livestock truck wait to pass, but the strikers are out in full force, ready to make their demands known.

The 1947 strike was a prelude to an even bigger walkout just over a year later, when packinghouse workers in South St. Paul and across the nation went on a strike that lasted ten bitter weeks. As the strike moved into its third month in May 1948, the situation grew especially tense in South St. Paul when a group of strikers allegedly roughed up some guards and caused damage in a midnight raid on the Cudahy plant. Amid calls for more police, the Dakota County sheriff reported that he had received "22 flat refusals" in an effort to enlist new deputies.

The next day, Governor Luther Youngdahl mobilized the National Guard to maintain order. This provocative event produced a memorable photograph—taken on the morning of May 15, 1948, as a phalanx of National Guardsmen, armed with rifles and bayonets, marched up the hill on Grand Avenue. Visible behind the guardsmen are portions of the stockyards and the huge Swift plant, a behemoth that sprawled over 28 acres and at its peak consumed 700 cattle an hour. There was no violence, though several strikers donned their World War II uniforms— "complete with chevrons and service ribbons," wrote the *Pioneer Press*—in hopes of embarrassing the young guardsmen. As it turned out, there were only scattered incidents over the next few days. The strike finally ended on May 21 when union and industry negotiators reached an agreement in Chicago.

Today, most of the old meat-packing complex is gone, though the stockyards remain in operation, and only the occasional pungent odor of doomed livestock on the hoof serves as a reminder of the day in 1948 when a small army of soldiers marched through the streets of South St. Paul.

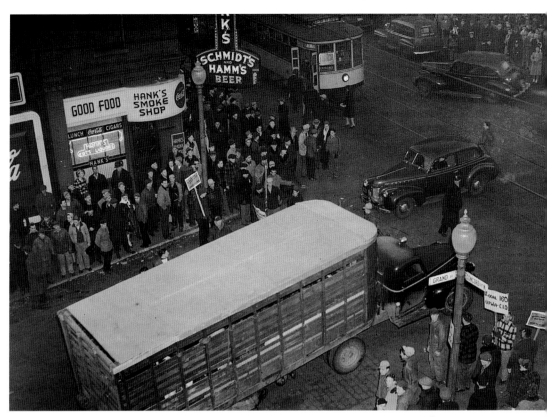

Dispatch / Larry Anderson

Dispatch / Larry Anderson

Pioneer Press / Chet Kryzak

AUG 2 3 1950

Dispatch / Hi Paul

ABOUT 3,000 MEXICAN AMERICANS were living in St. Paul by the early 1940s, and the tight-knit community on the West Side Flats east of Robert Street attracted a surprising amount of attention from the *Pioneer Press*. Much of the coverage was devoted to festivals and the like, but more serious issues—such as deportation—were also the subject of photographs.

Deportation became a big issue after World War II, which had brought thousands of Mexicans and other foreign workers into Minnesota to help with agricultural production. They labored in the fields, worked in canning plants, and performed other essential jobs.

Canning corn during the war was one thing. Becoming American citizens was another. Once the war ended, the old system of importing migrant laborers on a contract basis continued, and federal authorities regularly rounded up illegal immigrants who had filtered into the country to work. A photograph taken on August 23, 1950, at Holman Field in St. Paul shows a group of deportees preparing to board a plane to begin their trip back to Mexico. There's not a smiling face among them—hardly a surprise in view of the fact that they could earn far more money in the United States than in their homeland. Included among the "illegals" were several men who had helped out in Minnesota during the war. But with restrictive immigration laws back in place, they were no longer welcome.

MOTION PICTURE MORALITY—or the lack thereof—has long been of concern to all manner of people who believe the lords of Hollywood are corrupting the nation's youth. The issue remains as hotly debated now as it was back in 1950, when these young men—identified as Charles Ferguson and Ray Levang, both students at Bethel Seminary—marched in front of the Orpheum Theater in downtown St. Paul. What has changed over the past half century is the definition of generally acceptable conduct, on and off the big screen.

The protest shown here ostensibly centered on *Stromboli,* a movie starring, among others, Ingrid Bergman. Yet the movie itself—a "puzzling and obscure" work, according to one local critic—wasn't really the issue. The issue was Bergman herself, who had engaged in a notorious affair with the movie's director, Roberto Rossellini. She was married at the time, and her husband divorced her when the affair became public knowledge.

Although Bergman ended up marrying Rossellini (only to divorce him a few years later), she was so roundly condemned in this country that she was forced to return to Europe. She didn't resume her Hollywood career until 1956, by which time memories of the affair had faded. Today the uproar over Bergman's transgression seems almost quaint in light of the conspicuously bad behavior—amatory, criminal, and otherwise—that, if you believe the tabloids, is an everyday feature of life in the entertainment business.

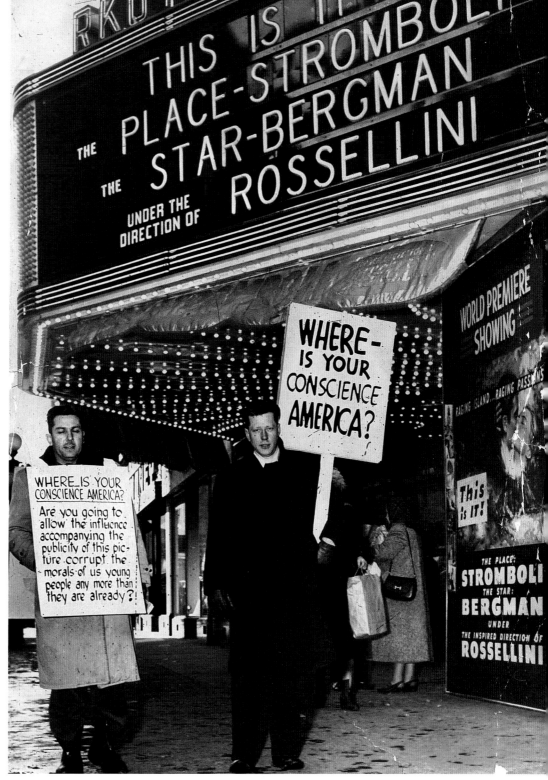

Pioneer Press / Ralph Welch

FEB 1 7 1950

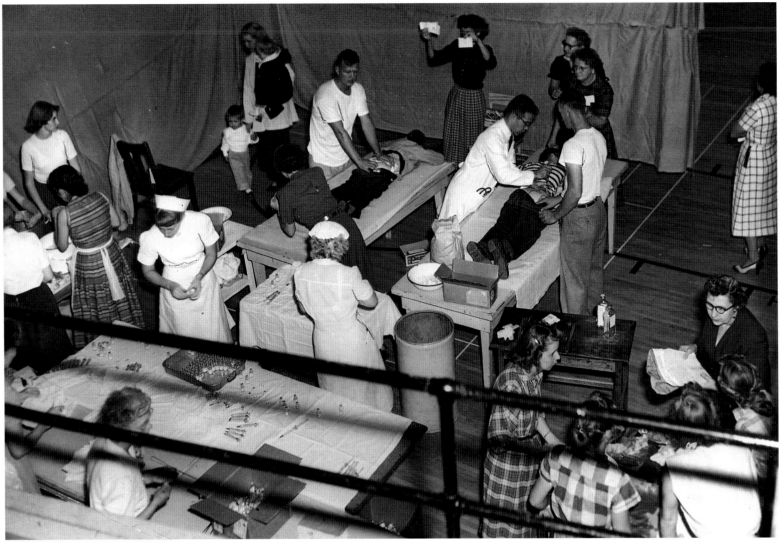

SEP 1 6 1953 *Pioneer Press* / photographer unknown, possibly Don Spavin or Earl Chapin

POLIOMYELITIS was in many ways the viral version of the "Red scare" that infected so much of American life in the 1950s. Spread by contaminated water or through contact with someone who'd already picked up the virus, polio was not usually fatal but could leave its victims—often children—crippled for life or sentenced to months or years of paralysis in an iron lung. The *Pioneer Press* and *Dispatch* followed the disease closely at this time, providing frequent updates on the number of new cases. By mid-September 1953, when this mass inoculation in St. Croix Falls, Wisconsin, was photographed, the city of St. Paul had reported 245 new cases for the year, including 14 fatalities. Statewide, the total was 1,437, with 57 deaths.

Known as "Operation Big Needle," the inoculation in St. Croix Falls and other communities in Polk County, Wisconsin, ran for

two days. Youngsters received gamma globulin shots, which provided only limited protection against polio. The shot—not a pleasant one, as many of its recipients recalled—had to be administered in the buttocks. Always angling for a cute story, the *Pioneer Press* published a nine-year-old boy's supposed account of the event as "told to" a reporter. Sounding like a story written by a reporter trying gamely to speak like a boy, it began: "They gave me the needle today and I'm still sore. Sore in more ways than one. In the first place, my backside hurts. Brother, how it hurts! In the second place, my dignity isn't feeling too good either."

Other children would soon be spared this indignity. By 1954, Dr. Jonas Salk was already conducting field trials of a new polio vaccine that required only a shot in the arm. A year later mass

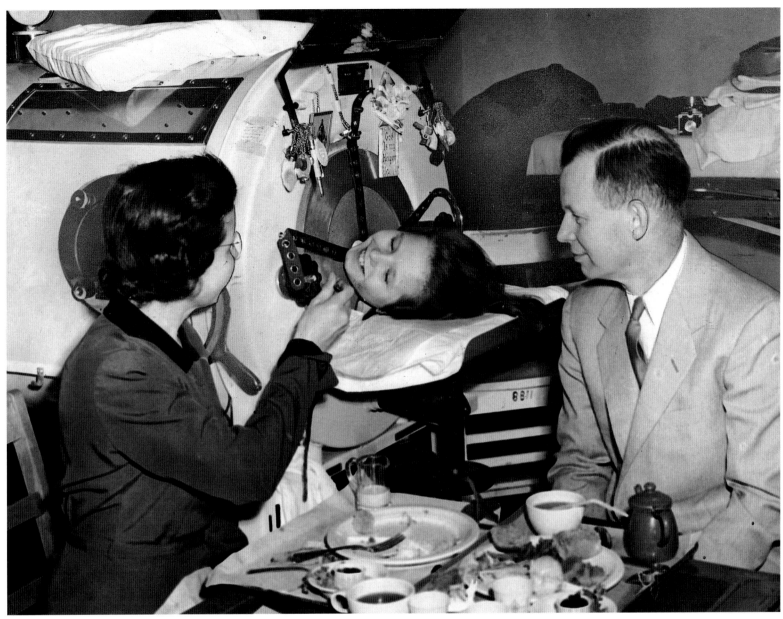

Dispatch / photographer unknown

inoculations began in earnest, and polio, perhaps the most dreaded disease of its time, was finally brought under control.

For a parent or child in the 1950s, there were few more fearful images than the sight of a polio victim imprisoned in an iron lung. Invented in the late 1920s, the iron lung was also a lifesaver—a 700-pound, seven-foot-long breathing device that worked much like a bellows, doing the work of paralyzed or weakened muscles. Some polio victims spent only a short time in the big steel tube. Others, struck hardest by the disease, might require the use of an iron lung for months or years.

In this photograph taken in 1953, just two years before the successful introduction of the Salk polio vaccine, Vivian Solli of Mankato occupies an iron lung at the Sister Kenny Institute in Minneapolis. Her parents, identified only as Mr. and Mrs.

G. E. Solli, are having lunch with her. There's no information with the photograph concerning Vivian's condition. But judging by the trinkets and other personal items hanging above her head, she'd been in the iron lung for some time. Note also the angled mirror that allowed her to see the room around her.

It's easy to assume that confinement in an iron lung was a terrible experience, as it must have been in many ways for Vivian and others like her. Yet some iron lung veterans also recall it as a welcome place of relief from what was otherwise an exhausting fight for every breath. Portable ventilators later took over the role of the iron lung, and today it's believed that fewer than 150 of the massive old machines still survive as reminders of the long fight against a crippling disease.

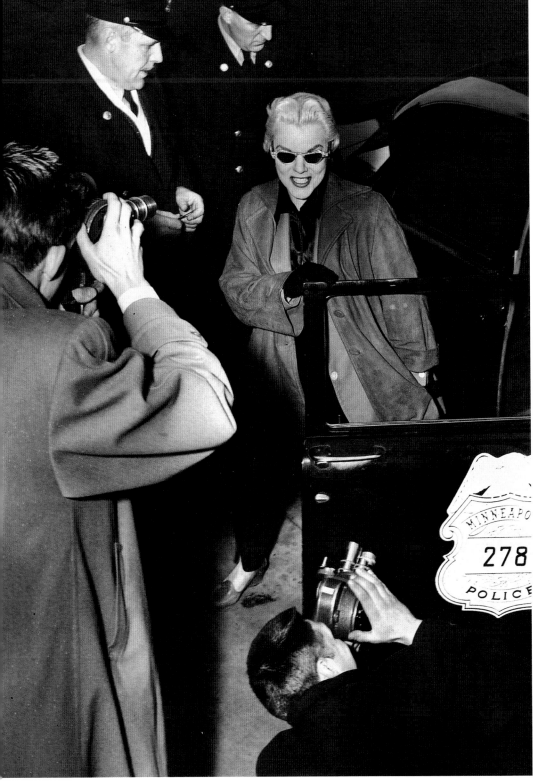

Pioneer Press / Buzz Magnuson

EARLY IN MARCH 1956, police in Minneapolis were apparently tipped off that something obscene was going on in their fair city. As a result, three members of the department's morals squad, headed by a detective named Jake Sullivan, went to the Alvin Theater on lower Hennepin Avenue to watch six "burlesque queens," as they were called, in action.

Diligent in the pursuit of their duties, the cops stayed for the entire show, after which they went backstage and arrested the dancers for "lewd and indecent exposure." Also arrested was the theater's proprietor, Edward Ross, who later allowed as how he had seen "nothing wrong" with the performance, which was undoubtedly far tamer than what goes on in the average "R"-rated movie, or music video, today.

Naturally, the press got wind of this epic police action. When the strippers were hauled off for booking on disorderly conduct charges, television and still photographers were waiting. The out-of-town dancers, who denied the charges, offered an intriguing set of stage names. Among them were Juanita "The Hotcha Girl" Danez, Sandra "Kitty Karr" Evans, Gracie "Flying Saucer" Wiener, and Rose "Kandy Kane" Martin, all in their twenties.

The first of these pictures shows Evans, perhaps the most photogenic of the sextet, as she emerges from a police car on her way to the booking. She does not appear to be overly distraught, since she was no doubt well aware that a highly publicized police raid couldn't help but be good for her kind of business in the long run. A second photograph, taken at the police station, offers a view of the show's top-billed attraction, 21-year-old June Carpentier of St. Louis, looking at once calm and mysterious in her dark sunglasses. Her stage name was "June Harlow." Martin hides under a scarf at her left while Wiener, looking rather bored with the proceedings, is to her right. Morals squad leader Sullivan, at far left, was quoted as saying that the show was "about as bad as the complaint said." Alas, most of the complaint's specifics

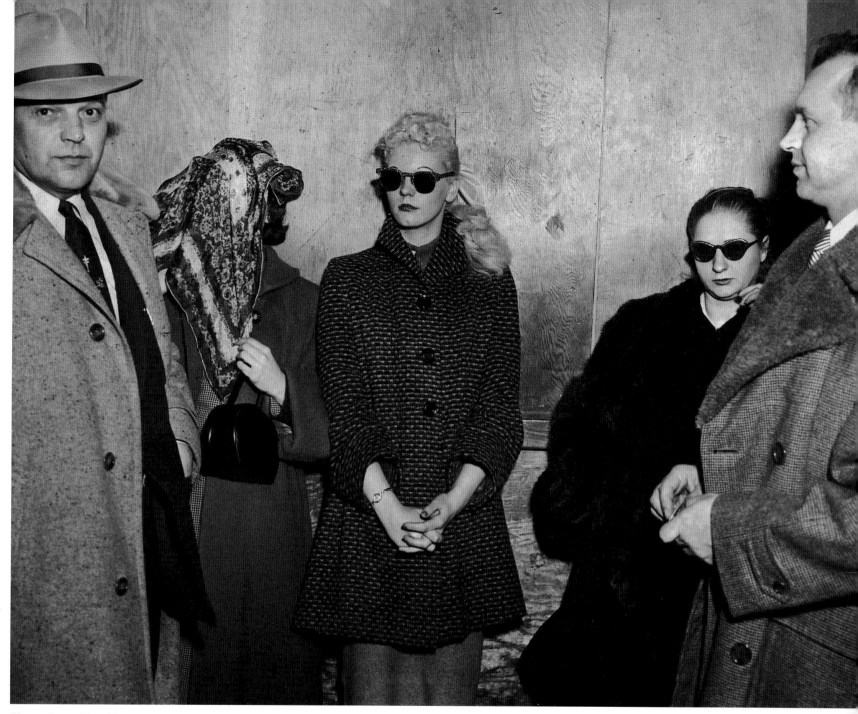

Pioneer Press / Buzz Magnuson

MAR 0 6 1956

appear lost to history, although it was alleged that the women executed "indecent bumps and grinds."

According to a *Pioneer Press* story, when the women were booked they "gave their occupations as 'interpretive' or 'exotic' dancers. But police merely wrote 'entertainers' on the arrest sheet." Ross and the women posted bail of $200 apiece and were released pending a court hearing the next day. Once the booking process (and the juicy photo opportunity it afforded) was over, the St. Paul newspapers quickly began to lose interest in the story, no doubt in part because it had all happened in Minneapolis.

Even so, the *Dispatch* did report the next day that four of the dancers planned to take their cases to trial and had won a delay so that they could display their allegedly scandalous costumes in court. One can imagine that the trial judge was eagerly awaiting this phase of the proceedings. The dancers' basic defense, wrote the *Dispatch,* was that "their costumes afforded more torso coverage than a Bikini bathing suit."

The ultimate disposition of the charges isn't known, but the show went on at the Alvin for some years to come. However, the day of the classic "burlesque queen" was already drawing to a close as other forms of erotic entertainment, including pornographic movies, became more widespread.

APR 0 9 1961

Pioneer Press / Spence Hollstadt

ONE OF THE MYTHS OF THE 1950S is that millions of Americans built basement fallout shelters in hopes of protecting themselves if those trigger-happy Reds in Moscow ever decided to drop "the big one." The truth, however, is that well-fortified home bunkers were uncommon even though Civil Defense officials touted their value. Part of the problem was undoubtedly cost, but there also seems to have been a pretty general public belief that the only thing worse than dying in a nuclear attack would be living (probably not for long) in the radiation-saturated aftermath. Still, by

one estimate about 200,000 home fallout shelters were built in this country during the Cold War period.

In the St. Paul area, fully equipped home shelters were extremely rare, with perhaps no more than 20 in existence in 1961 when this photograph was taken for a *Pioneer Press* article. The man in the shelter is Herb Garske, who built the concrete-block hideaway in his basement for $2,150, a figure that included $300 worth of groceries stacked on shelves next to what appears to be a pull-down bed. Crisco, Franco-American spaghetti, and Dinty

Moore beef stew were among the survival foods of choice.

It's unlikely that the *Pioneer Press* story did much to promote shelter building, however, since the writer quoted Civil Defense authorities as saying that a fair-sized nuclear bomb landing on the Marshall Avenue–Lake Street bridge between St. Paul and Minneapolis would destroy everything—and everyone—within a four-mile radius. "If you'd be lucky enough to get out of the city," the article concluded on a helpful note, "you would still need to find protection against fallout radiation."

Earlier stories had also explained, in painful detail, just what an atomic bomb would do to the Twin Cities. Perhaps the most graphic of these was a long article by reporter Roy Dunlap that ran in the *Pioneer Press* in January 1950. Not one to stint on metaphor, Dunlap imagined a nuclear bomb "screaming a soprano solo of death" as it fell from the sky. When it detonated, he wrote, much of downtown St. Paul would melt "like a chunk of paraffin tossed into a foundry furnace."

To underscore Dunlap's epic vision of destruction, one of the wizards in the *Pioneer Press* photo lab put together a bizarrely doctored photograph of the State Capitol, illustrating how it might look if a nuclear bomb landed nearby. The special effects were rather primitive by today's standards. The bomb-shattered Capitol was created by blacking out various parts of the structure, after which a second photograph, showing building debris, was superimposed over the bottom third of the image. Whether this picture sent readers scurrying to their basements to begin laying up concrete block is unknown, but it certainly made for one of the strangest views of the Capitol ever published.

Pioneer Press / photographer unknown

JAN 0 8 1950

GOODS

CAN A
MINNEAPOLIS
DIMESTORE
BE A SYMBOL OF
FREEDOM

FEB 2 9 1960

Dispatch / Hi Paul

ON FEBRUARY 28, 1960, newspapers around the country, including the *Pioneer Press,* gave front-page play to an Associated Press photograph showing a bat-wielding white man as he attacked a young black woman during a civil rights demonstration at a lunch counter in Montgomery, Alabama. That same day, as it so happened, a small group of blacks (joined by a few whites) staged a far less confrontational demonstration at the Woolworth's store in downtown Minneapolis (which had never, to anyone's knowledge, been segregated). A *Dispatch* photographer was on hand to record the event, and the result was this picture that captures the spirit of a time when there was hope and high idealism in matters of race.

The most interesting faces in the photograph belong to the older white man and young black woman sitting next to each other at the counter. The man is L. R. Tobin, the store manager, who'd invited the demonstrators in to have a cup of coffee. His

expression is hard to read, but he appears rather bemused, as though he's going with the flow of an event he can't really fathom. Next to him is 16-year-old Sandy Rogers, a student at St. Paul Central, and you can see the exuberance in her face as she grins for the camera. "We heard about the picketing through friends," she told a reporter. "We wanted to lend a little moral support. I don't think we can change the world, but we can help try."

Not everybody, however, thought integration was a good thing in the 1960s. Among the naysayers were two pickets who demonstrated outside a meeting at the old Selby Community Center on Holly Avenue in St. Paul. The meeting was held to explain the state's new fair housing law, which made it illegal to discriminate against minorities in selling or renting property. The pickets, identified as Clayton Goward (left) and Cal D. Mende, both of Minneapolis, said they had come to the event to protest "unfair discrimination to whites by the enforcement of the law."

Dispatch / Buzz Magnuson

DEC 1 9 1962

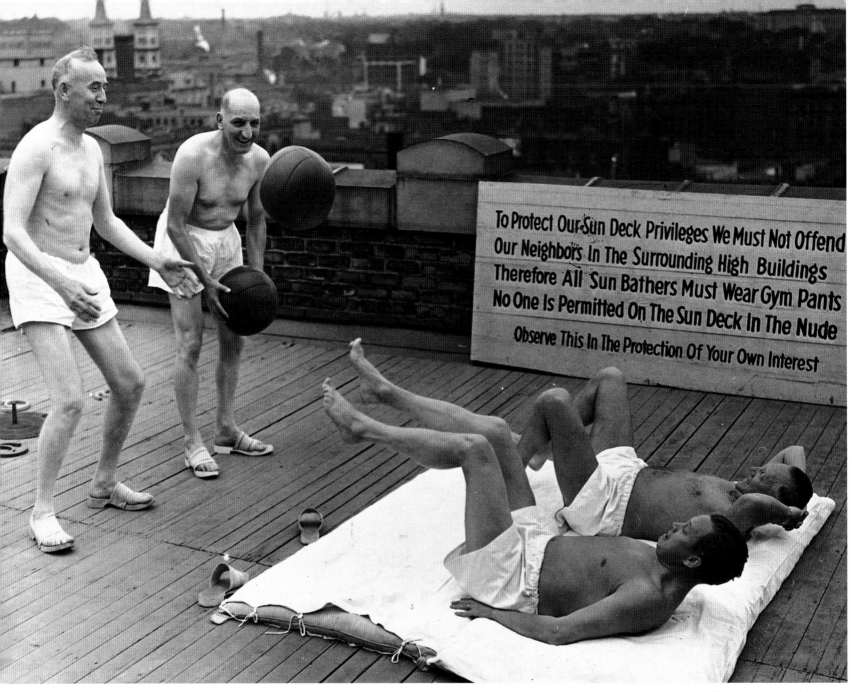

To Protect Our Sun Deck Privileges We Must Not Offend Our Neighbors In The Surrounding High Buildings Therefore All Sun Bathers Must Wear Gym Pants No One Is Permitted On The Sun Deck In The Nude

Observe This In The Protection Of Your Own Interest

JUL 2 7 1941

Pioneer Press / Jack Loveland

BACK IN THE OLD DAYS, members of the now-defunct St. Paul Athletic Club liked to cavort on a deck atop the 12-story building located in the heart of downtown. These were among the city's notable citizens—doctors, lawyers, judges, and businessmen— and many belonged to an informal group known as the Sons of Sol. Over the noon hour in the summer months, they would gather on the roof to play strange games with medicine balls and acquire Hollywood-style tans. The four sun worshipers shown here include a former St. Paul mayor, Mark Gehan, standing at far left. Once a year, the Sons of Sol even went to the trouble of electing a king, whose duties must have entailed, among other things, making sure his subjects kept their shorts on.

The large sign visible in this photograph suggests that sunbathing in the buff had become enough of a problem to warrant a strict warning from the club. The sign's concluding message— "Observe This In The Protection Of Your Own Interest"—further suggests that somebody watching from a nearby tall building had complained and perhaps even threatened to call the police. Although this photograph was taken in 1941, the practice of rooftop sunbathing continued at the Athletic Club in the years after World War II. It's not known, however, how long the Sons of Sol practiced their quaint rituals.

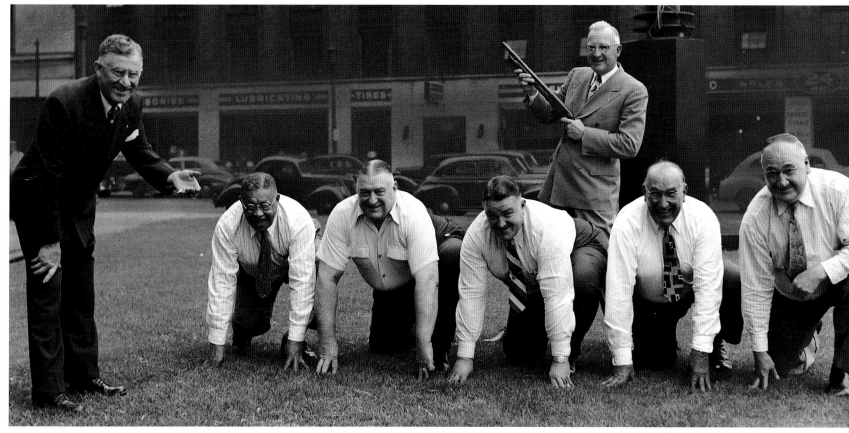

Dispatch / Jack Loveland

JUL 0 4 1946

HOLIDAYS ARE A NOTORIOUSLY SLOW TIME in the news trade. None is more so than the Fourth of July, when everybody is out vacationing instead of staying home and committing some noteworthy act of mayhem. Obviously desperate for news, the *Dispatch* on July 4, 1946, offered readers this wacky photograph. The hefty gentlemen shown here are participants in the—you guessed it—"fat men's race" to be held as part of an annual picnic for city of St. Paul and Ramsey County employees.

Excessive sensitivity to body appearance issues was not a feature of newspapering in the Speed Graphic era, so a head-line over the photograph reads: "Rotund to Take Part in Weighty Event." A caption below went on to note that "these nimble sprinters (gross displacement 1,341 pounds) are calculated either to burn up or bog down the track."

To add to the hilarity of this posed scene, taken in front of the city hall-courthouse, the photographer persuaded Ramsey District Judge Royden S. Dane to stand behind the men with a shotgun. Explained the *Dispatch:* "As an ordinary starter's pistol would hardly give enough impetus to throw so much tonnage into motion, the judge is using a sawed-off shotgun borrowed from the sheriff's office."

For the record, the contestants are, from left, Orrie Hall, Bill Picha, Harold St. Martin, Max Lang, and Tony Heidenreich. Standing beside them is Alfred F. Bonn, chairman of the picnic. It is not recorded who ultimately won the race, but it's a good bet that the event made for some truly breathless excitement.

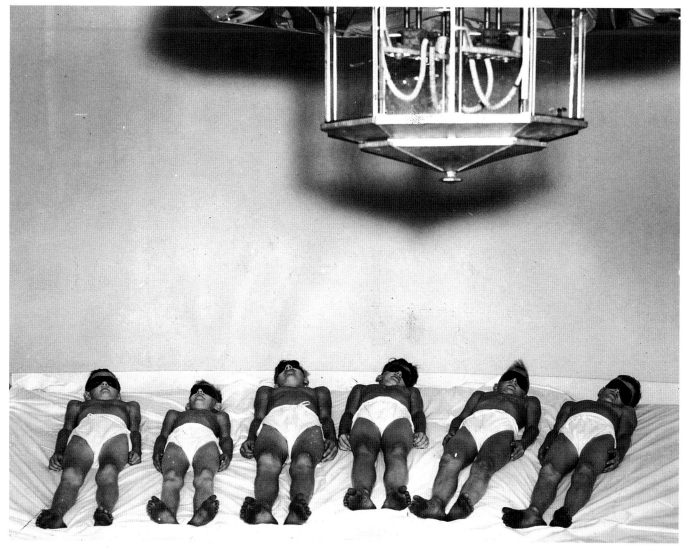

JUN / JUL 1949

Pioneer Press / photographer unknown

AMONG THE MORE CURIOUS INSTITUTIONS in the history of Ramsey County was the Children's Preventorium at Lake Owasso in Shoreview. Between 1915 and 1953 more than 1,000 children stayed, in some cases for years, at the institution, one of many around the country designed to prevent children exposed to tuberculosis from developing the disease. Serving a largely poor clientele, the "preve"—as it was usually called—was a peculiar combination of boarding school, group home, and health camp. The idea was that a lot of fresh air, sunshine, and vigorous exercise in an isolated environment would ward off full-blown tuberculosis, a dreaded and disabling disease now much less prevalent—and lethal—than it once was.

The strangest feature of the "preve" was the choice of white diapers (known as "drapes") as standard casual attire for its res-

idents, some as old as 16. The drapes were still being worn in 1949 when a *Pioneer Press* photographer shot this picture of six boys—"brown as berries," according to the caption, and all wearing eye shades—as they baked under a sun lamp. Skin cancer, clearly, was not a worry in those days.

Like many other treatments tried for tuberculosis over the years, the preventorium approach proved in the end to be of dubious value. New medical studies in the late 1940s revealed that children exposed to tuberculosis who stayed home with their families were no more likely to develop the disease than those sent away to live in isolation. A few years later, with its resident population down to just 13 children, the preventorium on the shores of Lake Owasso closed for good, although the building was later used as a home for retarded children.

OCT 0 6 1949

IN 1949 a *Dispatch* reporter went out to interview a cobbler named Mike Caulfield, who maintained a shop on Selby Avenue in St. Paul. Caulfield, who'd learned his trade in Ireland, specialized in producing custom shoes for deformed or otherwise abnormal feet. Naturally, the reporter wanted to know the most unusual job Caulfield had ever tackled. It turned out to be a very peculiar job indeed—the two-footed shoe he's holding here in his right hand (in his other hand is one of the plaster casts he used to establish a foot's exact shape).

The double shoe was made for unnamed conjoined twins, said to be stage performers and described thusly by the *Dispatch:*

"They were joined at the hips and it was necessary for them to move their near feet in unison." Caulfield, the story continued, "took their two ordinary shoes and incased them in one huge sole and upper. He still has the last 'pair' he made for them, because they died before he could deliver it."

One wonders who the twins were, what they did on stage, when they died, and how they got in touch with Caulfield. Unfortunately, the *Dispatch* article provides no additional details about what may well have been the oddest shoes ever made in St. Paul.

JUN 0 8 1958

Pioneer Press / Earl Chapin

THE PHOTOGRAPHERS OF THE SPEED GRAPHIC ERA were a creative lot, and given the chance they could turn even the dullest assignment into something, well, unusual. Here is a fine example in that regard. It shows four former teachers at a one-room school in Pierce County, Wisconsin, posing for the camera at a reunion to mark the school's closing in 1958. The school, called Lone Balsam, had been in operation since at least the 1880s but was being consolidated into the nearby Spring Valley, Wisconsin, school system.

A standard group shot of the four elderly teachers wouldn't have been very interesting, so photographer Earl Chapin (who covered western Wisconsin for the *Pioneer Press*) decided to spice things up. Chapin got his subjects to pose with rulers, supposedly a favorite weapon for teachers back when corporal punishment was permitted, just to show that public education had no room for softies in the old days.

The teachers were, from left, Elizabeth Dopkins, W. A. Sanford, Jennie Clark (who'd taught at the school in 1906), and Mrs. O. C. Wenum. They seem less than thrilled with the idea of wielding rulers like nightsticks (Clark, in particular), but they did their best to give the photographer the shot he wanted. Even so, they don't look very menacing, and one suspects that, as teachers, they really didn't need rulers or other pedagogical weaponry to keep children in line.

118

**IT IS HARD TO KEEP AWAY
NAUGHTY THOUGHTS** while look-
ing at this very odd picture taken
in January 1954 at the Women's
City Club in downtown St. Paul.
The occasion was a Twelfth Night
party, but beyond that the details
are regrettably sketchy. It was
obviously some sort of masked
and costumed affair, and the duo
here certainly must have earned
points for originality.

A note on the back of the
photograph reports only that the
woman at right went to the party
dressed as a "French beauty" while
her leashed companion acted the
part of a "French poodle." Note
that the "beauty"'s elegant outfit
comes complete with a long ciga-
rette holder of the kind that made
smoking look downright chic at
a time when nicotine and whiskey
were the social drugs of choice.

Chet Kryzak

JAN 0 6 1954

MAY 0 2 1959

Dispatch / Hi Paul

NOW AND THEN the St. Paul newspapers outdid themselves in the 1950s with a photograph so wonderfully strange that frail words can hardly do it justice. This is one such image, from 1959. The occasion was a "Clean-up, Paint-up, Fix-up Week" street-sweeping contest undertaken by the St. Paul Business and Professional Women's Club. Photographer Hi Paul, bless him, was there to record the moment for posterity.

Shown here are members of the winning team (no names were provided in the caption) as they await the starter's whistle on Seventh Street between Minnesota and Cedar Streets in downtown St. Paul. The team even had a junior auxiliary—the broom-wielding boy at the right of the picture. The exact rules governing the contest have been lost to history. Even so, the expressions on the women's faces leave little doubt that they are fired up for the event. It can't have been money alone that led them to throw aside caution and take their brooms to the street, since the prize for first place was a modest $25.

Pioneer Press / Roy Derickson

MODERN DANCE, like modern art, is one of those disciplines that people either find beautiful or baffling. It will be left to the viewer to decide which applies to this scene, taken in 1960 high up on the steel frame of the new YWCA being built on Kellogg Boulevard in downtown St. Paul. The dancers, according to the *Pioneer Press*, were attempting to "symbolize progress" along Kellogg, where a number of building projects were under way.

The newspaper's position in the baffling-or-beautiful debate seems to have come down in favor of the former, judging by a further comment that the steel framework formed "a bizarre rehearsal stage" for the dancers. From left, they were identified as Carol Schuldt, Billie Logan, Gerry Groehler, and Connie Stack. Schuldt and Logan were instructors in modern dance at the YWCA. This picture was taken for a Sunday pictorial magazine article entitled "New Look on an Old Street," so it's a good bet that the dance amid the girders was carefully staged for the benefit of the newspaper's photographer.

FACES
IN THE NEWS

The legacy of the Speed Graphic era in St. Paul includes a gallery of wonderful faces, captured by the newspapers' busy photographers as part of their daily routine. Although a few of the pictures in this chapter might qualify as formal portraits, most are quick photographs taken on assignment, without much fuss or preparation. Thousands of these unpretentious images were produced because of the way the *Pioneer Press* and *Dispatch*—and most other daily newspapers—operated at the time.

The newspaper "style" of the day, if it can be called that, was to offer readers a highly eclectic array of stories and photographs in the hope that they might find at least a few of them interesting. As many as 20 stories sometimes appeared on the front page alone—four to five times the number commonly seen today. Like an enormous bag of party favors, the newspapers were full of curiosities and small amusements. Open them up and you could never tell what sort of surprise might be in store for you.

One result of this approach was that the *Pioneer Press* and *Dispatch* in those days had an enormous appetite for locally generated photographs. This meant that very small events—a toddler getting his stomach pumped after swallowing some aspirin, a burglary at the neighborhood hardware store, or a picture of church ladies preparing artery-narrowing pastries for a bake sale—often found their way into print as sort of visual fillers. Various "official" pictures were also used exten-

sively. These included shots of groundbreakings, ribbon cutting and awards ceremonies, meetings, and all manner of other occasions considered worthy of publicity.

By contrast, today's newspapers are designed and packaged down to the last detail, and mere filler photographs of the old kind are rarely used. This is probably a good thing, sparing readers much forgettable imagery. Yet the more selective use of pictures in today's newspapers also has its drawbacks. The most obvious is that there simply aren't as many news photographs appearing now as there used to be. In part, of course, this is because St. Paul, like many other cities, has since the 1950s lost one of its daily newspapers. But even if the *Dispatch* hadn't gone the way of most afternoon dailies, the numbers would still be down.

One happy result of the old way of doing things was that the newspapers generated large numbers of photographs of people going about the everyday affairs of life. And because the news photographers of the Speed Graphic era spent so much time on the streets and went to so many events, they caught people from all rungs of society in all manner of moments.

The faces in this chapter cover a remarkable range, from Mexican immigrant laborers to a pair of stern-looking nuns to an armed robber whose family name was to become infamous in the 1950s. In some cases, the story behind the picture is well-documented. In others, little except the photograph itself survives to speak to us from the past.

photographer unknown

THIS IS A MYSTERY PHOTOGRAPH of the kind that pops up now and again in the *Pioneer Press* and *Dispatch* archives. It was shot in March 1944 in front of the Grand Hotel, a long-gone establishment near Rice Park in downtown St. Paul. A note on the back of the picture says simply: "Vance Swift, midget, and paper collection."

Dressed in a long coat, boots, and a big hat, Swift offers a confident wave to the camera as he sits atop what appears to be a rather loose pile of newspapers. The photograph may never have been published in the newspaper, so it's not known why it was taken. But it's certainly a memorable image, and one suspects that Swift was a downtown "character" well known to the photographers of the time.

BETTY ENGLE LEVIN'S BRIEF STINT
as a photographer at the *Pioneer Press*
and *Dispatch* lasted from 1941 to 1946,
or the approximate period of World
War II. That, of course, was a time when
millions of women admirably performed
jobs that had long been considered the
strict province of men, and LeVin's work
for the newspapers was no exception.

Here's one of her most charming
photographs, showing two girls—Louise
True, at left, and Joyce McCauley—as
they happily walk away with their prizes
from a "toy loan library" in St. Paul's
Summit-University area. It appears this
particular image—one of a series made
by LeVin—never made it into the news-
paper, but three others showing chil-
dren at the toy library were published
by the *Dispatch*.

Most of the published photographs
credited to LeVin are pictures of girls
and women, but she was also sent
out on spot news stories—the bloody
bread and butter of the Speed Graphic
era. LeVin, by the way, went on to have
a long, highly successful career as a
wedding and society photographer in
St. Paul.

Dispatch / Betty Engle LeVin

AUG 1 7 1944

DEC 2 4 1944

Pioneer Press / Betty Engle LeVin

ANOTHER PHOTOGRAPH by Betty Engle LeVin shows two young women waiting for escorts to take them home after a party in November 1944 sponsored by the Merriam Park Presbyterian Church in St. Paul. The "Back to the Hills" party was a teen mixer that involved wearing old clothes, bidding for lunch baskets, and finally following directions to meet up with escorts.

The young women, Betty Cedarberg (left) and Mary Ingersoll, were instructed to wait for their "dates" by a fire hydrant, which must have been a rather chilly experience in the cold of mid-November. Presumably, the boxes they're holding are the lunches they won in the bidding.

Pioneer Press / Hi Paul

SEP 0 2 1945

DURING WORLD WAR II about 120 men from Mexico came to work at a canning plant near Lakeland, Minnesota. They were among about 2,500 Mexican workers brought into Minnesota during the war to fill in at factories and work in the fields. On an August day in 1945, photographer Hi Paul captured some of the men enjoying a lunch that included baked ham, Spanish rice, and fresh vegetables "prepared in Mexican style," according to the *Pioneer Press*.

The men earned about 57 cents an hour and worked up to 12 hours a day turning out canned peas and sweet corn at the plant, operated by Stokely Foods, Inc. One of the workers told the newspaper: "We want the Americans to think well of us, and most of our troubles have come because we can't speak the language of our employers and they can't speak ours." Despite this language barrier, the plant manager said, "We would have been sunk without them."

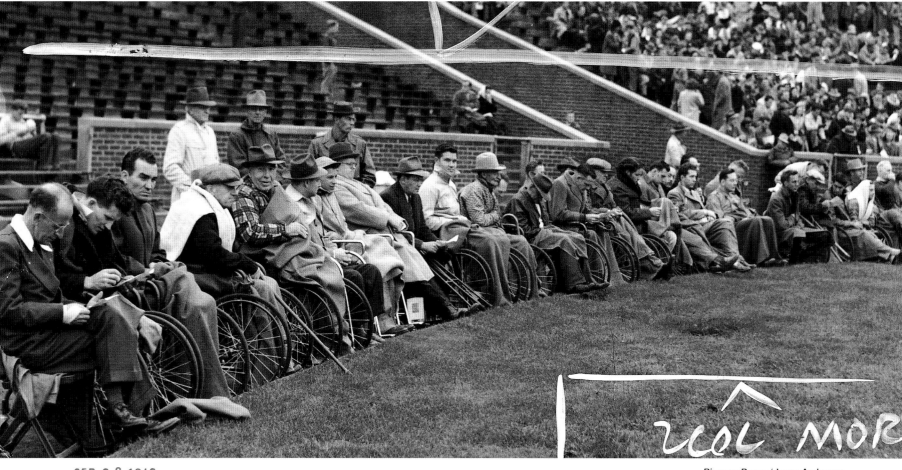

SEP 2 9 1946

Pioneer Press / Larry Anderson

ON WHAT LOOKS TO BE a chilly late September afternoon in 1946, a group of 23 wheelchair-bound veterans joined a crowd of more than 50,000 fans at Memorial Stadium to watch the University of Minnesota football team thrash Nebraska by a score of 33 to 6. The men, all patients at the Veterans Hospital in Minneapolis, were mostly young soldiers from World War II, although a few old-timers from World War I were also in attendance.

About 300,000 Minnesotans served in World War II. More than 6,000 died. Thousands of others, like many of the men in this picture, came home with damaged bodies, as the *Pioneer Press* pointed out in a brief story about the vets. "George McLevis of Minneapolis didn't even stand up when the band played 'Minnesota Hail to Thee,'" the story noted. "You see, George lost both his legs—all the way up to the hips—at Guadalcanal." Another man had been in a body cast for months. Still another had been partially paralyzed since a bullet tore through his leg in Italy.

One face stands out, near the center of the photograph. It belongs to the dark-haired young man in the light jacket sitting next to a pair of much older vets. He is the only man looking directly at the camera. His expression is enigmatic, though it hints at bitterness and loss. Whatever he was thinking, he doesn't seem to be taking much pleasure from the game and its display of athletic prowess by healthy young men unscarred by war.

Pioneer Press / Bud Martin

JUL 0 5 1948

SOME PHOTOGRAPHS SEEM SO BURSTING WITH LIFE that they almost jump out of the frame at you, and this is one of them. The five smiling girls here are senior finalists in a 1948 contest to determine Minnesota's best drum majorette. Each went through a routine of baton-twirling and strutting before a panel of judges to qualify for the finals.

The *Pioneer Press* thought the contest sufficiently interesting to publish five photographs of the girls in action during the contest, held at Forest Lake. The contestants are, from left, Gloria Saunders, Betty Mastrian, Maureen O'Brien, Pat Dunn, and Joanne Smisek. O'Brien was from Stillwater and Dunn from Richfield. The other girls were all from Minneapolis. This photograph was taken a day before the competition ended, and it's not known which girl turned out to be the winner.

JUL 2 9 1948

Dispatch / Jack Loveland

IN THE LATE 1940S and into the 1950s, the Minnesota Council of Churches and a group called the Committee on Race Relations sponsored a program that sent city kids to the countryside to experience a taste of farm life. A good many of the city kids were black, while the farms were in parts of rural Minnesota and Wisconsin that were 100 percent white, or close to it. The visits must have been eye-opening for both groups.

In 1948 a *Dispatch* photographer took this picture of eight youngsters at the St. Paul bus depot as they returned from their sojourn in the country, and what a handsome group they are. The star of the picture is the little guy in front, identified as Marvin Anderson (his brother Archie, in an identical shirt, is to his right). Hands on hips, hat tilted at a jaunty angle, Marvin looks ready to take on the world.

It was, of course, still a largely segregated world for these kids in 1948. Their home addresses in St. Paul tell the story. All of the youngsters lived in or near the old Rondo neighborhood, where the city's small but vibrant black community had been concentrated for decades. But even though de facto segregation was still a powerful reality in St. Paul and other northern cities in the late 1940s, change was coming. In fact, just a day after this photograph appeared in the *Dispatch,* President Harry Truman signed a historic executive order barring segregation in the U.S. military.

The program that sent inner-city kids from St. Paul to rural areas continued into the 1950s. In 1951 *Pioneer Press* photographer D. C. Dornberg took a series of pictures of mostly black kids from St. Paul enjoying their visit to the farm. Headlined

130

Pioneer Press / D. C. Dornberg

SEP 1 6 1951

"Strange Place, the Country," Dornberg's feature began with a short text offering a patently unbelievable account of the young-sters' introduction to the world of vegetables: "Twenty-one pairs of jaws fall open. It was true; they could see it. Peas and beans actually grow on plants in the ground. They only come in cans. This startling truth was only one of many that thoroughly jolted 21 St. Paul kids seeing a farm for the first time in their lives." One wonders how many of the youngsters, aged 9 to 12, were really "jolted" by the idea of vegetables growing in the ground.

Dornberg's photographs, fortunately, were much better than the prose accompanying them. This photograph focused on two sisters from St. Paul, Barbara and Gaynell Ballard. They're say-ing grace before a meal at the home of the Norman Reitz family (he's at right) in Olivia. The first corn on the cob of the season

awaits them, and it's hard to tell whether the girls are trying to look devout, or are simply eyeing all that luscious corn, as they fold their hands in prayer.

It would be fascinating to know more about their visit to the countryside. What did they do? What really surprised them? How were they treated by the townspeople? What did they and their hosts talk about at the end of the day? But perhaps the most interesting question of all is whether the girls and the Reitz family were able to make any lasting connection across the gulf of race and culture.

131

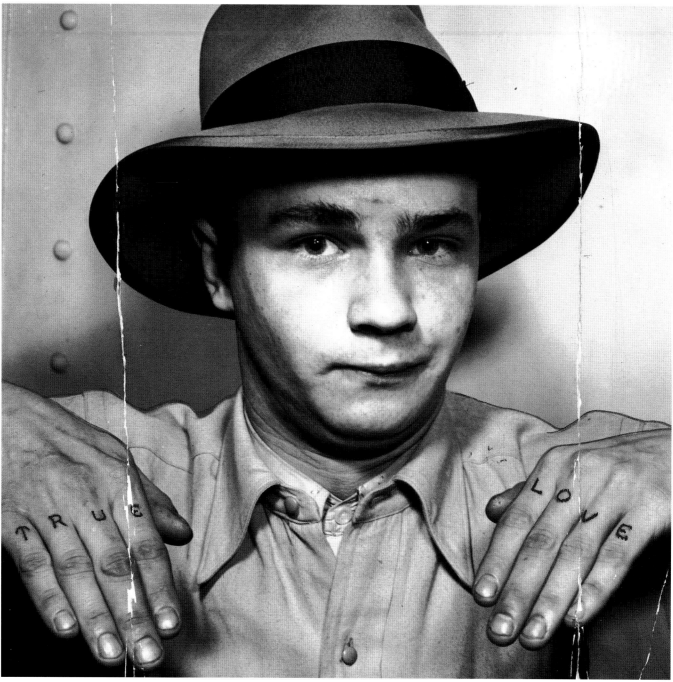

DEC 0 2 1948

Pioneer Press / Jack Loveland

HIS NAME WAS RICHARD O'KASICK, and he was a member of what was to become Minnesota's most infamous crime family in the 1950s. But unlike his three younger brothers, all of whom came to violent ends after a 1957 killing spree, Richard O'Kasick survived his encounters with the law. This picture was taken in December 1947 after O'Kasick and a partner tried to rob the manager of a used-car lot on University Avenue in St. Paul. They didn't get any money, however, and fled the scene. O'Kasick, 21, armed with a pair of pistols, was cornered at gunpoint by a St. Paul police patrolman moments later. His partner escaped.

Despite his youth, O'Kasick already had a long criminal record by this time and was not the least bit shy about posing for pictures in the newspaper. Here he's showing off the incongruous message of love tattooed on his fingers. "True Love Never Did Run Smooth," noted the *Pioneer Press* in its caption. O'Kasick told the newspaper that he'd had the tattoo done when he was 13 and "I've been sorry ever since."

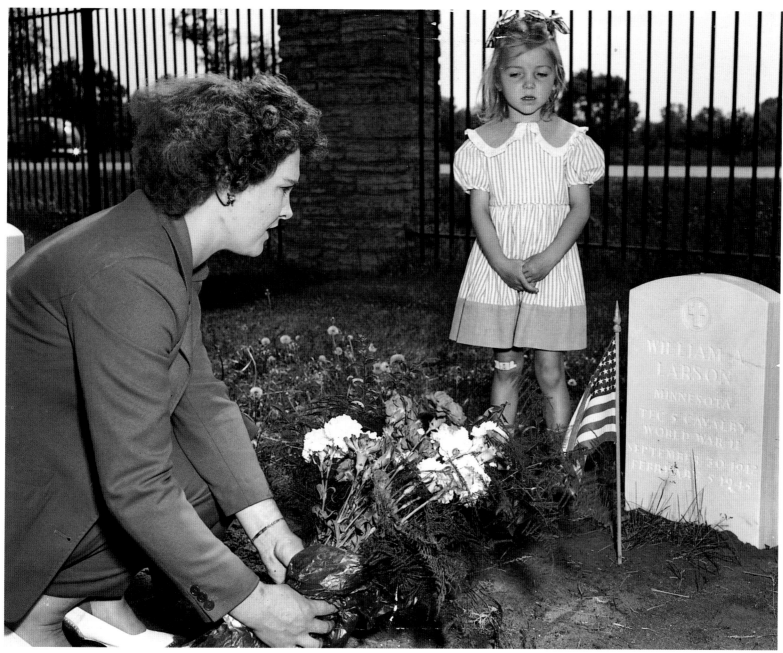

Pioneer Press / Ralph Welch

MAY 3 1 1949

THE BEST PHOTOGRAPHS from the Speed Graphic era have a way of pulling you into a scene, dissolving the distance between you and the subject so that you almost feel as though you have stepped directly into a moment out of time. That quality is evident in this touching picture taken on Memorial Day 1949 at Fort Snelling National Cemetery. World War II was still fresh in memory that year, and so Memorial Day was observed with a passion born of grief and loss. There were the usual parades, prayer services, and speeches, but for many people the day was then, as now, a time for personal remembrance.

Here, Mary Larson of Minneapolis places flowers at the grave of her husband, William A. Larson, as their four-year-old daughter Sharon—wearing a cute striped dress, bows in her hair, and a bandage on one knee—looks on. A brief caption says little about William Larson, other than that he was in an army cavalry unit. The headstone indicates that he died, presumably in combat, on February 5, 1945, at age 32. This means that Sharon, like thousands of early baby boomers, lost her father to war before she could have known him. One can only wonder if he had a chance to see her before he died. The photograph can't answer that question, but it does show that William Larson was not forgotten.

133

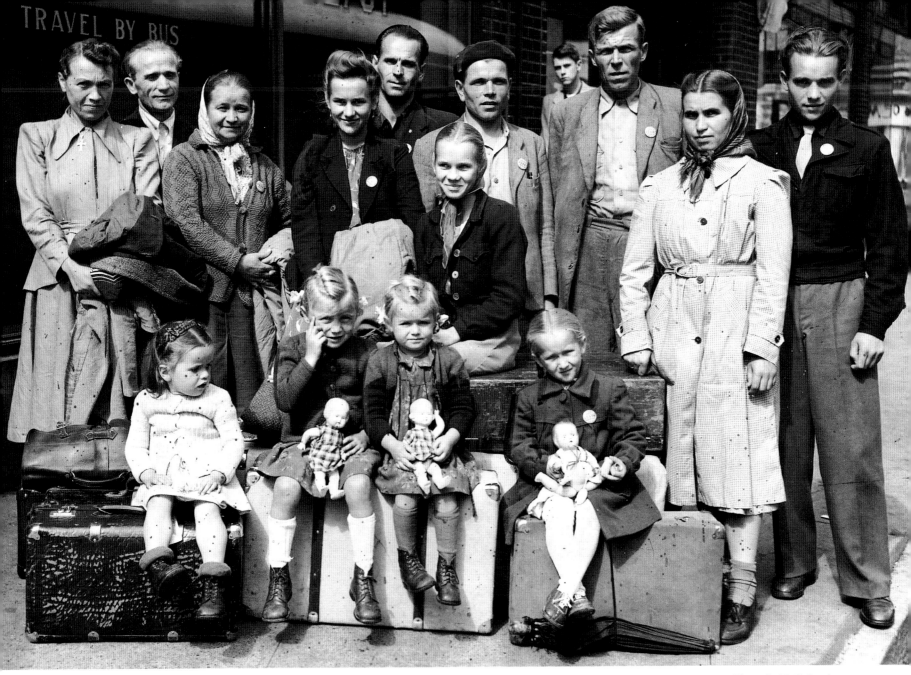

Dispatch / D. C. Dornberg

SEP 1 5 1949

AT THE END OF WORLD WAR II, Europe—especially Eastern Europe—was awash in a tide of refugees who for one reason or another could not, or would not, return to their native countries. Known as displaced persons, or simply DPs, they lived in huge camps until a number of nations, including the United States, agreed to take them in. In 1948 the U.S. Immigration Bureau announced that it would admit up to 205,000 DPs, so long as they weren't "communists or subversives."

Some ended up in Minnesota, including these four families from Ukraine, photographed in September 1949 in front of the old Union Bus Depot at Sixth and St. Peter Streets in downtown St. Paul. It's difficult even to imagine what the older of them must have lived through during the war and, later, in the crowded confinement of the camps. Despite their tiring trip, the families here look ready for their life in America. Their faces—the little girls holding their dolls, the proud young fellow on the right, the woman at far left with a cross dangling from her neck—are riveting.

"We have had four years of waiting in camps in Europe," one of the new arrivals told a *Dispatch* reporter (no mention

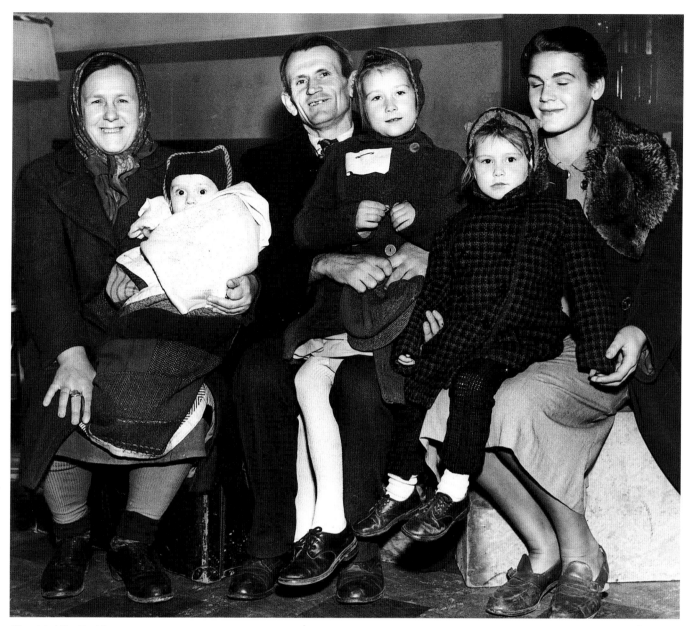

Dispatch / Roy Derickson

MAR 1 5 1950

is made of a translator). "We want one thing now. We want to work." The newspaper said two of the families were going to work at a turkey farm near Aitkin. The other two were to be "placed with dairy farmers." Their surnames were given by the *Dispatch* as Krue, Zerebko, Lytwyn, and Werhanowsky.

Another photograph shows refugees from Poland—the Wasyl Bykowski family—in March 1950 at the Frederic Hotel in downtown St. Paul. The family, on their way to Washington state, was stranded for ten days in St. Paul when their six-month-old baby boy came down with pneumonia. The baby received free treatment at Ancker Hospital while a local Polish American aid group put the family up at the hotel. This picture shows the Bykowskis on the day of their departure for Washington, where the *Dispatch* said they planned "to live on a fruit farm."

It would be intriguing to know, over half a century later, how these refugees fared in the New World.

MAR 0 5 1952

Dispatch / Roy Derickson

THEIR NAMES are Sister Mary Adorinus (left) and Sister Mary St. Clara, and it's clear from this 1952 photograph that they are not people to be trifled with. Sister Mary Adorinus was principal of Our Lady of Peace High School in St. Paul, while Sister Mary St. Clara—rated as one of the nation's seven outstanding women by *McCall's* magazine that year—had arrived to set up a food and home economics department at the high school. One suspects she did so very efficiently.

Pioneer Press / Ralph Welch

APR 2 2 1952

A MARVELOUS PHOTOGRAPH shows two residents of the old Ramsey County Home for the Aged receiving permanents in 1952. One of the residents, Theresa Sheppard, stares straight into the camera, but Laura Miller, sitting next to her, appears to be happily oblivious to the photographer's presence. The three beauticians were identified, from left, as Van Laningham, Sally Becker, and Theresa Merrill. All were members of the St. Paul Hairdressers Association and donated their services.

MAY 0 1 1953

THE DATE IS APRIL 30, 1953, and U.S. Marine Private Lione Peterson has come home to Black River Falls, Wisconsin, from the cruel war in Korea. Once thought to have been dead, Peterson had actually been captured by the North Koreans. He was freed in a flurry of prisoner-of-war exchanges arranged in the waning days of the war, which was to end that July.

Peterson's homecoming sparked the kind of elemental joy that few other events in human life inspire. His mother and three sisters stood "weeping uncontrollably" as he arrived in town, according to the *Pioneer Press*, which added in a characteristic flourish of the time: "The father, eyes moist, hovered beside them, making little masculine efforts to stop their crying."

Hobbled by leg injuries sustained in the war and undoubtedly very tired from his long journey home, Peterson himself said little during what must have been a draining event. But he flashed an engaging smile in this photograph as he stood with his arms around his parents. Also in this picture is a niece, who happily shows off the family's new dog.

Once the greetings were over, the celebration began in earnest. The town's high school band (minus uniforms, which inconveniently were at the cleaners in preparation for a state competition) led a march to the county courthouse, where Peterson was made an honorary lifetime member of the Veterans of Foreign Wars and the American Legion. It was late in the day by the time Peterson finally reached his family's house on the outskirts of town and enjoyed his first home-cooked meal in a very long time.

Pioneer Press / Ted Strasser

DEC 1 0 1956

AMONG THE THOUSANDS of Speed Graphic era photographs filed away in the *Pioneer Press* library, few could be described as flat-out gorgeous. This is one of them. It shows a group of "page boys" waiting to go onstage at a huge annual Christmas event known as the St. Paul Municipal Choral Pageant. Sponsored by the Women's Institute of St. Paul and the *Pioneer Press* and *Dispatch,* the pageant was by 1956 in its 16th year and always played before a full house of 12,000 people at the auditorium. Among those appearing on stage was Bernard H. Ridder, Sr., president of the newspapers' parent company. Ridder, a key figure in promoting the event, read a poem he'd written especially for the occasion. It is hard to imagine one of today's high-powered CEOs invoking the muse, but in the 1950s it did not seem to strike anyone as strange.

Having the big boss on hand ensured copious coverage of the event, and the *Pioneer Press* came through the next morning with seven pictures by photographer Ted Strasser. Six were standard fare—shots of musicians, speakers, and others as they performed their pageant duties. Somehow, while attending to his responsibilities amid all of this painstakingly organized solemnity, Strasser also managed to catch the page boys at a perfect moment, their eyes focused on the stage. Strasser was obviously busy that night because he neglected to identify the boys from left to right, as was customary practice. But he did get their names and here they are in no particular order: David Lowe, Michael Reed, Bradford King, Dwight St. John, John Dejonker, and Peter Jordan, all of St. Paul.

SEP 0 8 1956

BEFORE MR. ROGERS or Sesame Street or Barney there was, for the first generation of children exposed to the wonders of television, the *Howdy Doody Show*. Featuring Howdy, a marionette, his pal Buffalo Bob Smith, and a large cast of friends, the live show ran for more than 2,500 episodes between 1947 and 1960 on NBC. For most of its televised life it appeared in a late afternoon time slot—usually four thirty in the Twin Cities—and was enormously popular with the younger set. Among the inhabitants of "Doodyville" was Clarabell the Clown, a silent character who "spoke" only by honking a horn and who was very fond of jokes involving seltzer bottles.

Here's Clarabell, seltzer in hand, at St. Paul Children's Hospital in 1956. He's reading a *Blondie* comic book with a patient, eight-year-old Craig Henderson of Minneapolis. Young Craig looks a bit dubious about the proceedings but was undoubtedly thrilled to have the famous television icon pay him a visit.

Clarabell was in town for an appearance at the Golden Rule Department Store. It's not clear who this Clarabell was, since a number of actors played the clown over the years. The original Clarabell, however, was none other than Bob Keeshan, who later went on to a lengthy career in children's television as Captain Kangaroo. Keeshan, incidentally, was fired from the Clarabell role in 1952 for demanding more money from NBC.

Dispatch / Don Spavin

DEC 1 9 1958

THE GILLETTE STATE HOSPITAL FOR CRIPPLED CHILDREN, as it was originally called, drew many visits from *Pioneer Press* and *Dispatch* photographers. In December 1958, photographer Don Spavin and reporter Kathryn Boardman visited the hospital, then located on St. Paul's East Side, for a story about a program using music to help treat what a headline called "Crippled Tots." Boardman's story noted that "some of the young patients who are swinging along in the musical therapy program have stiff fingers, lie flat on their backs on hospital carts, one at least is deaf and two small girls have brand new artificial arms."

Spavin took a series of photographs for the story, none more touching than this image of the two girls, seated in small chairs and clearly enjoying the chance to make music. On the left, seven-year-old Eileen Morrison of Red Lake, Minnesota, seems to be having the time of her life as she rings two sets of bells held in the pincers of her new arms. It even appears that she's got her right leg going up and down with the beat. Beside her, four-year-old Pamela Westling of Isle, Minnesota, smiles into the camera as she, too, rings bells in time with the music.

Spavin's photograph is as direct and simple as can be, and that is why it is so affecting. It makes no effort either to over-dramatize or understate the girls' situation. It simply shows them as they were, at a happy moment in their young lives. One hopes there were many more.

JAN 2 5 1945

Pioneer Press / photographer identified only as Gene

THIS PHOTOGRAPH OFFERS A SMALL but revealing window into a vanished way of life. It's January 22, 1945, and the man at left, Jack MacArthur, is literally pulling down the final curtain of a 37-year career in the theater business. The scene is the Orpheum Theater in St. Paul, where MacArthur is spending his last night as stage manager before retiring. At far right, throwing the light switches, is the man who will succeed him, George Chater.

But it is the man in the middle—79-year-old Tom Barrett—who draws you into the picture. Identified as a singer and dancer, he looks every bit the part of an old-time vaudevillian. The graceful pose of his hand, the slightly cocked hat, the perfectly aligned bow tie, and the impeccable clothes all convey a sense of theatrical elegance. It is easy to imagine him soft shoeing across the stage, twirling a cane and singing some old and perhaps even slightly bawdy tune.

Vaudeville—nearly as old as Barrett himself—was all but dead by this time. The Orpheum, like other old vaudeville houses, would soon abandon live stage shows in favor of movies only.

Dispatch / Hi Paul

FEB 2 5 1960

THE ELDERLY CONVICT in his cell listening to a crude radio is Frank Novak. Seventy-seven years old and blinded by glaucoma, Novak had been sent to Stillwater State Prison in 1910 for robbing and murdering a man after a night of drinking in Granite Falls. By the time this picture was taken in 1960, he'd been behind bars for 50 years, longer than anyone else in state history.

A *Dispatch* reporter came out to visit Novak after word got out that he was about to be paroled, the state finally having decided that an elderly blind man posed no dire threat to society. Novak told the reporter that he'd have been better off if he'd been convicted of first-degree murder, rather than second-degree murder, back in 1910. That's because Minnesota didn't abolish the death penalty until 1911. "If I'd been convicted of first-degree murder, I'd rather have been put to death than live in prison for 50 years," he said. "A life sentence is living death, but a death sentence releases a prisoner."

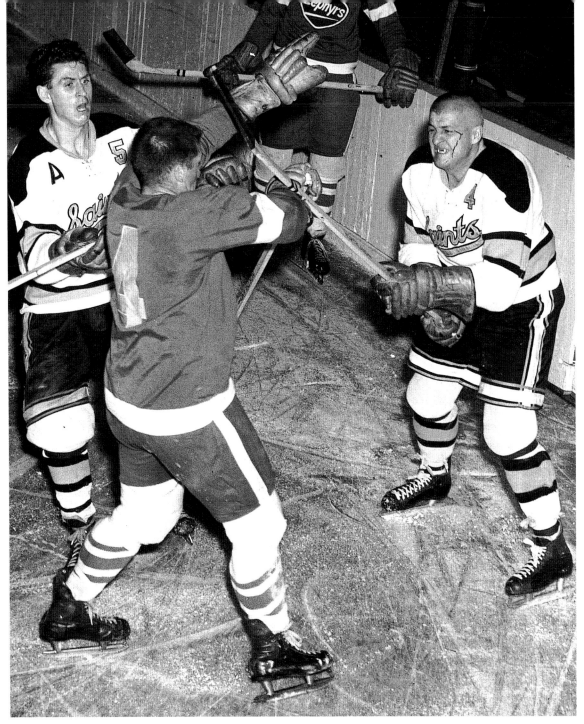

NOV 1 9 1960

Pioneer Press / Buzz Magnuson

BEFORE THE NATIONAL HOCKEY LEAGUE arrived in St. Paul via the Minnesota Wild, a number of minor league teams played in the city at various times. The St. Paul Fighting Saints competed in the International Hockey League in the early 1960s, an era known for its smash-mouth style of hockey. For evidence to that effect, one need only look at this photograph taken at a game in November 1960 between the Saints and the mighty Muskegon Zephyrs.

The rugged-looking customer at right with blood dripping down his face is Jarrin' John Bailey, a legendary "slapshot artist" and fan favorite. Bailey was not known to be shy about mixing it up along the boards, and here he's demonstrating the finer points of high sticking to an unidentified Zephyr. The gaps in Bailey's mouth suggest that he'd suffered quite a number of dental misadventures during the course of his career. Professional hockey at this time was definitely not a sport for the timid, since none of the players typically wore helmets, faceguards, or any of the other protective gear taken for granted today.

144

Pioneer Press / Buzz Magnuson

AUG 1 5 1965

IF YOU LIVE TO THE RIPE OLD AGE OF 100, you're entitled to have pretty much anything you want for your birthday. So when Mary Kowalski of St. Paul reached the century mark, she naturally wanted to meet her television idol—Reggie Lisowski, better known to professional wrestling enthusiasts as the inimitable "Crusher." The gravel-voiced brawler from Milwaukee was one of the most popular grapplers of the time and made a nice living by serving as the official nemesis of that famed apostle of "scientific" wrestling, Vern Gagne. The Crusher had read about Kowalski's birthday wish in the *Dispatch,* so he stopped by her home on the East Side one afternoon before a wrestling match in the Twin Cities.

Kowalski, looking as pleased as she could be, told the Crusher she was "very surprised that you'd come to see an old girl like me." The two chatted in Polish while the Crusher, trademark cigar in his mouth, signed an autographed picture "to my favorite doll, Mary." He told a reporter that Kowalski proved to be "a wonderful hostess. First thing when I come in, she gives me a can of beer and keeps 'em coming."

Kowalski, by the way, was believed to be St. Paul's oldest resident when she died in November 1972 at the age of 107.

145

BIG THINGS

ENTIRE BOOKS HAVE BEEN WRITTEN about America's fascination with the oversized—from food portions to sports utility vehicles. Newspapers have long shared this interest in documenting the unusually large. Over the years, big things—whether animal, vegetable, or mineral—have served as reliable photographic fill in the *Pioneer Press* and *Dispatch,* although the journalistic appetite for images of this kind seems to be waning. The photographs in this section offer a look at four jumbo items that, in the old days, were deemed worthy of publicity.

Back in 1950, the Gopher Diggers 4-H Club crafted their own incredible hulk—a large "vegetable man" made from lettuce, carrots, and other products of nature's bounty. Naturally, a *Dispatch* photographer came out to snap a picture of the big green fellow when he went on display at the Washington County Fair. The two 4-H members admiring their handiwork are Barbara and Richard Teeters of Lakeland, Minnesota.

Dispatch / Aug. 11, 1950 / Ted Strasser

Mrs. Oscar Getchell of St. Paul shows off her pride and joy—a huge Boston variety fern said to be 47 years old. The *Pioneer Press* first photographed the fern in 1940, when it was a mere youngster of 34. "It's like one of the family," Mrs. Getchell said of the plant, given to her mother in 1906 by a St. Paul florist. "I wouldn't part with it at any price."

Pioneer Press / Apr. 12, 1953 / Roy Derickson

In Minnesota, the big fish is a cultural icon, the dream of every angler who's ever set off for a day on the water. Here, from 1960, is a close-up view of a record mud catfish hauled in from the St. Croix River near Stillwater by Al Stoll. A *Dispatch* story said it took Stoll well over an hour to land the 60-pound monster, which was caught with a minnow on a 25-pound test line.

Dispatch / Sept. 28, 1960 / Don Spavin

Not even the Jolly Green Giant ever raised beans like these. Mrs. Jack Gleason of Webster, Wisconsin, poses with four-foot-high beans grown from seeds said to be from Canada. Described as four inches in diameter and "having the appearance of a gourd," the big beans "cooked up much faster than green beans," said Mrs. Gleason, whose other specialties included 50-pound watermelons and super-sized radishes.

Pioneer Press / Oct. 11, 1964 / Earl Chapin

DEAD
OF NIGHT

When the flashbulb was invented in 1930, night photography shed many of its limitations. Light was made as portable and as easy to use as the camera itself. The bulb came along at about the same time as the first versions of the Speed Graphic camera, which was a great advance over its bulky, glass-plate predecessors. Armed with this new equipment, press photographers in particular began to work the night, certain that they could grab a shot in even the darkest environments. Tabloid newspapers—the New York *Daily News,* started in 1919, was the first—were particularly quick to exploit this new opportunity.

Night photographs taken with the Speed Graphic have a look all their own. The camera's big flash casts a sharp, harsh light in which images seem almost to be carved out of the encircling darkness. With their brutally unnatural light and deep shadows, these pictures inevitably convey a sense of melodramatic, intensified reality—the essence of the "noir" look.

Before "breaking" news was largely ceded to local television, the *Pioneer Press* and *Dispatch* always maintained an overnight photographer who roamed the city and its environs in search of whatever he could extract from the darkness with the Speed Graphic's powerful flash. If the night photographer got something good, he'd race back to the newspaper office and develop the film. Depending on the hour, the pictures could be used in the morning *Pioneer Press* (its last deadline was around 1 A.M.) or the afternoon *Dispatch*. Although routine assignments sometimes fell to the night photographer, "spot" news—the usual mayhem, in other words—was always a top priority.

Looking at these photographs today, a viewer might be tempted to conclude that St. Paul was once a kind of nightmare world after dark, haunted by lurid spectacles of crime and disarray. It wasn't so, of course. Good photographers have a way of finding what they're looking for, and the night cruisers weren't much interested in pictures of ordinary life, which in St. Paul then—as now—tended to be decidedly sedate in the wee hours of the morning. Weegee had roiling, round-the-clock Manhattan as his sinister playground, whereas St. Paul's nocturnal photographers often had to work hard to find something of interest after the sun went down.

Still, things did happen now and then in quiet old St. Paul at night, and the early to mid-1950s in particular seem to have generated more than their share of sensational events. Some of the newspapers' greatest spot news photographs date from these years, not just because big stories "broke" but because the night photographers were in a position to get to the scene quickly and capture the moment. There were huge fires in old buildings and churches, spectacular auto wrecks on dark suburban highways, and the usual quotient of murder, assault, and miscellaneous thuggery. And because the *Pioneer Press* and *Dispatch* photographers typically had instant access to the scene of the action, they were able to capture pictures that show in intimate detail what St. Paul (and in some cases, Minneapolis) looked like, long ago, in the dead of night.

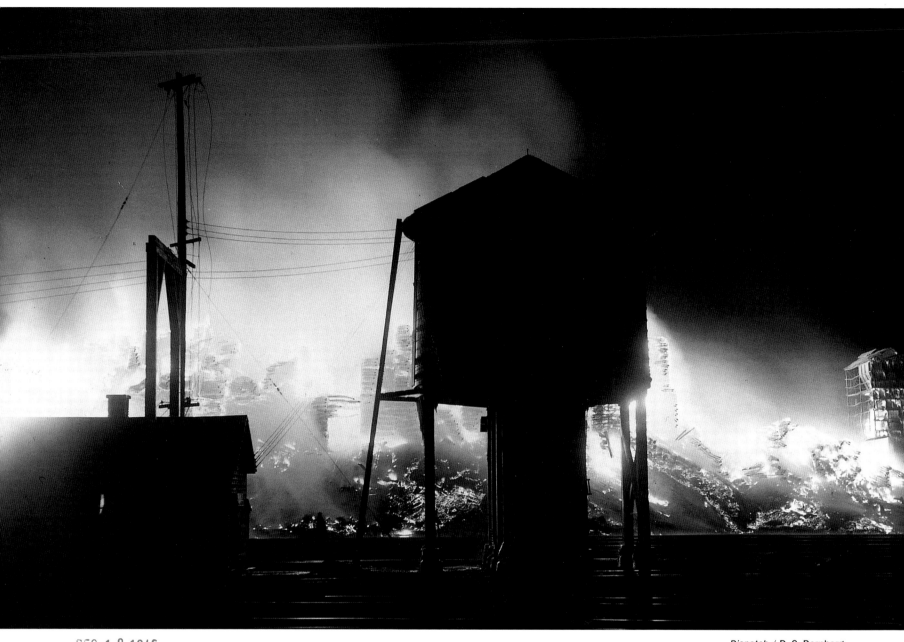

DEC 1 9 1946

Dispatch / D. C. Dornberg

THIS EERILY BEAUTIFUL PHOTOGRAPH shows part of a huge fire that raced through a grain elevator in southeast Minneapolis just before Christmas in 1946. The fire was very intense, feeding on both the elevator itself and the grain stored inside. At one point, the *Dispatch* reported, "blazing streams of lava-like barley" poured from the elevator, owned by the Froedterf Grain and Malting Company. It must have been quite a spectacle.

The elevator was located beside tracks belonging to the Great Northern Railway. Note how the tracks—there are at least seven sets—shimmer in the light of the fire. Steam was still the motive force for most trains in 1946, and cylindrical water towers like the one centered here were a common sight along the tracks. The tower survived the fire, but the elevator was a total loss.

BEFORE URBAN RENEWAL and the construction of upscale condos, downtown St. Paul was chock-full of Victorian-era residential hotels and apartments, mostly inhabited by the elderly and people of limited means. The four-story Frontier Building at the southeast corner of Fourth and Robert Streets was among the oldest of these apartment blocks, dating to 1880 and known for many years as the Minor Hotel. In the early morning hours of July 28, 1959, the building caught fire, forcing many of its 27 residents—mostly older women—to flee down fire escapes and ladders.

Photographer Spence Hollstadt caught this dramatic scene at the height of the fire. As 50-year-old Alvina Berg makes her way down a fire escape, a woman on the floor above climbs out of her apartment onto a metal balcony. Farther above, on the top floor, a third woman (circled) looks out from her smoke-filled room, where there appears to be no fire escape, and screams for help. According to the *Dispatch,* 300 spectators "watched in anxious horror as one person after another, some flopping limp in unconsciousness, were carried down the long fire ladders."

Despite heroic rescue efforts by firemen, one woman was found dead in her fourth-floor apartment, and three other women later died from smoke inhalation. The Frontier Building was subsequently demolished, and a new federal courthouse was constructed on the site seven years later.

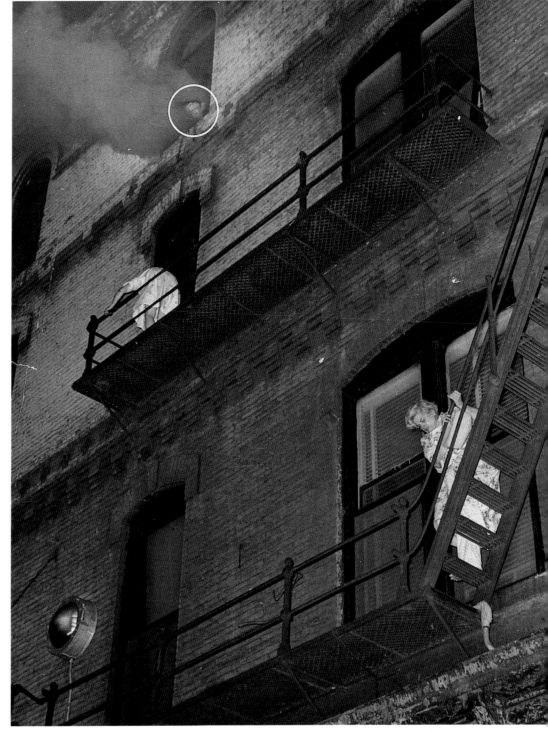

Dispatch / Spence Hollstadt

JUL 2 8 1959

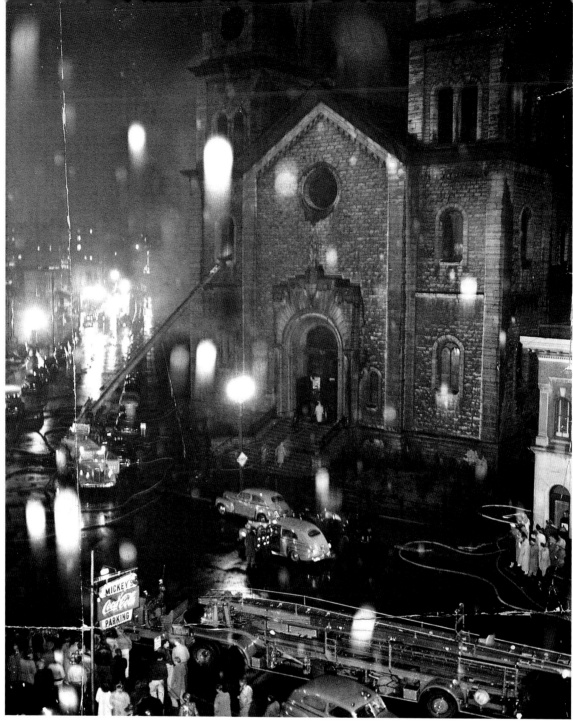

APR 2 1 1951

Pioneer Press / Dick Magnuson

NIGHT FIRES, with their color and drama, have always drawn news photographers like the proverbial moth to the flame. Here are pictures of two historic church fires, with very different outcomes, that made big news in the early 1950s.

The first photograph shows a fire at Assumption Catholic Church in downtown St. Paul in April 1951. The two-towered stone church, built in 1874, was even then one of the city's oldest places of worship. This atmospheric, rain-obscured photograph by Dick Magnuson shows police and fire vehicles in front of the church on what was then Ninth Street (today it's Seventh). Note the tangle of fire hoses as well as the fire ladder extending up to a window beneath one of the towers.

Prowlers looking to steal money from offering boxes apparently started the fire, which caused about $65,000 worth of damage, much of it to the church's pipe organ. Even so, Sunday masses were held at the church just two days later, and Assumption is still going strong today. So is one of the neighborhood's other monuments—Mickey's Diner—a sign for which is visible above the crowd gathered at lower left.

Over in downtown Minneapolis, another historic stone church did not fare as well in its encounter with fire. St. Olaf's

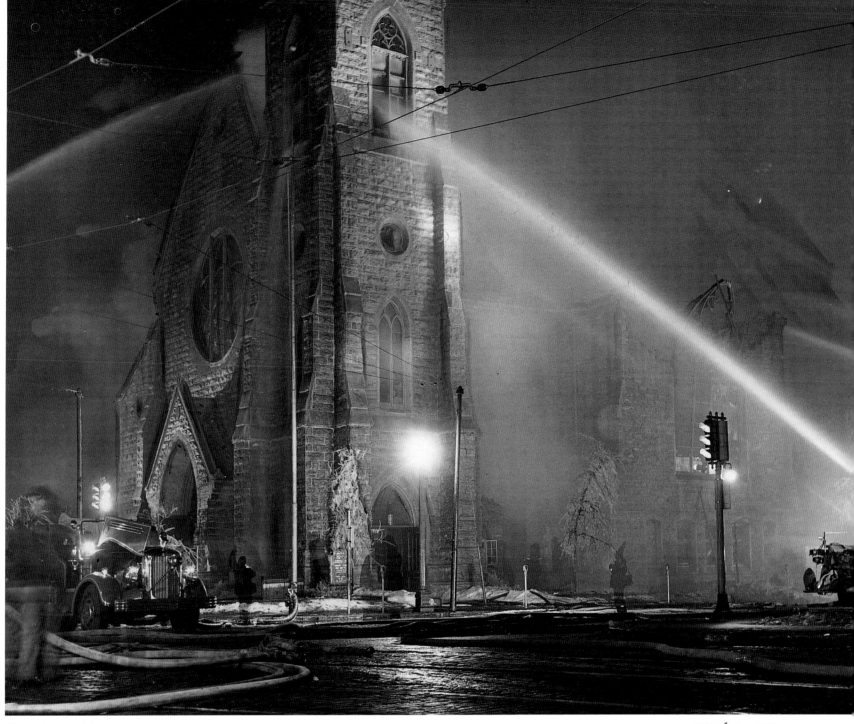

Pioneer Press / Sylvan Doroshow

FEB 1 9 1953

Catholic Church at Eighth Street and Second Avenue South dated to 1880, when it had been built by a Protestant congregation as the Church of the Redeemer. Its most prominent feature was a 200-foot-high spire that once dominated the southern end of downtown. St. Olaf's purchased the building in 1940 and some years later refurbished it at a cost of $300,000. Then the unthinkable happened.

At around ten o'clock on the night of February 18, 1953, not long after worshipers had filled the church for Ash Wednesday masses, a fire broke out in the attic. By the time the alarm was sounded, the *Pioneer Press* reported, the fire "had made great headway through the 75-year-old church's massive timbers." The fire quickly roared out of control, shooting flames 100 feet high and creating a glow that attracted spectators from across the city. WCCO-TV even provided a live broadcast of the fire.

Two firemen were injured, one critically, before the blaze was finally extinguished. But the church was a ruin, and the city ordered its immediate demolition because of fears that remaining walls could topple at any time. St. Olaf's later built a new church on the site.

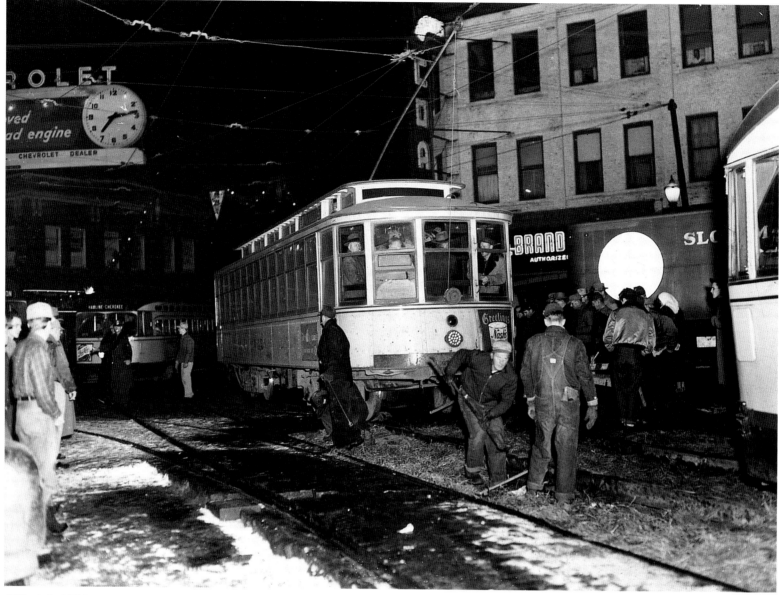

DEC 1 1 1951

Pioneer Press / Sylvan Doroshow

INCLEMENT WEATHER COULD ALSO CAUSE HAVOC
in the dead of night, and that's the case here, as workers try to put a derailed streetcar back on the tracks in December 1951 following a snowstorm that coated streets with a treacherous layer of ice. This photograph was taken looking northwest on Wabasha Street toward the intersection of Rice Street and University Avenue in St. Paul.

The trolley jumped the tracks as it came up Wabasha and tried to turn on Rice. Before long, 30 streetcars were backed up behind it all the way through downtown. Note the bundled-up riders at the back of the stalled streetcar, while outside a crowd of sidewalk superintendents watches the work crews in action.

Much of downtown was left in a snarl by the snowfall, and this photograph serves as a reminder that the combination of bad weather and bad traffic has been around for a long time.

154

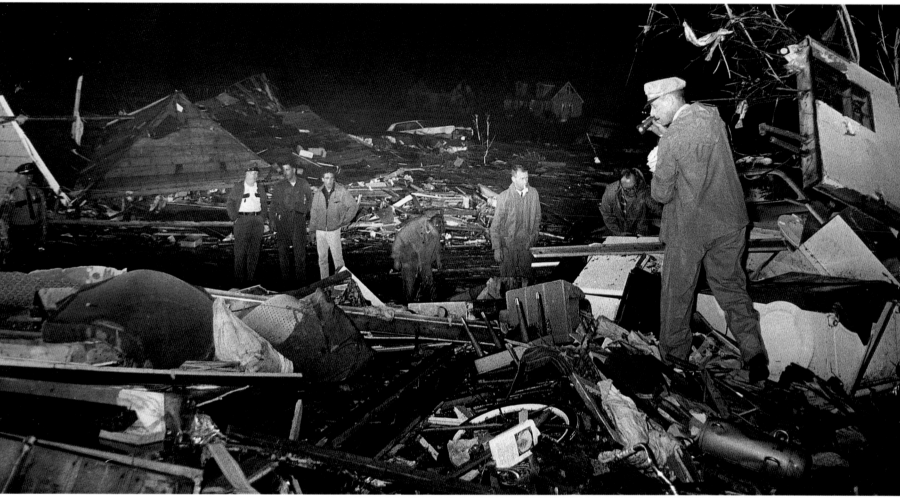

Dispatch / Tom Young

MAY 0 7 1965

SOME OF THE TEN OR SO TORNADOES that roared though several Twin Cities suburbs on May 6, 1965, struck at nightfall, adding to the difficulty of finding victims trapped in the wreckage. Here's a scene taken at midnight in a Mounds View neighborhood that had been pulverized just hours before by a tornado that probably packed winds in excess of 200 miles an hour. The man with the flashlight is a Ramsey County sheriff's deputy named Roland Rentz. He's searching through what remains of a house on Knollwood Drive belonging to a friend and fellow deputy who was found injured nearby.

The tornado's power is evident from the damage it caused. Note the flattened house at rear and, behind it, a car that looks to have been tossed up on a pile of debris. Note also the section of a house's wall lodged into a stripped tree at right. Minnesota Governor Karl Rolvaag went out immediately to tour the hardest-hit areas and memorably described the situation as "utter, sheer, total disaster."

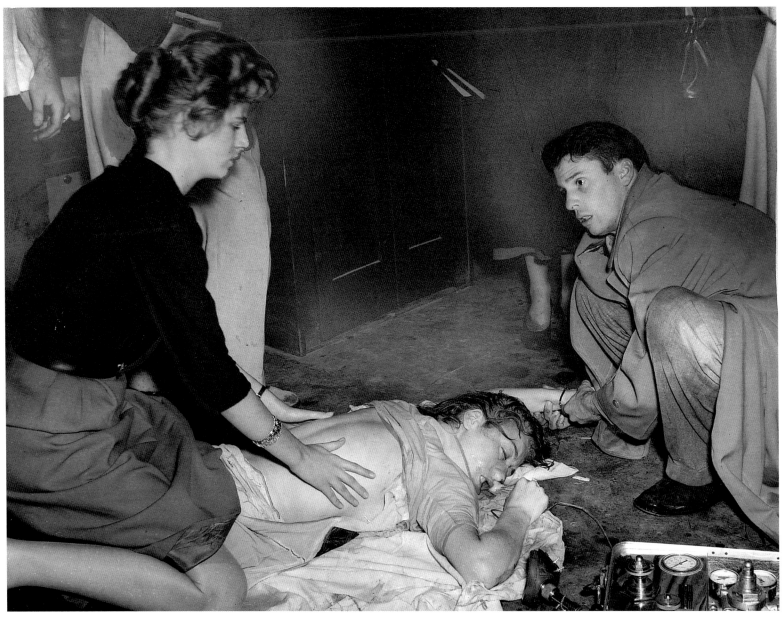

NOV 0 7 1955

Dispatch / Sylvan Doroshow

ON A NOVEMBER NIGHT IN 1955 six Minneapolis women ranging in age from 21 to 30 attended a dance at the River Road Club in Mendota. The club, a roadhouse popular with young people, was located just upstream from the Mendota bridge on a steep embankment above the Minnesota River.

The women, who had come in one car, left the club when it closed at one o'clock in the morning. Their car was parked in the club's lot, facing the river, and the roads were treacherous with ice. A witness said that after the driver started the car, it "seemed to shoot across the road and drop out of sight" down the embankment. Rolling over several times, it landed wheels up in the Minnesota's murky water. One woman managed to crawl out through

an open window and was pulled to safety by a bystander. The other five women were trapped inside the submerged vehicle. Witnesses rushed to help, but no one seemed certain what to do as they waited for fire and police units to arrive.

A 22-year-old St. Thomas University student and U.S. Army veteran from St. Paul named John Settergren then went into action. Using a hose as a makeshift rope, Settergren wrapped it around his waist and made his way down to the river. "The lights of the car were shining but I couldn't see the car," he later said. Diving repeatedly into the water, he managed to force open one of the car's doors and pull out four of the trapped women.

156

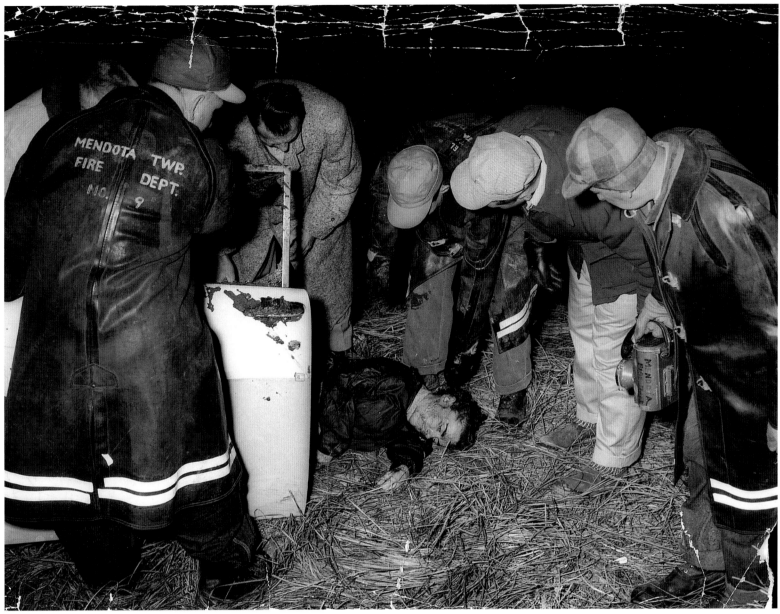

Dispatch / Sylvan Doroshow

NOV 0 7 1955

One by one the victims were carried back up to the club, where bystanders and firemen worked to save them. Photographer Sylvan Doroshow had arrived by this time and took a dramatic picture that shows 21-year-old Nancy Frasier of Minneapolis trying to resuscitate one of the victims (using the approved method of the time) while an unidentified man checks for any sign of a pulse. "The scene inside the club was one of confusion as police, firemen and spectators rushed in and out the door while rescuers worked feverishly over the limp bodies," the Dispatch reported. All their efforts proved futile. Meanwhile, members of the Mendota Township Fire Department and other rescuers had managed to pull the car out of the water.

Caught in the Speed Graphic's harsh circle of light, the body of the fifth and last victim lies on the grass as the firemen gather around her.

The dead women were later identified as Margaret Miskowiec, 30, and her 28-year-old sister, Delores; Ruth Ann Pulkrabek, 21; Caroline Krasick, 21; and Ann Mairs, 28, who owned the car. In March 1956, five months after the accident, there was a small, happy footnote to this terrible accident. The sole survivor, 24-year-old Donna Mae Wills, announced that she would marry William A. Mathias, 26, the man who had pulled her out of the water.

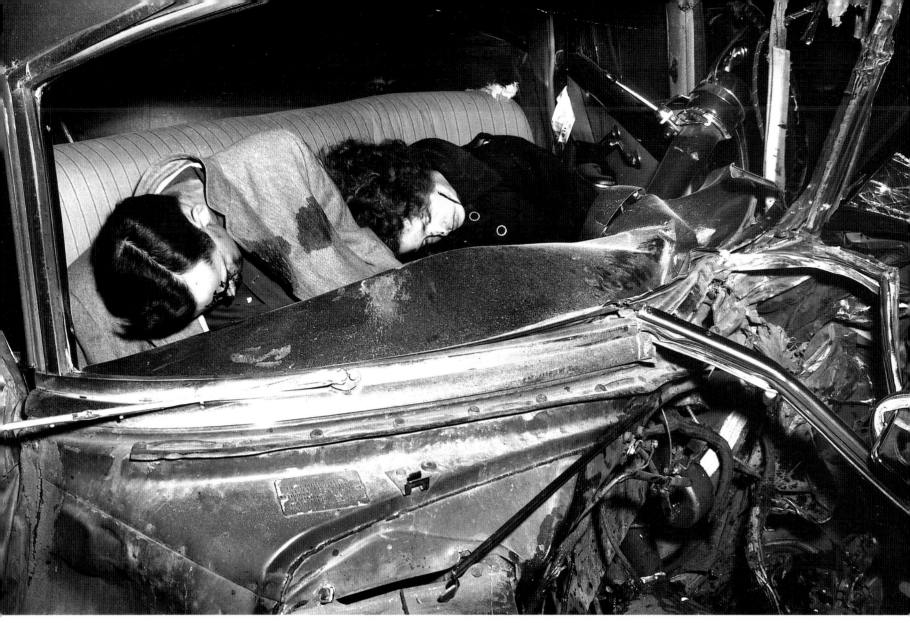

FEB 1 8 1957

Pioneer Press / Dick Magnuson

THE 1950S WERE A TIME of unparalleled highway carnage because of high-powered cars, overcrowded roads, and the lack of such rudimentary safety equipment as seat belts. Here is a startling photograph of Minnesota's 71st and 72nd traffic fatalities of the year in 1957.

Robert and Beverly Maalis were newlyweds from Minneapolis, he 31 and she just 18, on their way home in the early morning hours of February 17. She was behind the wheel, driving on Highway 36 in Roseville near the Hennepin County line. In those days, the highway made a sharp curve as it passed over the tracks of the Minnesota Transfer Railroad. Mrs. Maalis missed the curve, and the car veered out of control before slamming into an abutment at an estimated speed of 70 miles an hour.

Photographer Dick Magnuson, prowling the night, went to the scene and shot this picture of the couple, both dead, slumped over in the front seat almost as though sleeping. But the blood and the mangled car— note how the force of the impact wrenched the steering wheel out of position—leave no doubt as to what happened.

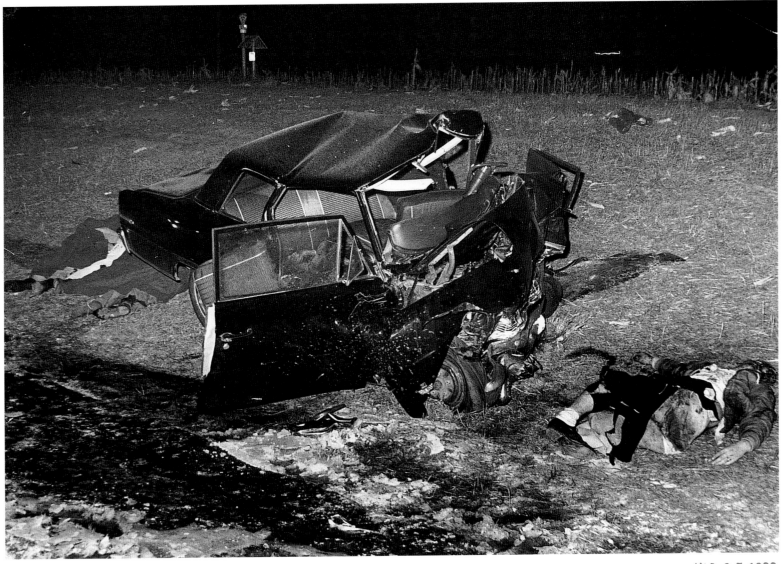

Pioneer Press / Neale Van Ness

MAR 0 7 1966

THIS PHOTOGRAPH OF THE SLAUGHTER left behind by an accident in 1966 is one of many such pictures taken at a time when large, fast cars collided on heavily traveled two-lane highways around the Twin Cities. The crash occurred just after midnight on Highway 61 and left seven people dead, including five young people from Forest Lake whose bodies still lay scattered around their ruined automobile when photographer Neale Van Ness took this picture. The five young victims—identified by the *Pioneer Press* as Howard L. Nielsen, Patricia Ann Johnson, James D. Berggren, Gordon W. Marcott, and Michael Rarden—ranged in age from 18 to 22. One passenger, a 17-year-old boy,

survived with multiple injuries. The occupants of the other vehicle— John K. Froberg and his wife, Sylvia P. Froberg, both 41, of Lindstrom—were also killed when the youths' car apparently crossed the center line.

The violence of the impact is evident from the amount of damage to the errant car, which was left with its front end "rolled up almost to the windshield," as the newspaper put it. A veteran Minnesota Highway Patrol officer said that "he couldn't remember a worse accident in this area in terms of lives lost." This grisly picture, incidentally, was published on the front page of the *Pioneer Press.*

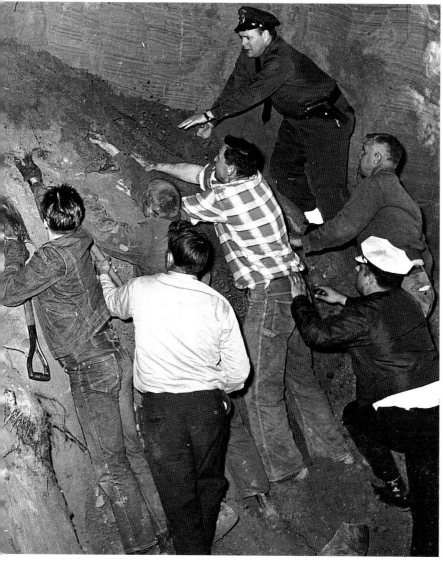

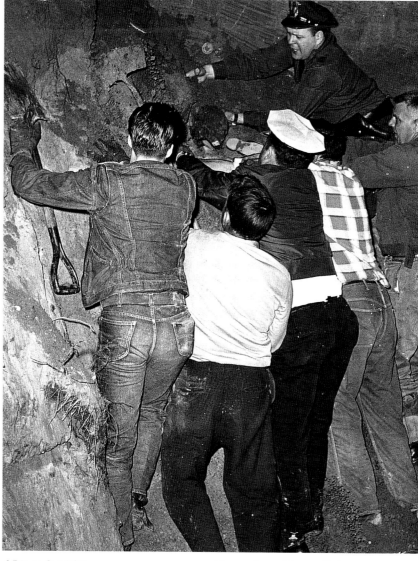

APR 0 6 1963 *Pioneer Press* / Spence Hollstadt

APR 0 6 1963 *Pioneer Press* / Spence Hollstadt

NO ACCIDENTS ARE MORE HEARTBREAKING than those that claim the lives of children. The photographs on these two pages show in painful detail the desperate effort to save a five-year-old boy from West St. Paul trapped under tons of sand. The boy, Brian Vassar, had gone out to play one evening on a steep embankment right behind his house. He and two older brothers had dug out a hollow in the 20-foot-high bluff. Just as darkness was settling in, one of the brothers came home to report that Brian had been buried by a sudden cave-in.

The rescue attempt was captured by photographer Spence Hollstadt in a sequence of pictures. The first two were taken just as rescuers—police and firemen, along with neighbors—find the boy's body after nearly an hour of digging. By this time, the men have largely abandoned their shovels and are clawing at the heavy sand as they work to free the boy. In the third photograph, two firemen carry Brian to a resuscitator in hopes of reviving him. Their efforts failed, however, and the boy was pronounced dead at the scene. Note the onlookers and another photographer in the background, stationed within a few feet of the rescuers. This sort of proximity to disaster was common for news photographers at the time.

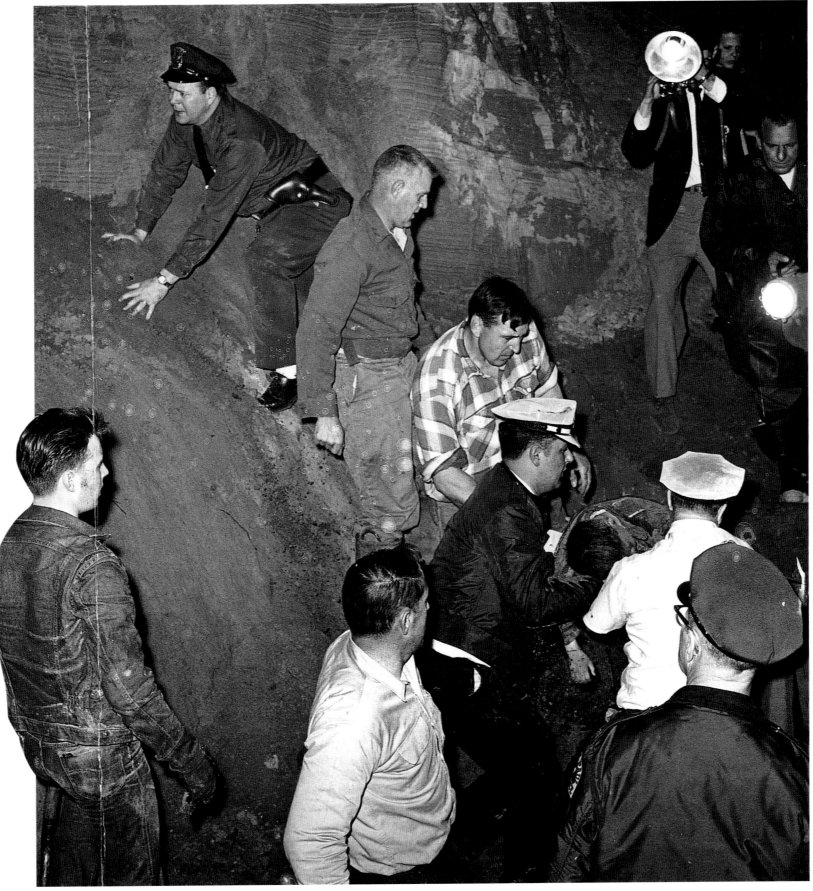

APR 0 6 1963

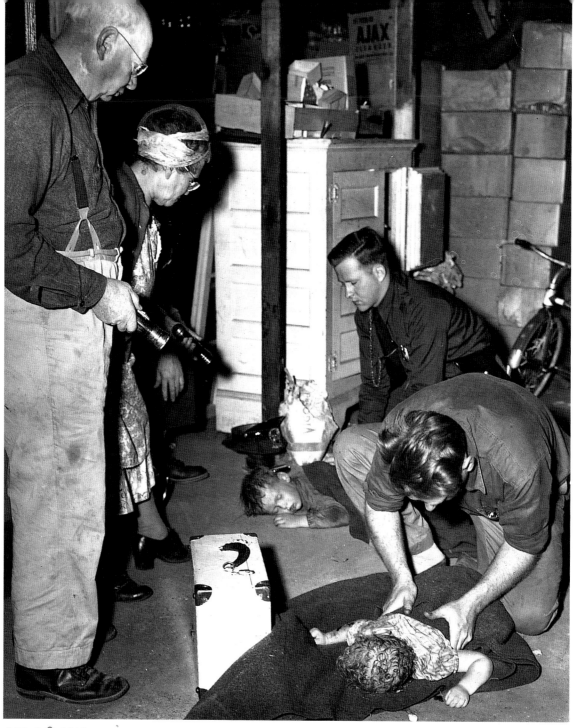

SEP 0 2 1949

Pioneer Press / Sheldon Menier

AFTER THE PASSAGE OF OVER HALF A CENTURY, this remains a photograph that is very difficult to look at. Two children— five-year-old Franklin Sherer and a two-year-old girl named Sandra whom the boy's parents planned to adopt—lie dead on the floor of a garage next door to their home on St. Paul's East Side. A police officer and another man work in vain to resuscitate the children as other neighbors stand by with flashlights.

The youngsters had wandered into the garage and then accidentally locked themselves inside the old icebox behind them, each in a separate compartment. By the time the boy's father found them three hours later after a frantic search, both youngsters had suffocated.

This photograph was taken by a man who lived nearby, before fire rescue units reached the scene. A *Pioneer Press* photographer also arrived a few minutes later and took a picture of the boy's stunned father, Stanley Sherer, as firemen began their futile revival efforts. Three photographs of the tragedy, including the one here, appeared the next morning on the front page of the *Pioneer Press,* along with a detailed account of the accident. It is highly unlikely that a picture like this would be published by most newspapers today, although its emotional impact is undeniable.

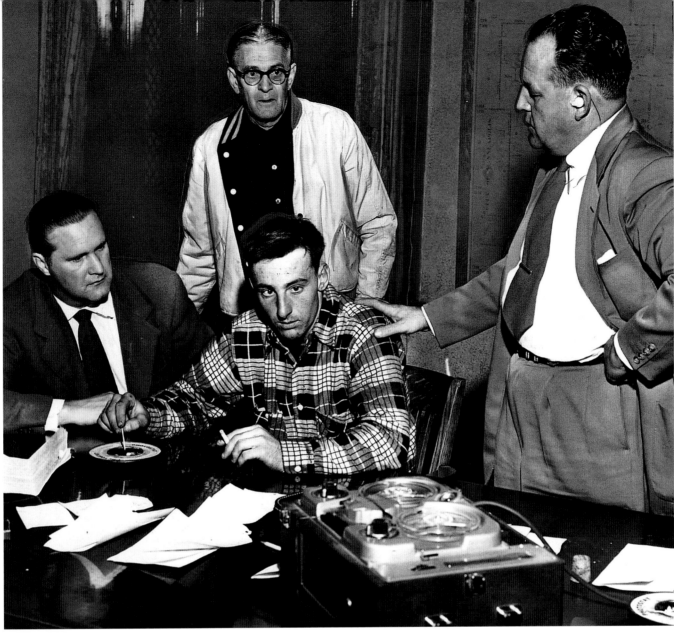

Pioneer Press / Dick Magnuson

OCT 0 6 1952

SEXUAL PREDATORS were a threat to children in the 1950s, just as they are today, and men suspected of such crimes received no mercy from the press or public. An especially brutal incident made headlines in 1952 when a six-year-old New Brighton boy was dragged away from his school during recess, molested, beaten, and then left for dead next to a culvert.

Over the next four days, authorities launched what the *Pioneer Press* described as "the most intensive manhunt in the history of Ramsey County." A suspect was quickly identified, but the man hid out for three days before he surrendered to police at the home of his mother and stepfather in Columbia Heights.

Once the police had their man, the publicity machinery of the era moved into high gear, making sure everyone got a good look at the 20-year-old suspect. His name was Charles Hentges, and here he is under the bright lights delivering his confession to, from left, Lieutenant Gordon Blade of the St. Paul Police Department and two Ramsey County sheriff's deputies, Norton Risedorph and Kermit Hedman (later sheriff for many years).

The *Pioneer Press* said Hentges told interrogators that he was drunk at the time of the attack but that he'd also had an "urge to kill" for many years. His mother was later quoted as saying she didn't think there was "anything wrong mentally" with Hentges. The courts disagreed. Hentges was sentenced to ten years in prison for attempted murder but was later sent to St. Peter State Hospital after being diagnosed as a "psychopathic personality."

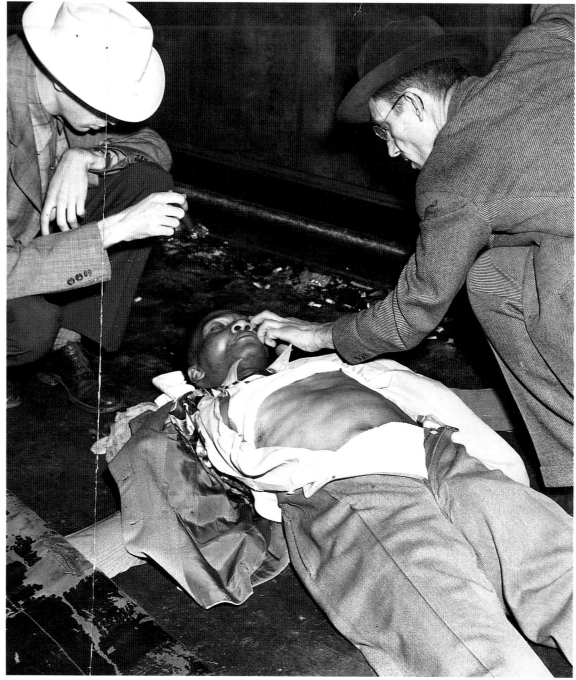

JUN 0 3 1946

Pioneer Press / Ralph Welch

ONE NIGHT IN 1946 at a tavern in St. Paul's old Rondo neighborhood, Reginald Hopwood got into a dispute, the exact nature of which is lost to history but which apparently involved a woman. Hopwood, 35, was shot in the right side (note the clearly visible bullet hole) and fell to the floor, badly wounded.

A cruising *Pioneer Press* photographer and a reporter arrived shortly after the police to check out the shooting. They waltzed right into the crime scene as Dr. James Byram, at right, a police surgeon, was examining Hopwood. Such was the level of cooperation between the press and the police in those days that the fellow holding the small flashlight for Byram is none other than a *Pioneer Press* reporter named Everett Peterson. A story two days after the shooting said Hopwood was in "slightly improved" condition at Ancker Hospital and that police were still trying to piece together the story of what happened.

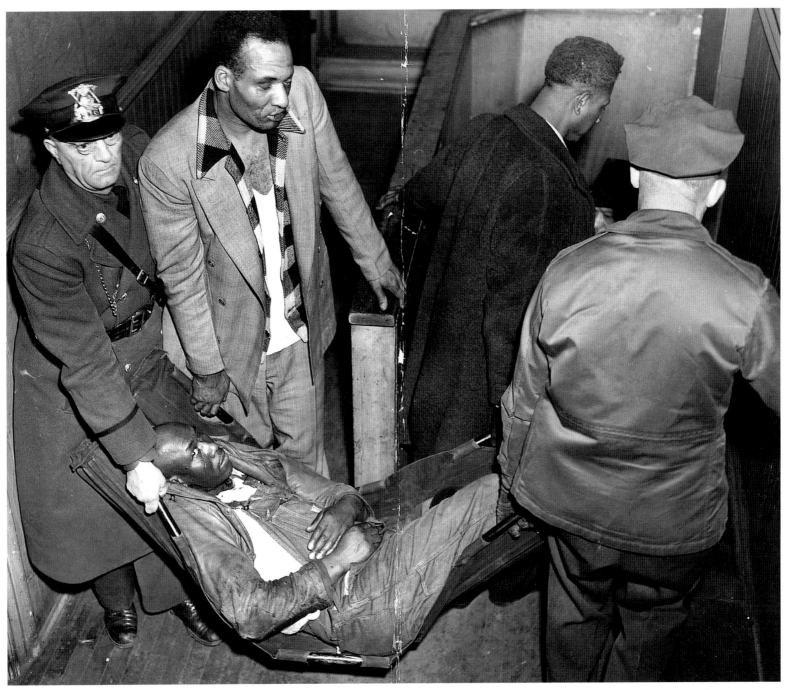

Dispatch / Larry Anderson

APR 2 3 1947

THE HOUR IS LATE, the scene is a seedy downtown St. Paul apartment building, and the man being hauled down a narrow stairway has been shot by a bullet intended for someone else. The wounded man is John Henry Moore, 41. He was shot in the neck at the apartment of a friend who'd argued earlier with the assailant.

The bullet left Moore paralyzed on one side of his body, and the doleful look he's directing at the photographer suggests he may well have known, or suspected, his fate. Note also the wearily expressive face of the police officer at left who's helping carry Moore down the steps. The officer and the other stretcher bearers in the picture aren't identified.

It doesn't appear this photograph ever ran in the newspapers, but notes attached to the back of the print by photographer Larry Anderson are interesting: "Got call on my way home on my radio . . . shooting at 7th and Broadway . . . assailant missing . . . party shot thru neck [taken] to ancher hosp [Ancker Hospital] . . . being carried out of the room down the stairs . . . none too much of a hurry to get him to ancher."

165

DEC 2 0 1948

Pioneer Press / Ted Strasser

HERE, FROM DECEMBER 1948, is another reenactment picture of the kind often used during the Speed Graphic era. The man posing in the trunk is Joseph Ehnes, 59, of St. Paul, who clearly was not having a merry Christmas season. Described by the *Pioneer Press* as a "5-foot-1-inch dental technician," Ehnes told police he was robbed, beaten, and kidnapped by two men who had accosted him in the parking lot of a bar on St. Peter Street, then a rough part of downtown St. Paul.

The picture was taken in the St. Paul Police Department's garage, where the car had been towed after Ehnes's abductors abandoned it during another attempted kidnapping. Ehnes, too frightened to make a sound, wasn't discovered until an officer pried open the trunk. "For about 10 seconds after police lifted the trunk cover, Ehnes made no move," the *Pioneer Press*

said. "Officers feared he was dead. Then he blinked his eyes." All told, Ehnes spent about five hours in the trunk and was described as being "numb from the cold" when police finally freed him. Despite his ordeal, Ehnes climbed right back into the trunk so that photographer Ted Strasser could snap this picture, which ran on the front page.

Ehnes suffered two black eyes and cuts and bruises in the attack. His assailants, meanwhile, escaped the police after their unsuccessful attempt to abduct a young woman. The *Pioneer Press* concluded its story by noting that "police are holding Ehnes until he recovers from shock and is able to tell a more detailed story. Ehnes admitted having several drinks downtown before starting home."

THIS IS LYLE SLAWSON, 52, of St. Paul, and he's just shot his wife and himself after what the *Dispatch* described, perhaps inadequately, as a "marital tiff." As disagreements go, it was certainly intense, judging by Slawson's bloody, bandaged face. The bandage covers a long furrow where the bullet he'd fired at himself skipped across his forehead without inflicting serious harm. His 38-year-old wife, Dorothy, shot in the face, was in far more serious condition and was already on her way to Ancker Hospital when this photograph was taken.

Note that Slawson is holding what are presumably his wife's shoes and other articles of clothing. Slawson, who was also taken to Ancker, may have intended to bring them to his wife. The police officer is unidentified but the look on his face suggests he's seen this sort of thing before.

The *Dispatch* reported that the shootings "occurred about 1:40 A.M. as the couple sat in the kitchen of their second-floor apartment drinking beer at a table bedecked with tulips." Perhaps flowers and alcohol don't mix. Police never determined exactly what the argument was about, but a woman living downstairs told the newspaper that after Mrs. Slawson was shot, she cried out: "Why did you shoot me? I don't want to die. Give me the gun and I'll shoot the dog, too." Not wishing to alarm animal lovers, the newspaper concluded its story by noting that the couple's "mongrel dog" was being cared for by a neighbor.

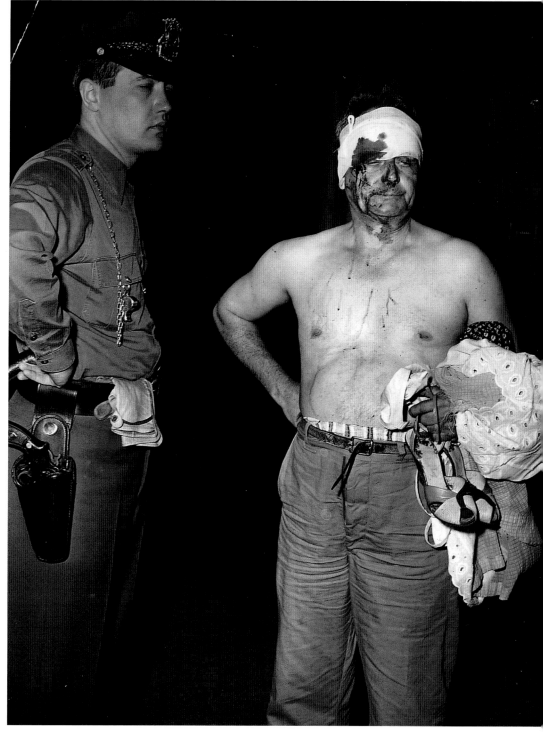

Dispatch / Dick Magnuson

MAY 3 1 1954

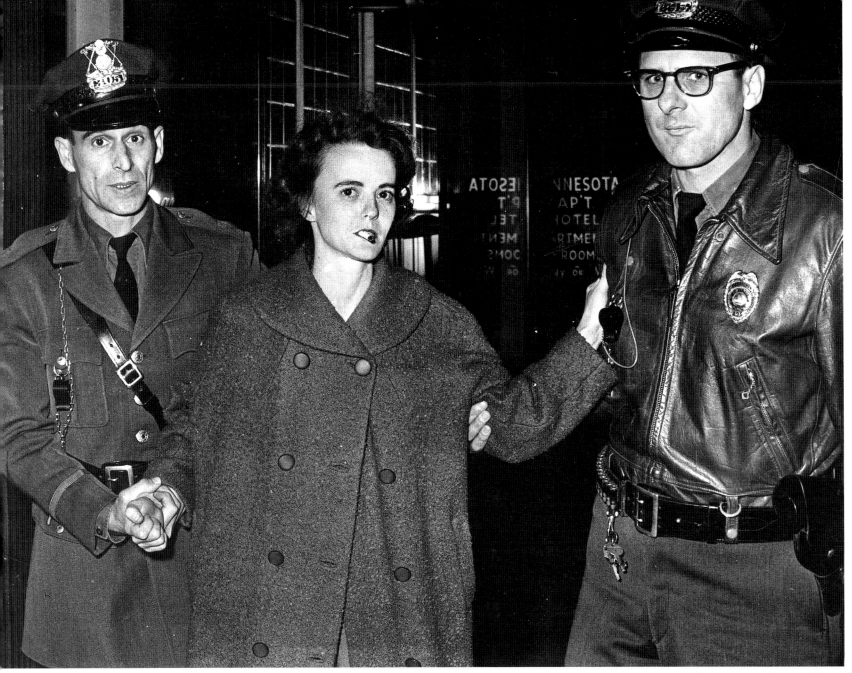

OCT 2 7 1961

Pioneer Press / Spence Hollstadt

HER NAME IS UNKNOWN, but she was having a very bad night when this photograph was taken in October 1961 outside the Minnesota Hotel in downtown St. Paul. She'd checked into the hotel, not one of the city's more elegant establishments, at three o'clock in the afternoon. A few hours later, after arguing with what the *Pioneer Press* described as a "man friend," she was perched on a ledge three stories above Fourth Street and threatening to jump.

Police and firemen finally talked her down, after which she was taken away to Ancker Hospital by two unidentified St. Paul police officers. She was scheduled for a "mental examination" at the hospital but doesn't look too happy about having survived her brush with suicide.

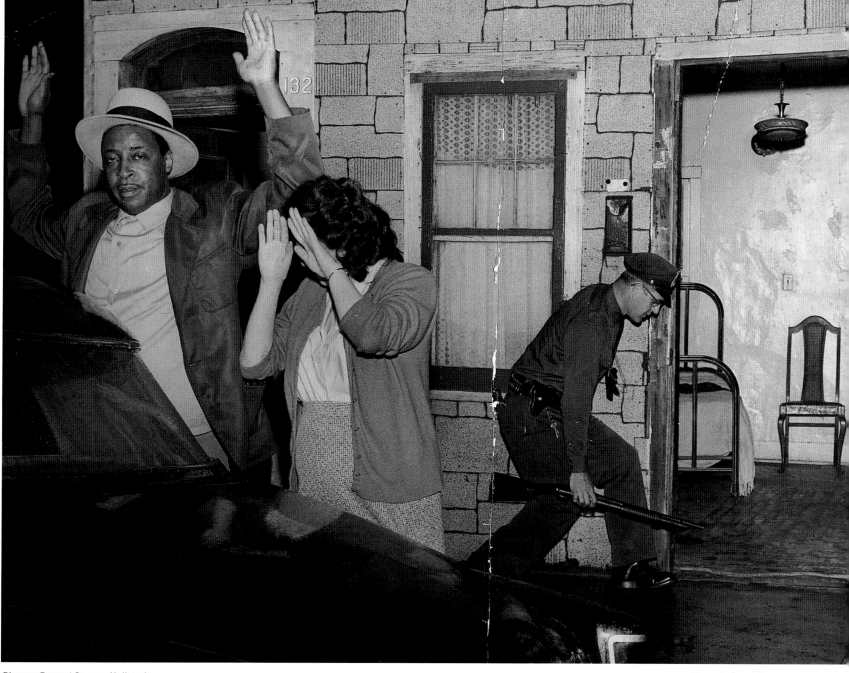

Pioneer Press / Spence Hollstadt

MAY 2 9 1960

IT WASN'T QUITE THE OK CORRAL, but one night in May 1960 a noisy gun battle broke out on State Street in the heart of St. Paul's old West Side Flats. There was the usual trifecta of drinking, arguing, and taunting before the bullets started to fly. One of the combatants, 40-year-old William Amos, has his hands up as St. Paul police patrolman Vernon Michael, shotgun at the ready, prepares to enter Amos's house.

Amos told police two men in their twenties, and their 73-year-old father, had followed him to the house from a nearby tavern and threatened to kill him if he came outside. "I'm an American citizen and no one can tell me I can't come out of my house," Amos told police by way of explaining what happened next.

Armed with a .38 caliber revolver, Amos went out to confront the men. In the ensuing gun fight, he managed to wound all three men (none seriously) before police arrived to break up the Wild West show. Photographer Spence Hollstadt must have been right on the heels of the police, since he was able to capture this picture moments after Amos and an unidentified woman surrendered.

NOV 3 0 1963

Dispatch / Spence Hollstadt

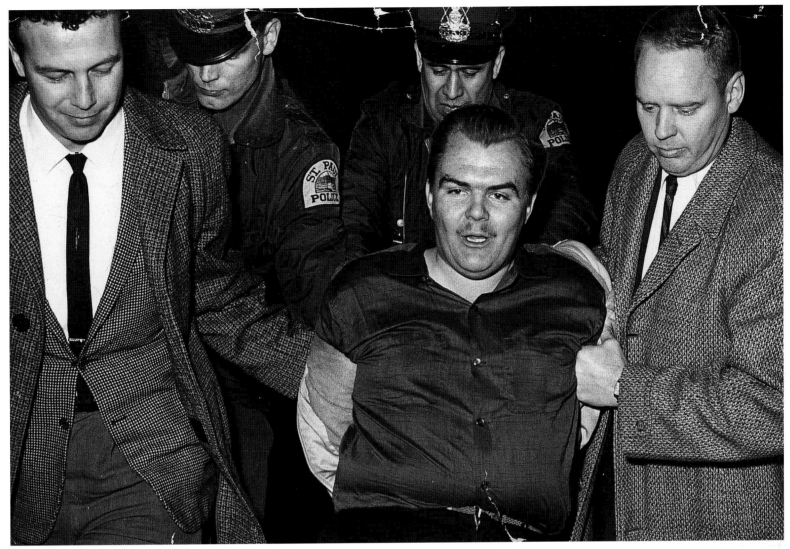

Dispatch / Spence Hollstadt

NOV 3 0 1963

IN THE EARLY MORNING HOURS of November 30, 1963, Wayne Noel Dahlstrom, 23, walked up to a supermarket on Thomas Avenue in St. Paul and blasted out six windows with a shotgun. Next, he went to a nearby bar, which like the supermarket was closed for the evening, and blew out two more windows. Then he left, apparently to rearm. Police, meanwhile, arrived to find the shattered windows and Dahlstrom's shotgun lying in front of the bar.

As officers questioned witnesses, Dahlstrom returned with an automatic rifle. Two policemen, showing commendable restraint, tried to calm Dahlstrom. His response was to fire a shot at them after allegedly screaming, "Are you lousy cops yellow? Why don't you come get me?" Rest assured, they did, and photographer Spence Hollstadt was on hand to record the action.

In the first picture, Dahlstrom leans against a tree moments after a police bullet caught him in the buttocks. St. Paul police officer Robert Lee, pistol drawn, is coming up from behind to subdue Dahlstrom. Despite his painful wound, Dahlstrom was still performing his tough guy act when a phalanx of uniformed officers and two detectives, Bob Page (left) and Don Trooien, hauled him away to jail.

It was later discovered that Dahlstrom, who seems to have had some anger-management problems, had shot out the supermarket's windows because he was upset about a letter from an attorney demanding payment for damages he'd caused to the same windows a few months earlier.

JAN 0 8 1962

Pioneer Press / Buzz Magnuson

HERE'S ANOTHER EXAMPLE of the extraordinary access to crime scenes that news photographers once enjoyed in St. Paul and elsewhere. This photograph was taken in January 1962 in the basement of the Gordon and Ferguson, Inc., building (later known as Sibley Square at Mears Park) in the Lowertown District of St. Paul. It's a Sunday night and just minutes earlier a St. Paul police patrolman had spotted a young man hanging around the building's loading-dock door. Investigation revealed that the door had been forced open. Reinforcements in blue arrived and soon found two other men hiding in the basement.

Photographer Buzz Magnuson wasn't far behind and recorded the scene not long after the arrests. Two of the burglary suspects are handcuffed around thick concrete columns while a third—presumably the lookout—is cuffed with his hands behind his back at left center. The suspects were identified as Donald T. Bergman, 21, James E. Sokol, 18, and Clarence R. Ellsworth, 24, all of St. Paul. *Pioneer Press* editors liked this photograph enough to display it on the front page, not exactly the sort of publicity the three young men are likely to have appreciated.

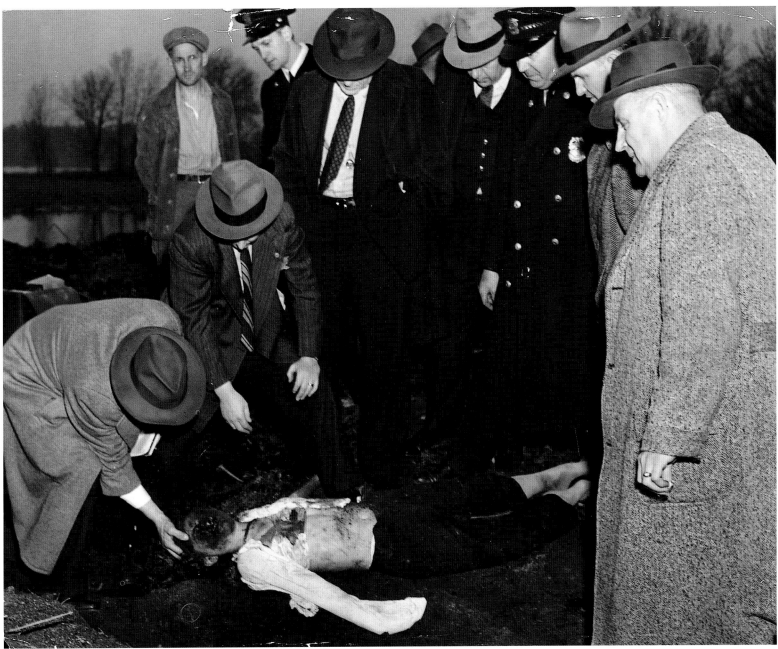

Dispatch / photographer unknown

APR 3 0 1943

MURDER WAS, OF COURSE, THE WORST CRIME of all in the dead of night, and news photographers made it a point to snap pictures of just about every corpse that turned up. This 1943 photograph of a murdered woman is unusually gruesome even by the show-it-all journalistic standards of the time, and it's possible it never ran in the newspaper. However, other pictures of the crime scene were published in the *Dispatch*.

The dead woman is 30-year-old Ruth Shableau, who was found at a city dump near Cedar Lake in Minneapolis. She'd been brutally beaten and apparently buried in a shallow grave while still clinging to life. The Hennepin County coroner is inspecting Shableau's battered face as police officers look on.

The crime was quickly solved. The day after Shableau's body was discovered, the man she'd been living with, James Talbot, committed suicide by inhaling carbon monoxide from his car exhaust in a garage he rented. Talbot left behind a matter-of-fact suicide note to his mother that read: "I'm sorry. A drunken fight. I love her and so goodbye. Thursday—$4 due on garage—you will find the money in my watch pocket. Ruth had insurance, and her bonds are in the dresser. I'm sorry mother. Hope we meet soon. Jim."

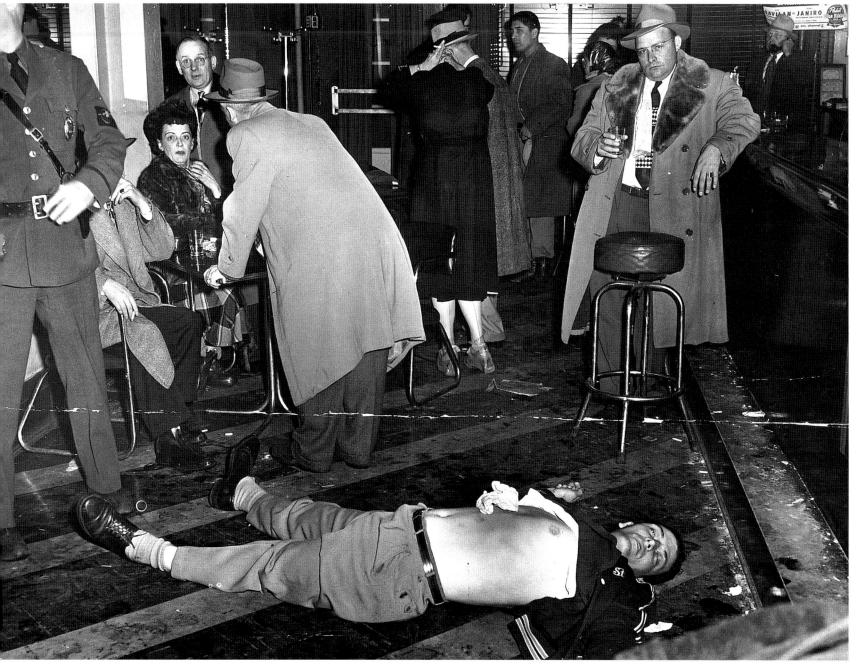

NOV 0 5 1951

Pioneer Press / Dick Magnuson

THESE ARE TWO RICHLY TEXTURED PHOTOGRAPHS of killings in 1950s St. Paul. Each not only offers a portrayal of deadly violence but also provides an inside look at the rough, cigarette-littered world of the city's tavern culture. So atmospheric are these pictures that, if you look at them long enough, you can almost smell the beer and the smoke.

The first photograph was taken in November 1951 at the long-gone Jackson Bar on West Sixth Street in downtown St. Paul. The man lying on the striped linoleum floor is Michael Erich O'Hara, 27. He'd actually been shot in a building lobby just outside the bar. Mortally wounded in the chest, he made it into the

bar before falling dead to the floor. Bernard (Mutt) Martineau, president of the local bartender's union, quickly confessed to the killing. He said there'd been an argument because O'Hara was upset that Martineau hadn't found him a bartending job.

According to the *Pioneer Press*, bar patrons thought it was a "gag" when O'Hara staggered into the bar. "The noisy crowd of Saturday night drinkers was stunned when they saw blood seeping through the victim's jacket. Only the blare of a juke box broke the hush. Then a woman began sobbing hysterically and a man opened O'Hara's jacket and shirt and called for a towel."

174

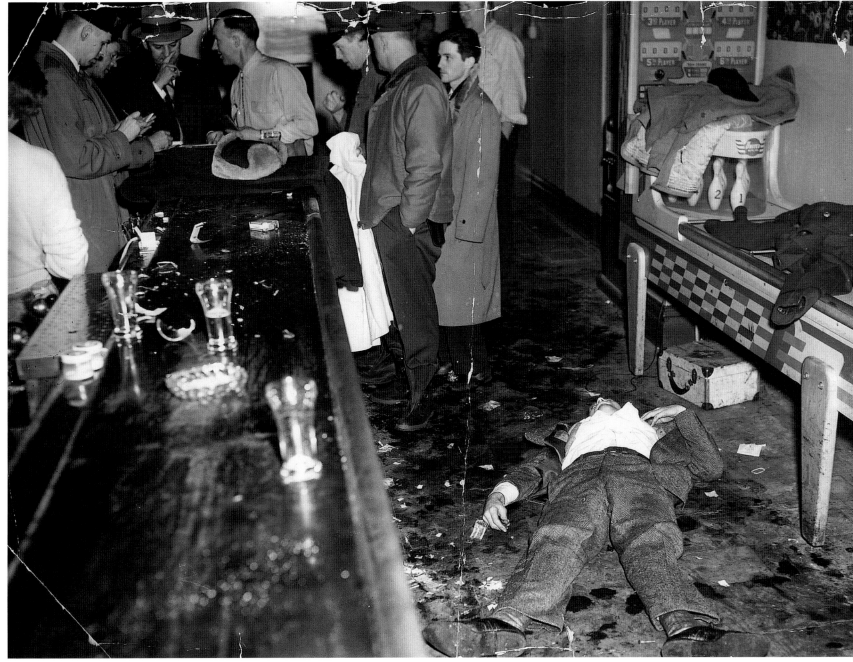

Pioneer Press / Dick Magnuson

FEB 2 5 1957

In this photograph, police detectives are questioning the bar's patrons about the shooting. Among them, at left, is a woman who looks as though she might have been the one "sobbing hysterically." But the most riveting figure here is the unidentified man in the long coat and hat standing at the bar, drink in hand. He seems almost defiant, as though he's determined not to allow his evening to be ruined by such petty annoyances as a murder, police questioning, and the appearance of a newspaper photographer.

The second picture is from 1957 and was taken at Jimmie's Bar on Selby Avenue, where a man was shot dead by a "baby-faced" robber. The victim, 38-year-old Edward John Olson of St. Paul, was shot after he threw a beer glass at the robber and then charged him in an attempt to thwart the holdup. The shattered glass can be seen on the bar. In the background, a bevy of police detectives question a man who may be the bartender. The tall man at rear center is James McKelvey, the bar's owner. Note the cigarette butts strewn on the floor and the bowling game, once a fixture in many neighborhood bars. It's not known whether Olson's killer, who escaped with $350, was ever apprehended.

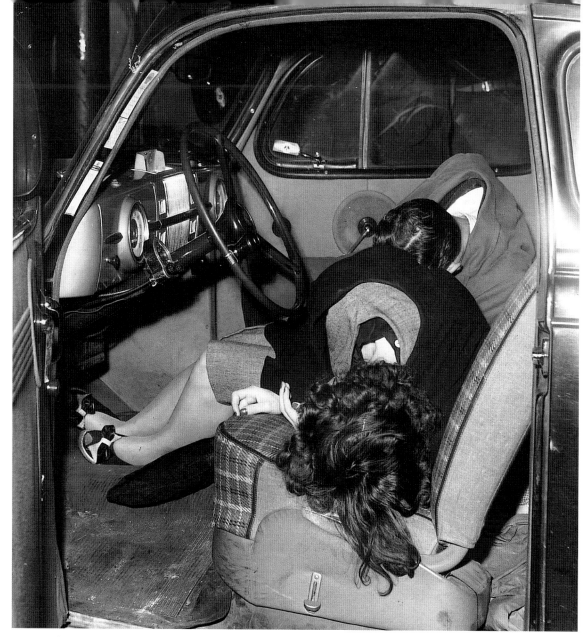

NOV 0 1 1946

Dispatch / Larry Anderson

ON THE DAY AFTER HALLOWEEN in 1946 the *Dispatch* offered this image of death on the front page. Lying in the front seat of the car are Esther Gustafson, 28, and Leo J. Kelner, 42, described as a "rejected suitor." Kelner killed Gustafson and then himself after hijacking the car in which Gustafson was riding with her date that night.

Although the term wasn't in use then, Kelner appears to have been a classic stalker. A note found in Gustafson's purse after her death said, "I'm scared stiff of Leo J. Kelner and I know he will kill me sooner or later. . . . He wants to marry me and I hate him. . . . He has me convinced I will be better off dead as I know he will never leave me alone." The note was written just ten days before Gustafson's death. Kelner had apparently been

stalking her for over a year, but she'd declined to press charges with police because, she said, Kelner was the sole support of his mother.

Gustafson's date, a man named Richard Voosen, said Kelner followed them during the course of the evening. When Voosen drove Gustafson home, Kelner pulled up next to them and forced his way into the front seat of the car at gunpoint. Voosen was ordered to drive while Kelner talked to Gustafson. As the car neared Rice Street and Lawson Avenue, the *Dispatch* reported, "a shot rang out in the close confines of the coupe and Miss Gustafson gasped and slumped over." Voosen then jumped from the car, only to hear a second shot as Kelner ended his own life.

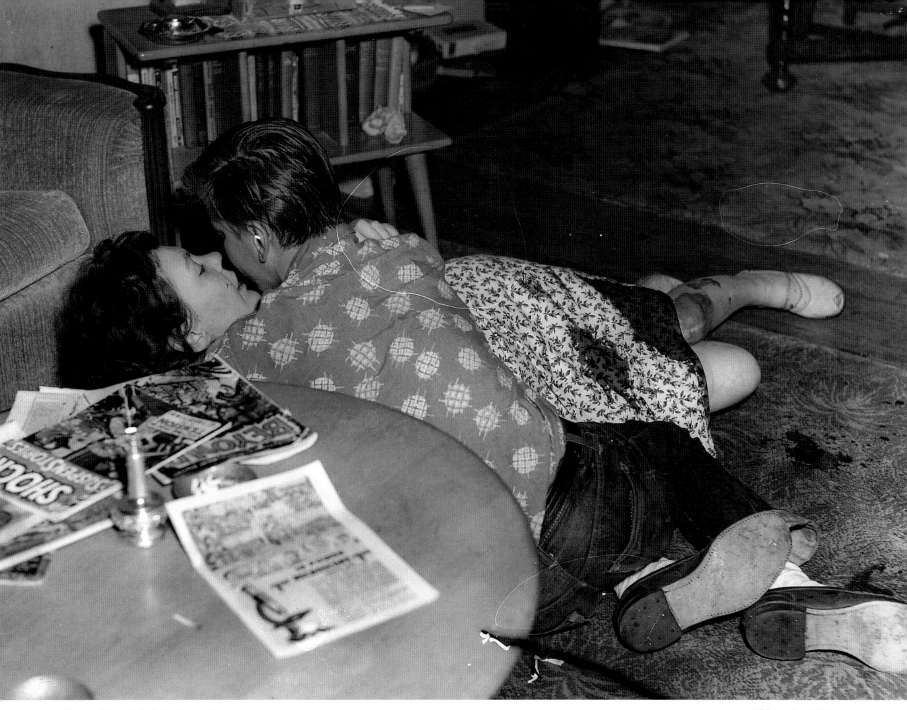

Pioneer Press / photographer unknown

SEP 1 1 1954

THIS PHOTOGRAPH, remarkable for its emotional power and intimacy, was published on the front page of the *Pioneer Press* in September 1954. It was taken by an unidentified freelance news photographer at the home of a St. Paul woman who'd just stabbed her husband to death during a quarrel. The woman, Lorraine Weber, is being comforted by her 14-year-old son, who along with his younger sister witnessed the stabbing of their father, Karl Weber. Note the stains, presumably blood, visible on Mrs. Weber's skirt and the carpeting.

Mrs. Weber told police she stabbed her husband with a seven-inch butcher knife after he hit their young daughter "for no reason at all." The killing culminated what police said was a long history of domestic abuse and discord, punctuated by frequent calls to authorities. A *Pioneer Press* reporter on the scene wrote that Mrs. Weber, as she fell to the floor, sobbed, "I love him . . . I really love him. I don't know why I did it. What will we do without him." Meanwhile, the newspaper said, "the son was calm and the daughter was sitting outside on the porch apparently suffering from shock."

177

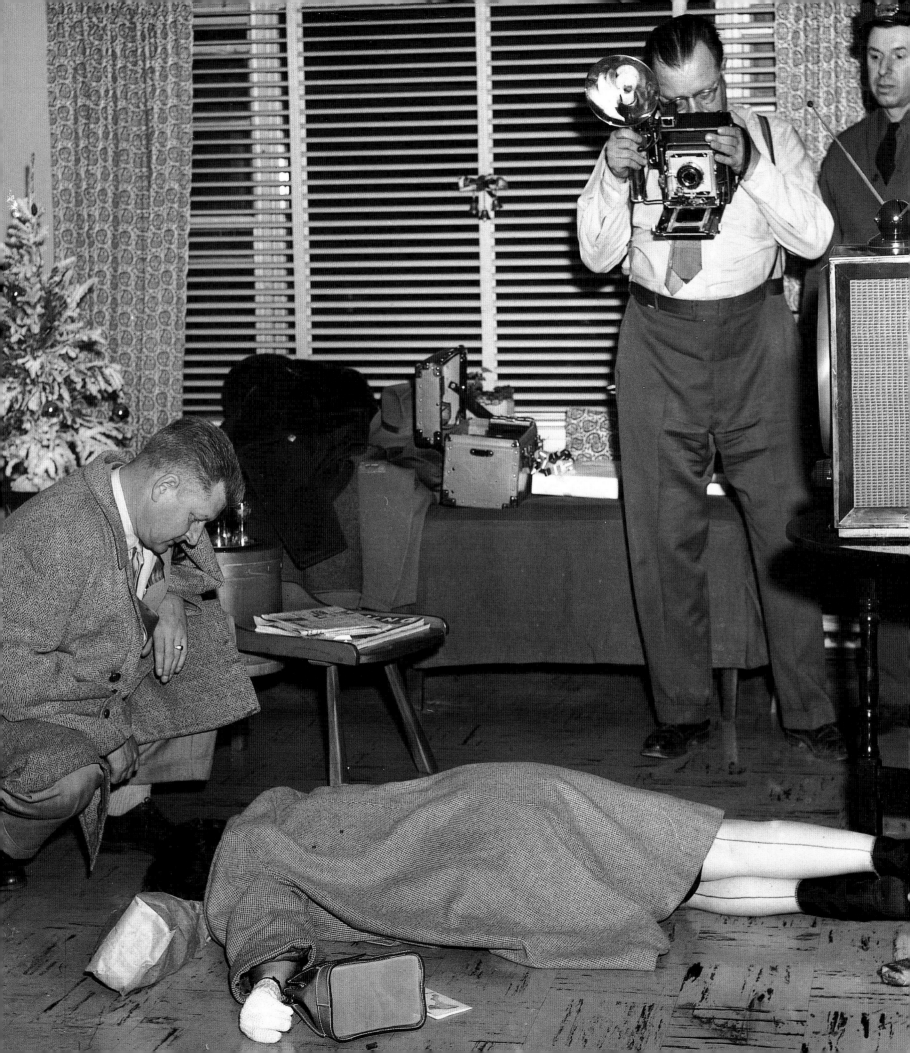

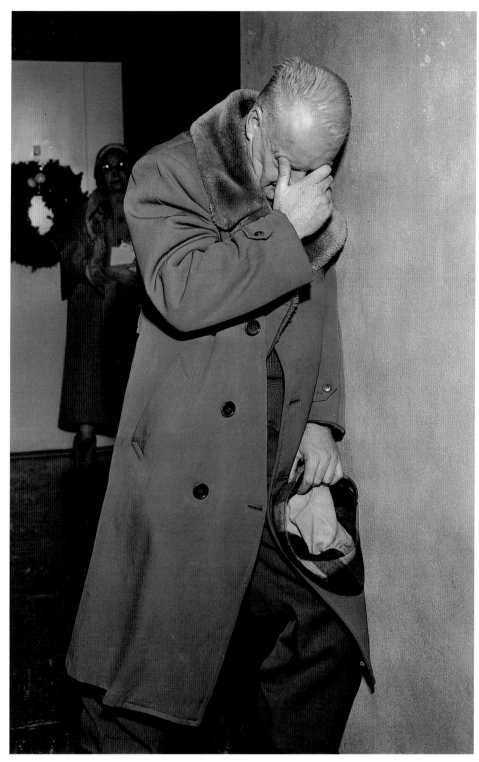

DEC 2 9 1955

Pioneer Press / Ted Strasser

DEC 2 9 1955

THERE CAN BE NO MISTAKING that this is a murder from the 1950s. The thin-legged furniture, the big television set with its bulky rabbit ears, the blood-smeared linoleum floor, and the police photographer with a Speed Graphic camera all firmly identify the era of the crime. It's also the Christmas season, as indicated by the small tree at left and the ornament hanging in front of the venetian blinds.

The dead woman is Ann Finn, 39, of St. Paul. She was shot three times in the back. Note the bullet holes visible in her coat. Mrs. Finn was killed in her Highland Park apartment by her husband, from whom she'd separated after only a month of marriage. St. Paul police detective Grant Willinger examines the body while Dr. John Dalton, a police criminologist, handles the camera work. Police patrolman Paul Philipp is at right.

John E. Finn, 48, told police he killed his estranged wife because "it seemed the only way out. I wanted peace of mind." He'd waited in ambush for her in a hallway closet across from the door to her apartment. When she arrived home, Finn charged into the apartment behind her. The two argued briefly, after which Ann Finn turned away, apparently in disgust. Finn shot her, then asked the tenant of another apartment to call the police. He was found standing in the hallway outside the apartment when Philipp arrived. "You'd better look at my wife," Finn told the startled patrolman. "Something has happened to her."

His head hung in shame, Finn was still leaning up against a wall in the hallway when photographer Ted Strasser took this candid shot. "I'll have to be repentant for this a long time," Finn told a reporter, adding, "I'm confused."

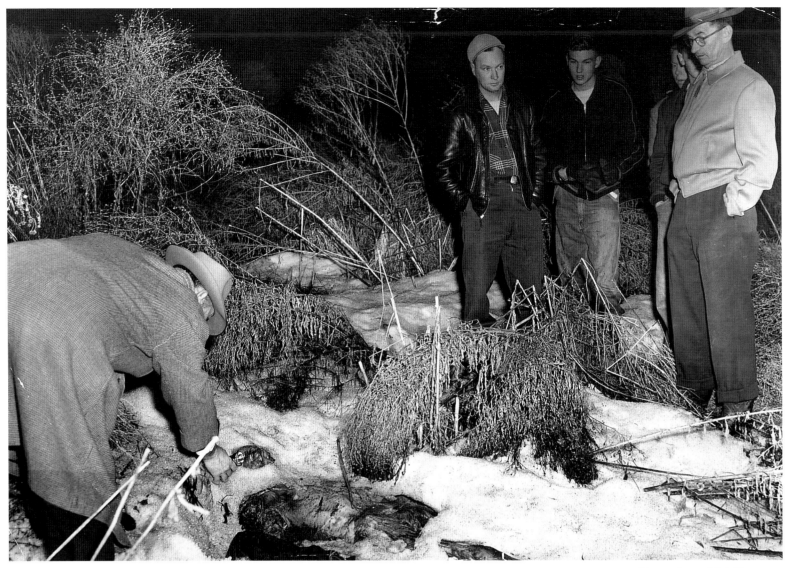

MAR 0 3 1956

NOT EVEN A DECOMPOSED CORPSE was considered too disturbing an image for the newspapers of the 1950s. So when two schoolboys found a man's body in a swampy area near Crosby Lake one March night in 1956, photographer Dick Magnuson was quickly on the scene. Here, a St. Paul police detective named Melvin Plummer is examining the corpse's head. The boys in the background are unidentified but are probably the ones who discovered the body.

The *Pioneer Press* reported that the dead man was naked except for a T-shirt, although other clothes were found near the body. The condition of the body suggested that the man had been dead for several months. Beyond this, the newspaper had little more to say about how the man died or who he was.

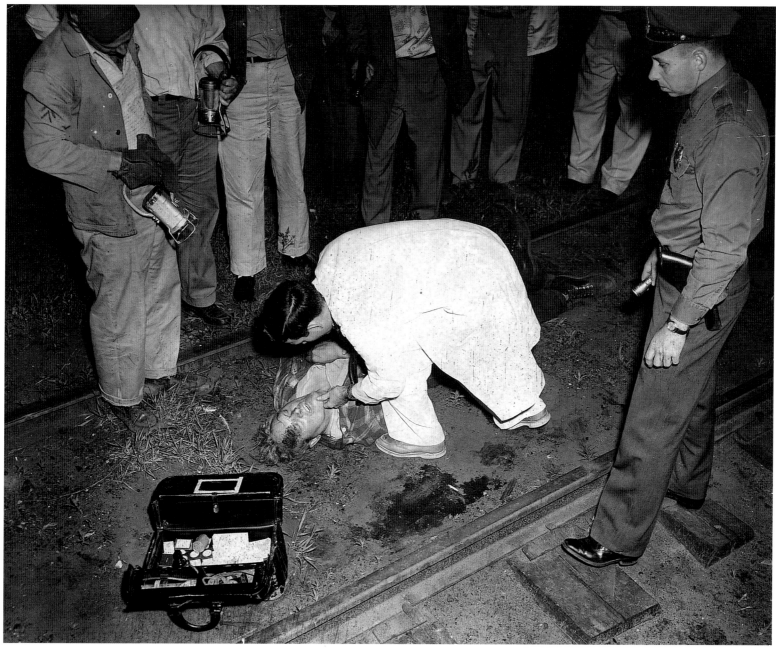

JUN 0 1 1957

NO EVENT THAT INVOLVED VIOLENT INJURY or death was too small to escape the overnight photographers of the era. But some occurrences were considered insufficiently interesting to merit publication of the picture in the newspaper. This is one such case. Earl R. Zishka, 60, the man lying on the ground, has just jumped from the old Sixth Street bridge in St. Paul. The bridge, now replaced by a modern freeway span, crossed over the Northern Pacific Railroad tracks, and it was a railroad employee who found the badly injured man.

A doctor or possibly an ambulance attendant is examining Zishka as a policeman and railroad workers look on. It must have been almost pitch-black at the scene judging by the tight circle of light provided by the camera's flash. Nothing is known about why Zishka may have jumped or what ultimately happened to him. This photograph snatched from the night is all that remains of an otherwise obscure incident.

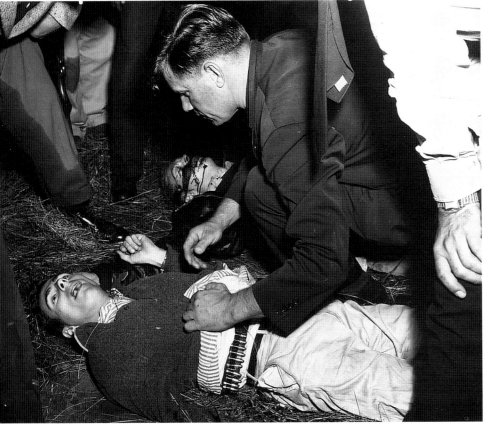

SEP 1 5 1957

Pioneer Press / Leo Stock

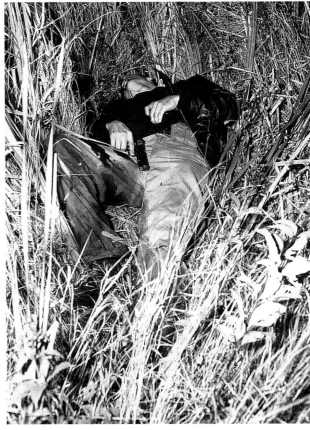

SEP 1 5 1957

Pioneer Press / Leo Stock

THE MOST SENSATIONAL CRIME SPREE in the Twin Cities in the 1950s centered on the murderous exploits of three handsome young brothers from Minneapolis. Their names were Roger, Ronald, and James O'Kasick. They ranged in age from 20 to 26, and they seem to have lived a kind of gangster fantasy. Armed robbers by trade, they installed steel plates in their getaway cars to deflect bullets, carried big pistols, preferred armor-piercing ammunition, wore bandoleers, and had no reservations about shooting it out with the police. Their criminal careers were short but deadly.

On the night of August 18, 1957, as the Lutheran World Federation was delivering the word of God in St. Paul (see page 84), the brothers were driving a stolen car near Lake Street in South Minneapolis on their way to a holdup. Two policemen spotted the stolen vehicle and gave chase. A wild gunfight ensued in which officer Robert Fossum was killed and his partner, Ward Canfield, critically wounded after being shot and then run over. Canfield later required 18 surgeries and had a leg amputated

because of his injuries. Despite a relentless manhunt, the brothers got away after hijacking two cars and briefly holding one of their owners hostage.

Exactly four weeks later, on September 14, the brothers—whom the police had not identified as prime suspects—ran out of luck. Two Anoka County sheriff's deputies on patrol near the Carlos Avery Game Refuge chanced upon Roger O'Kasick, the oldest of the trio and their apparent leader, as he was walking down a remote road with a gas can. Sensing something suspicious about his behavior, the deputies arrested Roger and drove him to his parked car. The other brothers were waiting there. They supposedly yelled "you dirty coppers" and opened fire. One of the deputies was wounded, and the brothers sped off. Later, they took a 32-year-old man named Eugene Lindgren as a hostage, but they couldn't shake the police, now aided by a spotter plane. With two Highway Patrol officers in pursuit, the brothers lost control of their stolen Cadillac as it slid into a ditch in the game refuge.

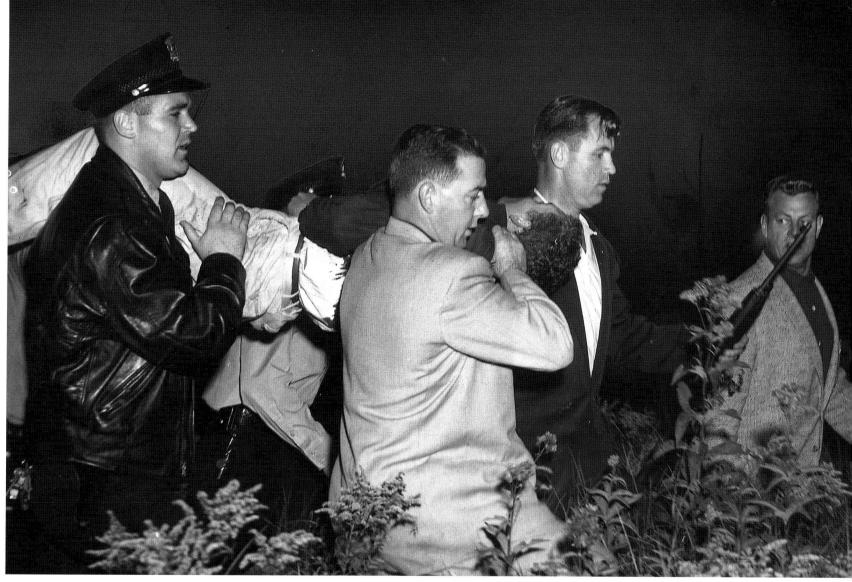

Pioneer Press / Leo Stock

SEP 1 5 1957

The brothers ran from the car, dragging Lindgren with them. As a patrol officer approached, Roger O'Kasick shot and killed Lindgren. It was to be Roger's last criminal act. The patrolman raked the fleeing brothers with shotgun fire. Roger and Ronald were apparently killed instantly. James escaped, though not for long. Uncertain as to whether the brothers were still alive in the thick foliage, an army of police officers surrounded the area. James, with nowhere to go, shot himself in the chest as the posse moved in.

Newspaper and television photographers followed the action on their police scanners and descended on the game refuge in plenty of time to shoot pictures of the dead and wounded O'Kasicks. One photograph shows Detective Captain Cliff Egeland of the Minneapolis police examining the body of Ronald O'Kasick, 24, his eyes wide open in death. Note the ammunition belt around his waist. Roger O'Kasick is laid out next to his brother. In another picture Roger lies as he was

found, still gripping a .45 caliber automatic pistol. James, 20, survived his self-inflicted wound and is shown being carried from the scene, none too gently, by police officers.

Three days after this last spasm of violence, a lightly attended prayer service was held for the dead brothers in Minneapolis. Their father, Michael, serving time for violating his parole on a robbery conviction, couldn't attend, but a sister who'd just been returned to the Shakopee Women's Reformatory on forgery charges after an escape was allowed a brief visit under guard. Two other O'Kasick brothers, including Richard (see page 132), later changed their last names to avoid being associated with the notorious criminals. A year and a day after two of his brothers died, James O'Kasick—serving a life sentence at the St. Cloud Reformatory—plunged a carefully sharpened table knife six inches into his abdomen. He died within an hour, bringing an end to a bloody family saga of murder and waste.

CITY
OF OLD

The photographers of the Speed Graphic era worked at a time when St. Paul was in the throes of a tumultuous rearrangement. Not since the boom days of the 1880s had there been such a dynamic and unsettling period in the life of the city. For the photographers (and for many other St. Paulites), these were truly strange days, as entire sections of the city vanished in a fog of dust and debris, to be replaced by new buildings, roads, and parks.

This transformation was especially startling because the city had long seemed immune to the lure of "progress." A visitor to downtown St. Paul and its environs in the years immediately after World War II would have found a rather tired-looking place still living off its legacy of Victorian- and Edwardian-era buildings. Although some modern structures could be found in what the newspapers liked to call the "loop," much of downtown had changed little in decades. Narrow streets still followed inefficient alignments laid out in horse-and-buggy days. Yellow wooden trolleys and a few new streamlined cars clattered along routes dating back to the 1890s. On the fringes of downtown, weather-beaten rooming houses and faded apartment buildings lined streets paved with hand-set cobblestones.

This was the city of old, an honest mix of beauty and squalor largely untouched by the sleek varnish of historic preservation. By 1950, however, St. Paul's leaders were anxious for change. Modernizing the city, they believed, would help stanch the flow of new households and businesses to fast-growing suburbs. The population of Roseville, for example, sextupled from about 4,000 people at the time of the city's incorporation in 1948 to 24,000 by 1960. Other first-tier suburbs grew with equal gusto.

Fearing St. Paul would be left behind in the rush to the suburbs, civic leaders concluded that drastic measures were in order. There would have to be new buildings, high-speed highways, wider and more auto-friendly streets, big housing projects to replace blighted blocks of old homes, and a new mall to create a suitable foreground for Cass Gilbert's gleaming State Capitol. Whereas the city of old was narrow, cramped, and entangled in its own obdurate history, the new St. Paul would be efficient, spacious, and above all else, "modern."

Although this process of modernization would require decades, many of its key components were either planned or carried out in the late 1940s and 1950s. These years saw, among other things, the replacement of trolleys with buses, completion of the State Capitol mall, establishment of one-way streets to speed downtown traffic, the beginning of large urban renewal projects in the older neighborhoods around downtown (as well as in downtown itself), and final planning for the Interstate 94 and 35E corridors.

Pioneer Press and *Dispatch* photographers took thousands of pictures during this transformation. For the most part, they are not sentimental images. They show the St. Paul of old not as it exists in nostalgic recollection but as much of it really was—a city of crumbling brickwork, ragged streets, and proud old mansions scoured of their last traces of paint. An unmistakable strain of melancholy runs through many of these pictures, which form a unique visual record of St. Paul as it struggled to remake itself.

Pioneer Press / Hi Paul

ON THE FIRST DAY OF SEPTEMBER in 1946 photographer Hi Paul hitched a ride on the Goodyear Airship *Ranger,* which was on a promotional tour of the Midwest. The time was late afternoon, and as the blimp wafted along just west of downtown St. Paul, he took this crisp image of the city, looking southeast.

Among the landmarks in view, at the lower edge of the photograph just left of center, is Miller Hospital, where the Minnesota History Center is today. Also visible is the Hotel Barteau (long known as the Piedmont Apartments, it's the building with a corner tower just to the right of the hospital). Note the array of old buildings that fill the blocks between the hospital and the

turn in the grid at St. Peter Street. This area west of St. Peter along Sixth, Seventh, and Ninth Streets was a classic mixed-use transitional neighborhood located between the downtown core and residential areas farther out along Seventh and up the bluffs.

Most of the old buildings in this neighborhood were demolished in the 1960s and 1970s to make room for Interstates 35E and 94, freeway ramps, large commercial developments (such as the expansion of the St. Paul Companies headquarters), and the inevitable parking lots. The streets were also rearranged to achieve better traffic flow, and today the area bears little resemblance to the scene in this picture.

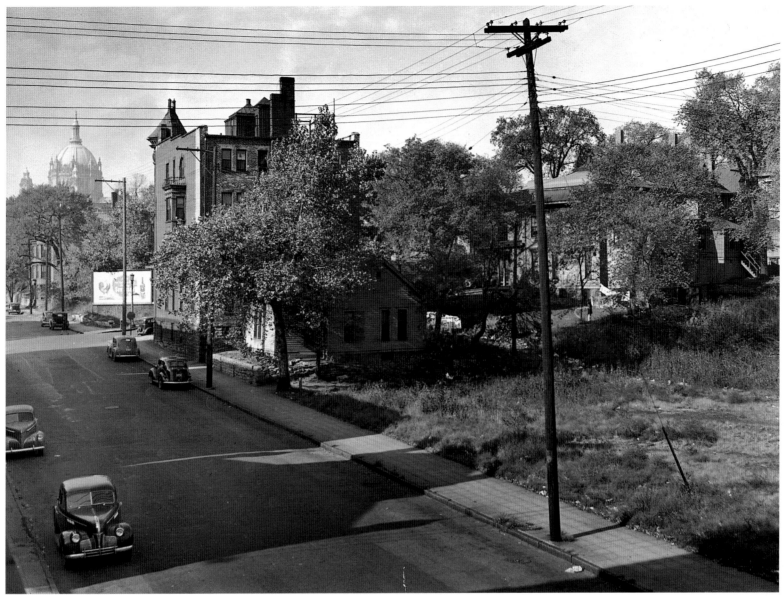

Pioneer Press / Jack Loveland

ALMOST A YEAR BEFORE Hi Paul took his panoramic picture, plans for rearranging large parts of St. Paul were already well under way. In November 1945, the *Pioneer Press* published a Sunday magazine article previewing plans for the State Capitol Mall and the highway corridors that would later become Interstates 35E and 94. One of the photographs that accompanied the article provides an instructive view of a small corner of the city that, two decades later, would be lost to concrete and traffic.

The view was taken along College Avenue (now mostly gone) looking southwest past Wabasha Street. The St. Paul Cathedral looms in the distance, and it's the only structure shown here that still stands today. This area was badly run-down in 1945, and that's part of the reason why clearing it all away seemed so appealing. Note the litter-strewn vacant lot at right, the old apartment building at the corner, and the large houses (mostly from the 1880s and long since subdivided) that line up along Wabasha. Today, Interstate 94 runs straight down the middle of this scene.

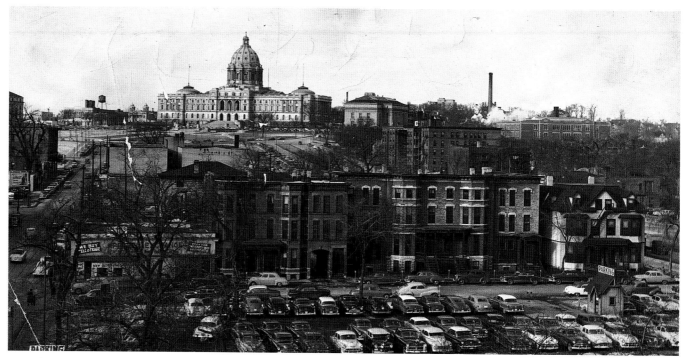

Roy Derickson

Dispatch / Dick Magnuson

IT'S EASY TO UNDERSTAND why civic leaders in St. Paul were so enthusiastic about the State Capitol Mall project that began in the late 1940s. Even before the Capitol opened in 1905, architect Cass Gilbert had prepared plans for a grand mall, but little came of the idea until after World War II. The mall, and the interstate highways that would follow, promised to clear away numerous old buildings described by newspaper editorialists as a "screen of ugliness" marring views of the Capitol from downtown. Here are three views of the mall as it was being carved out of the city of old.

A 1949 photograph taken from the Capitol's roof (one of the golden horses in the Quadriga is at left) provides a general view of the neighborhood that aesthetes of the era found so offensive. The camera is pointed toward the southwest across Wabasha Street, where a trolley is making its way downtown. The "screen" consisted of a mishmash of nineteenth-century buildings, including many rooming houses and apartments as well as monuments like Trinity Lutheran Church with its eye-catching spire. All of these buildings were soon to be swallowed up by the new mall.

Another picture, from 1953, shows a line of brick row houses along Tenth Street east of Wabasha Street (at left). Behind them, the new mall looks all but complete. In the foreground, parked cars fill a vacant block where the first two state capitols were located and that later became the home of the Minnesota Arts and Science Center (now Musictech College and Minnesota Business Academy).

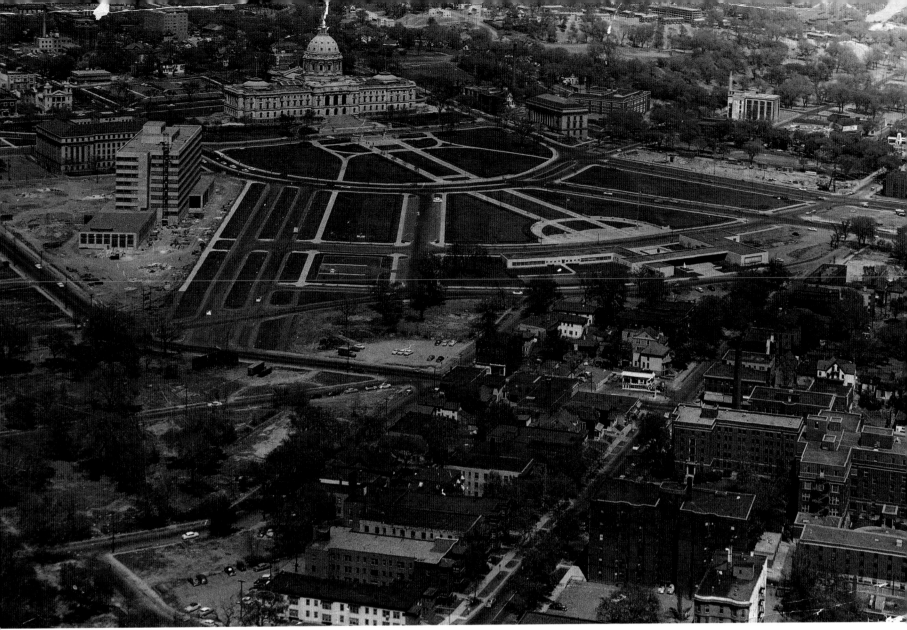

Don Spavin

JUN 2 5 – 2 9 1960

The three-story row houses, in the bracketed Italianate style, probably dated to the 1880s, and they look charming. Note that one of them even has an arched carriageway leading to a rear courtyard. The houses—undoubtedly subdivided by this time—were later demolished to make way for a new city public health building.

This photograph shows other historic buildings of note. At upper right, near the tall smokestack, is Mechanic Arts High School, demolished in the 1980s. Behind and just to the left of the row houses, only partly in view, is a large stone house built for a clothing manufacturer named William Mason in 1869. It came down in 1954.

An aerial photograph taken in 1960 shows the mall and its surroundings just before the interstate highways came through. Note that John Ireland Boulevard (center left in front of the Minnesota Transportation Department building) has yet to be extended to its present length and that the Veterans Service Building (at the lower end of the fan-shaped mall) had only one floor at this time.

The building-lined street that angles through the bottom right of the picture is Summit Avenue. This stretch of Summit, which originally ran all the way to Robert Street, was home to elegant old apartment buildings like the Marlborough (the tall building with the indented court at lower right), a few large houses, and the Miller Hospital complex (just past the Marlborough). Today, virtually all traces of this genteel residential district and its pleasing tangle of streets are gone.

189

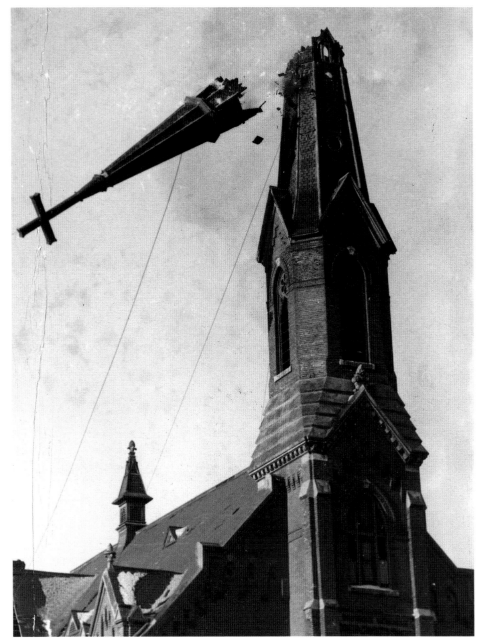

JAN 1 8 1952

TRINITY LUTHERAN CHURCH at Wabasha and Tilton Streets (the latter no longer exists) was among the historic buildings torn down to make way for the Capitol Mall. Founded by German immigrants in 1855, Trinity was one of the oldest congregations in St. Paul. The steeple of the Gothic-style church, built in 1886, long served as a prominent landmark on the northern edge of downtown.

Two photographs from 1952 show the demolition. In the first, the top 30 feet or so of the spire is being pulled down. D. C. Dornberg, one of the newspapers' most technically skilled photographers, took five shots showing various stages of the steeple's plunge to the ground. The picture here is the second in the series, catching the instant that the spire and its cross—looking almost like a missile speeding past the church—begin their freefall.

About three weeks later, the work of destruction was still under way, and a crane was called in to remove the church's bell from what was left of the tower. According to the *Pioneer Press,* the two-ton bell dated to 1899. The Trinity congregation had by this time moved to a new church on Rice Street that had no bell tower. So the old bell was trucked away and installed in a church on the West Side, Emanuel Lutheran, which was in need of more ringing power.

Among those watching the bell's removal was the Reverend A. C. Haase, pastor of Trinity for 42 years. He told a reporter he wasn't all that happy with the congregation's new church, which not only lacked a bell tower but was also without an elevated pulpit of the kind from which Haase had delivered an estimated 7,000 sermons during his long tenure.

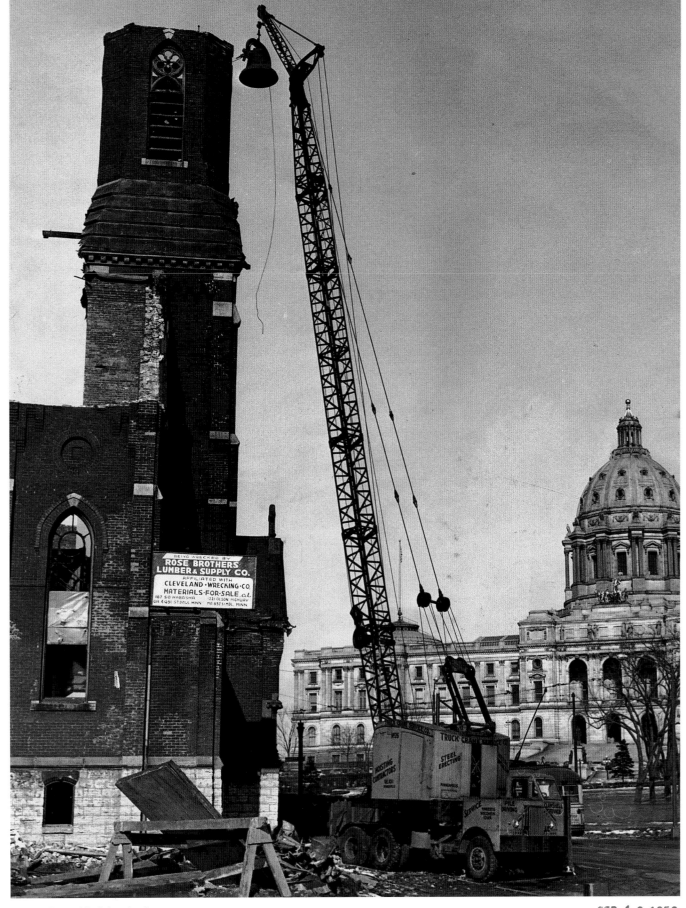

Pioneer Press / Jack Loveland

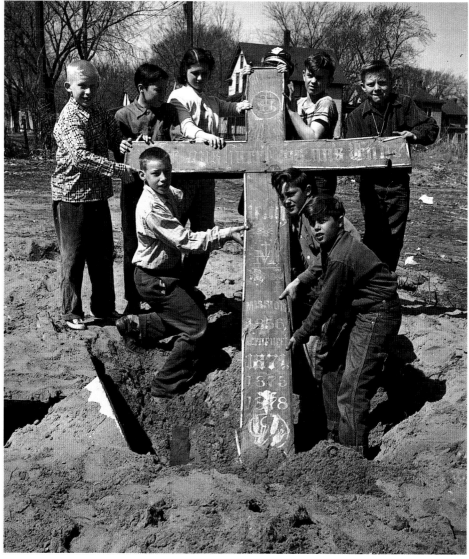

APR 1 0 1955

Pioneer Press / photographer unknown

ON GOOD FRIDAY in 1955 a group of kids undertook some tunneling and fort building in a vacant lot in the Capitol Approach area, which was then being extensively redeveloped. As the youngsters dug away near Cathedral Place (a now vanished street) and Central Avenue, they unearthed a mystery in the form of a nine-by-five-foot wooden cross complete with gilt lettering and what were said to be "Catholic symbols."

A *Pioneer Press* photographer and reporter were called to the scene, and the kids happily reenacted their discovery. Then, over one boy's objections, the newsmen appropriated the 60-pound cross and hauled it back to their offices for "verification." Said a *Pioneer Press* story: "Easter shoppers were stunned as the newsmen's station wagon carrying the cross inched through the Loop traffic."

An ecumenical detective team soon solved the mystery of the buried cross. Reverend John Stelmes, pastor of Assumption

Catholic Church, and Reverend G. A. Thiele, pastor of Emanuel Lutheran Church, both in St. Paul, translated the German script. It stated: "He Who Perseveres to the End Will Be Saved. Mission 1856. Renewed 1871, 1873, 1878, 1888." These dates pointed to Assumption, known to have sponsored a mission in 1856. Stelmes then recalled that an Assumption trustee who lived near the State Capitol had made a copy of the mission cross in his home before his death in January 1955. The trustee, it was theorized, had then disposed of the old cross, believed to date to 1871, by burying it near his house. "It is indeed strange that the cross was found on Good Friday," Stelmes noted in a *Pioneer Press* story about the resurrected cross that appeared, appropriately enough, on Easter Sunday. The cross was later mounted near the pulpit in Assumption Church, where it remains today.

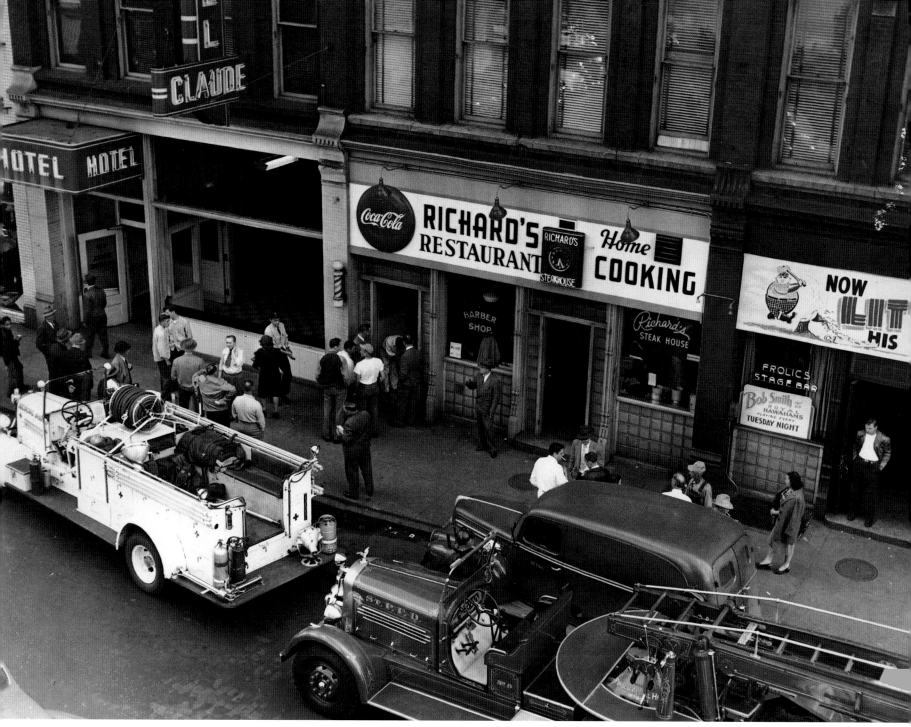

Pioneer Press / Jack Loveland

MAY 1 8 1948

THE YOUNGSTERS WHO FOUND BURIED TREASURE near the Capitol were just blocks away from the old St. Paul Loop, which didn't change quite as quickly as the neighborhoods around it. Here's a picture that shows how much of the downtown core looked before the big urban renewal push began in the late 1950s. The scene is along the west side of St. Peter Street just south of what is today Seventh Street but in 1948 was Ninth Street. A small explosion in the basement of the Claude Hotel brought fire trucks to the area, prompting this photograph.

What's really of interest, however, is the streetscape with its mix of small businesses on the ground floor of the Victorian-era brick buildings. A bar, a steak house, and a barbershop are visible in addition to the hotel. Rows of three- to six-story brick buildings like these occupied many downtown blocks well into the 1960s but are almost all gone today. As for the Claude Hotel, its site is now home to the headquarters of The St. Paul Companies.

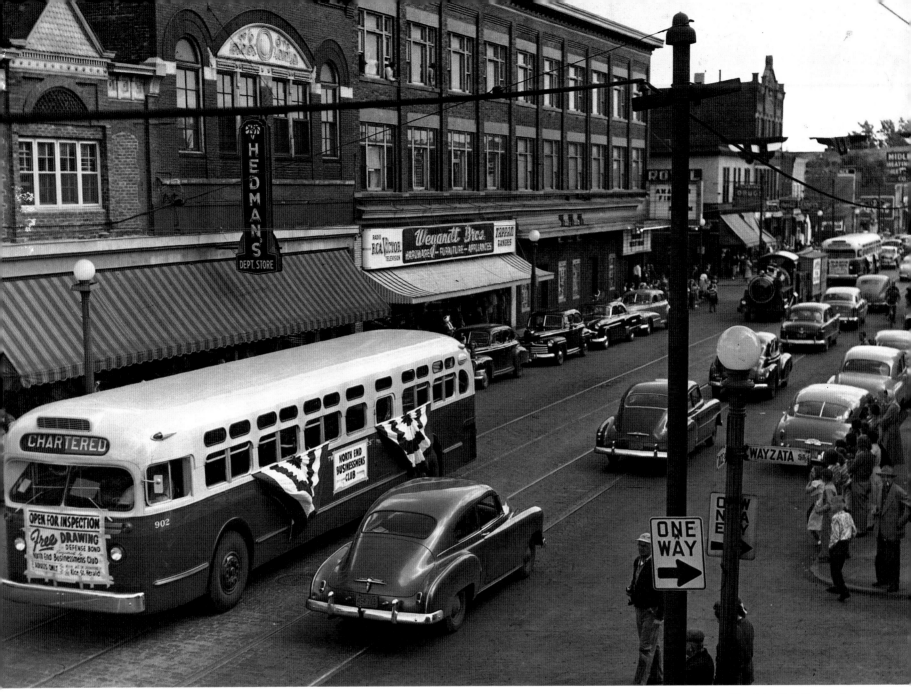

APR 2 9 1952

Dispatch / D. C. Dornberg

THE STREETCAR SYSTEM in the Twin Cities was another casualty of progress in the 1950s. Once one of the finest in the nation, the system run by Twin City Rapid Transit Company was still relatively robust as late as 1949, when 165 million riders, accounting for an estimated 36 percent of all trips in the metropolitan area, still rode the streetcars.

Unfortunately, unscrupulous new owners took over the company that year. To boost profits, they slashed service and sold off equipment, alienating loyal riders and public officials in the process. As it turned out, some of the owners were also crooks. They looted the company's assets, and a number of them later went to prison for their crimes. By 1954 the last of the streetcars

were gone, replaced by a fleet of buses provided by General Motors Corporation.

A photograph taken along Rice Street in St. Paul in 1952 shows several of GM's new 51-seat buses "on parade" as part of a promotional campaign. The sign on the front of the lead bus announced that it's "open for inspection." Buses, in fact, had replaced streetcars on some streetcar routes as early as 1938 and were already carrying a quarter of all Twin Cities transit riders when this picture was shot.

The streetcars disappeared so quickly that work on removing tracks, wires, and other vestiges of the system took the better part of a decade. Taking down wires was the easiest part of the

Dispatch / Roy Derickson

NOV 0 6 1953

job. In a picture from 1953, a workman in a crane bucket is shown removing overhead trolley wires at Fifth and Jackson Streets in downtown St. Paul. Removing tracks was a far more time-consuming and costly job, largely done in conjunction with repaving projects. A view along Selby Avenue near Milton Street in 1956 shows a section of old track being maneuvered onto a flat-bed truck.

It must have been strange for streetcars riders—accustomed to the particular sound and smell and rhythmic sway of the trolley—to switch so suddenly to buses. Yet there's little evidence of any great nostalgia for streetcars at the time. That would come later.

Dispatch / Jack Loveland

JUL 0 8 1956

MAY 0 5 1952

Dispatch / Ted Strasser

MONDAY, MAY 5, 1952, was a D-day of sorts in downtown St. Paul. That morning Fifth and Sixth Streets were officially converted to one-way thoroughfares. The idea was to speed traffic, and it worked so well that today these streets are like raceways. Anticipating that the change would occasion much befuddlement, a *Dispatch* photographer stationed himself at Fifth and Robert Streets and waited for the inevitable to occur. One suspects he didn't have to hang around very long before an oblivious driver tried to go the wrong way on Fifth.

Just to make sure no one missed the mistake, an editor inserted an arrow above the offending vehicle, which is attempting to turn west onto Fifth into the flow of oncoming traffic that includes a new streamlined trolley heading for Snelling Station. The *Dispatch* published other photographs showing a variety of motoring miscues on day one of the new downtown order but noted: "Fortunately, police were not issuing tags for violations today—just giving 'polite warnings.'"

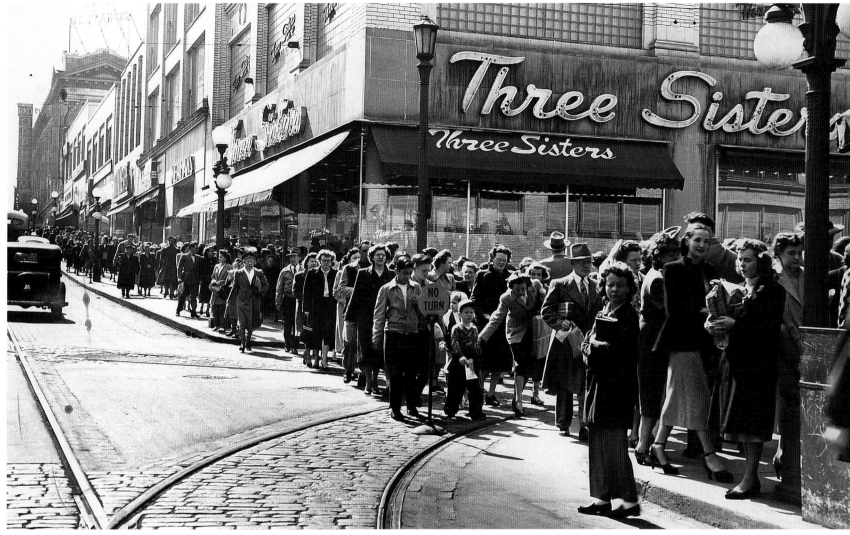

Pioneer Press / Ted Strasser

APR 1 0 1949

IN THE YEARS IMMEDIATELY AFTER WORLD WAR II, St. Paul enjoyed a brief downtown boom as hordes of returning servicemen started families and crowded into what housing was available, mostly in the city. Here's a scene looking west up Seventh Street from Cedar Street taken in April 1949, just before Easter. The day was mild, the sun was shining, and it must have seemed as if everyone in St. Paul had come up with the same idea: Go downtown and shop.

The sidewalks are so crowded that you'd almost swear the throngs were on their way to some special event, but that wasn't the case. It's more likely that many of these people were heading for the Golden Rule or Emporium, two big department stores just a couple of blocks away on Seventh. Two other department stores, Schuneman's and Field-Schlick, also offered shopping opportunities, as did specialty shops like the Three Sisters store.

Town Square and Wells Fargo Place (formerly the World Trade Center) occupy these blocks today, and this once busy stretch of Seventh is gone, as are most downtown shoppers.

DEC 2 6 1950

Dispatch / D. C. Dornberg

HERE ARE TWO IMAGES of St. Paul's railroad heritage, both taken on the day after Christmas but 11 years apart. The first, from 1950, has a huffing steam locomotive as its centerpiece. The ground was fresh with snow, and the temperature was below zero when photographer D. C. Dornberg went up to the roof of the 32-story First National Bank Building, then St. Paul's tallest. He snapped this picture as a passenger train pulled by a locomotive trailing huge billows of smoke and steam chugged along the tracks below Kellogg Mall park just west of the Robert Street bridge.

DEC 2 6 1961

Note the long shadows cast by the sun from its position far in the southern sky. Note, too, the crisp geometric patterns created by snow-covered trees and bushes in the park, which appears unmarred by footsteps. This photograph, like so many at the time, marked the end of an era because steam locomotives were soon to vanish.

Passenger trains continued to stop at St. Paul's Union Depot through the 1950s and 1960s, but their numbers steadily diminished as interstate highways and improved airline service made train travel seem slow and old-fashioned. In 1961, photographer Ted Strasser caught this melancholy view of the Union Depot's nearly empty concourse. The clock says it's just past eight thirty in the morning, and fewer than a dozen people await their trains under the concourse's vaulted ceiling. In notes accompanying this picture, Strasser wrote: "Almost empty—the Depot seems so strange." Ten years later the last train left the depot, and the concourse—now owned by the U.S. Postal Service—has been vacant ever since.

SEP 1 0 1950

Pioneer Press / Jerry Lundquist

BEFORE 7-ELEVEN AND SUPER AMERICA, there was the corner "mom and pop" grocery store, a fixture in every urban residential neighborhood. In fact, in many neighborhoods a child in search of candy or a father looking for a loaf of bread might easily find several stores within a few blocks' walk from home.

This picture from 1950, shot for a *Pioneer Press* Sunday magazine feature on salesmen, offers a view of Haider's Grocery on Aldine Street near Lafond Avenue in St. Paul. Haider's was a typical example of the small groceries that still dotted the city at this time. Note the overhanging neon sign courtesy of 7Up, the two Coca Cola signs, and the weekly specials (including a three-pound can of Crisco for 87 cents) painted on the front window.

The man approaching the store is Bill Redmond, a salesman for Quaker Oats. Equipped with premiums, advertising materials, and a sample case, he's about to call on the store's owner, Robert Haider. The grocery was one of 700 in Redmond's territory, which stretched from North St. Paul to near Rochester. One wonders how many "mom and pop" groceries would be found in the same area today. As for Haider's Grocery, it's long gone, but the store building still stands and is now home to a pizza place.

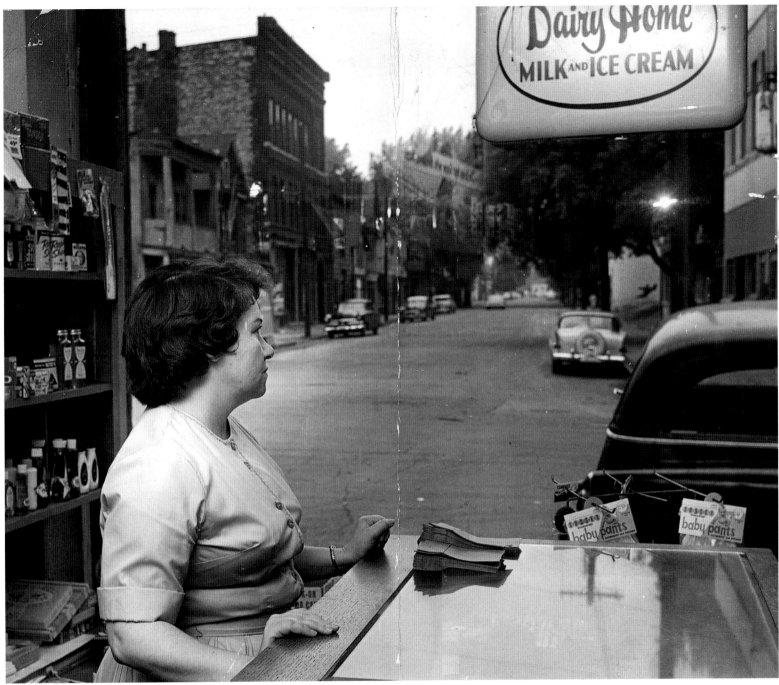

Pioneer Press / Don Spavin

THIS PHOTOGRAPH and the panoramic shot on the next two pages were taken about two years apart. They demonstrate the fate of St. Paul's historic West Side Flats in the early 1960s. The first picture, taken in 1962, is a wonderfully evocative image that shows Ruth Atkins behind the counter of her family grocery store at the corner of Fairfield Avenue and State Street in the heart of the flats. She's looking west down Fairfield, then a commercial thoroughfare, toward Robert Street. Note the Dairy Home sign above and the rack by the counter holding baby pants.

Born and raised on the flats, the 39-year-old Atkins had spent years building up the grocery business with her husband. But her store, and everything else in this photograph, was about to vanish. After the devastating flood of 1952, the city had finally decided to put up higher levees and then clear out much of the flats to make way for an industrial park. By the early 1960s the St. Paul Port Authority was moving families out of the area. Atkins's store and everything else visible in this photograph, including Fairfield Avenue itself, would be gone within a year.

MAY 1 6 1964

Pioneer Press / photographer unknown

A COMPOSITE PANORAMIC PHOTOGRAPH taken in May 1964 dramatizes the destruction of Mrs. Atkins's world. The view is looking east from Robert Street, across Fillmore and Indiana Avenues. Scores of buildings and homes have been cleared away for the new industrial park, and only a scattering of trees and the cars parked on streets going nowhere suggest that there was once a full-fledged neighborhood here. Before long, many of the streets, Indiana among them, would also disappear in favor of the more suburban-style arrangement of roads that serves the area today.

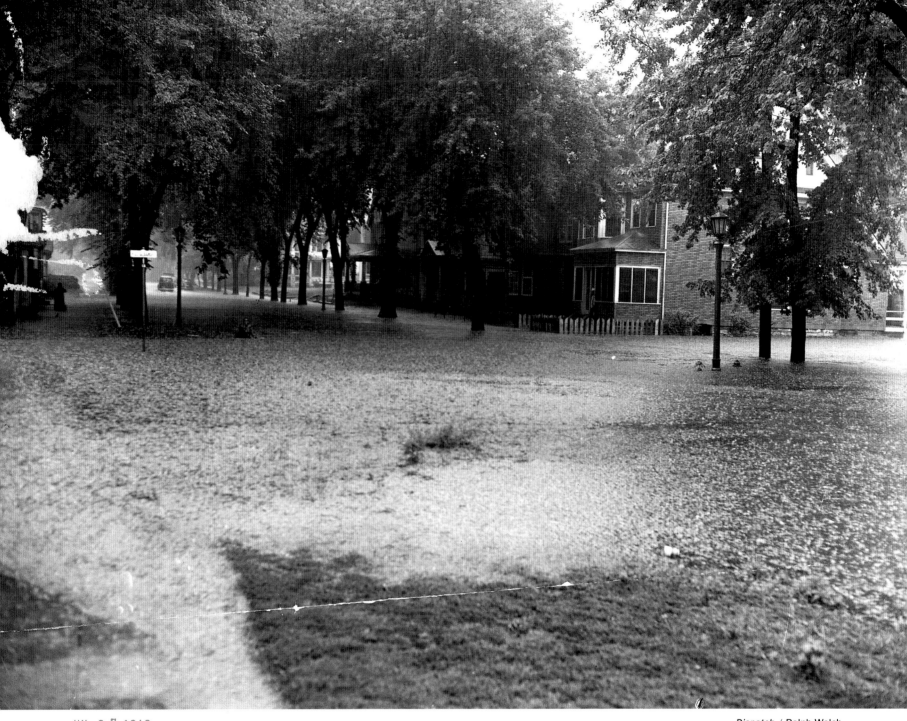

JUL 2 7 1949

Dispatch / Ralph Welch

YOU CAN ALMOST FEEL the rain pounding down in this water-logged view of a St. Paul intersection taken in July 1949 after a cloudburst dumped well over three inches of rain on the city. A boy stands waist-deep in water that ponded at Carroll Avenue and St. Albans Street. Storm drains couldn't keep up with the heavy rain, which was coming down at over an inch an hour. Ralph Welch's atmospheric photograph also provides a look at one of the most notable features of the city of old—its magnificent canopy of elms.

Before Dutch beetles accomplished their work of destruction, most residential streets in St. Paul and Minneapolis were shaded by ranks of mature elms planted with military precision along the boulevards. The canopy that formed over time was remarkable, and in the summer walking or riding down streets in St. Paul and Minneapolis was like passing through a long green tunnel. Trees of many varieties have been planted along city streets since the elm disaster to form a new urban forest. Yet it's doubtful these new plantings will ever quite match the disciplined majesty of the old elm canopy.

Dispatch / Ted Strasser

MAR 2 4 1960

THERE WAS A DISTINCT SENSE of faded grandeur in St. Paul in the 1950s and early 1960s, especially around the fringes of downtown, where scores of decaying buildings awaited their date with the wrecking ball. This elegiac picture, taken by Ted Strasser in March 1960, is one of the best of its kind.

It shows the Jesse Pomroy house, at University Avenue and Jackson Street. Built in the early 1870s, the house featured an unusual two-story porch but was otherwise a textbook example of the French Second Empire style. Pomroy was a pioneer lum-ber dealer and builder in St. Paul, and his house contained exquisite interior woodwork, including a staircase built of black walnut. As with most near-downtown mansions, the Pomroy house was later subdivided into apartments.

By the time Strasser took this photograph, the house was near the end of its days. Interstate 94 was coming through the neighborhood, and redevelopment soon claimed the historic property.

Ted Strasser

ON A GLOOMY DECEMBER DAY IN 1959, photographer Ted Strasser wandered down to the Upper Levee Flats in St. Paul to take a final look at a neighborhood that was about to disappear. People had lived on the flats, near the foot of Chestnut Street, since the earliest days of the city. Over time, the riverfront community came to consist largely of Italian immigrants, who occupied small wood-frame houses lined up along narrow dirt

streets. Since the area was in the Mississippi's floodplain, these homes frequently ended up under water.

The record flood of 1952 finally spelled the end of the old Upper Levee community. The city decided to clear out the area for new roads and a scrap yard, and by late 1959 virtually all of the homes on the flats were vacant and awaiting demolition. Strasser's first photograph offers a view down the community's main street,

Ted Strasser

looking southwest. Northern States Power Company's High Bridge Power Plant, which at that time sported a large sign and a quintet of smokestacks, forms a backdrop. Also visible is part of the old High Bridge with its spidery web of trusses.

Two of the levee's old houses are the subject of another photograph. For some reason, one of the homes has been tipped on its side. Both houses are small and, like others on the levee, have the look of being homemade. The wavy siding on the house at left could be regarded as an inadvertent symbol of the floods that led to the community's demise. Today, a new community—consisting of upscale apartments, town homes, and condominiums—occupies the historic ground that immigrants once called home.

MAR 1 1 1950

Pioneer Press / Jerry Lundquist

ON THE MORNING OF MARCH 10, 1950, workmen in downtown St. Paul were preparing to tear down an old building on Seventh Street that formed part of Bannon's Department Store. Dating to 1883, the three-story, brick-fronted building was one of many of its era still to be found downtown. To make sure no one was harmed by falling debris, workers that morning began to build a temporary protective canopy over the side-walk in front of the store. The canopy, as it turned out, was not of much use.

Sometime after ten o'clock, the workers heard an ominous cracking noise as the building, probably weakened by earlier demolition work, began to shift. "The wall started to crumble at the bottom, and, like

the wriggling of a snake, the crumbling went higher and higher," said a carpenter working on the site who seems to have had a talent for metaphor. He cleared out just in time, as did other workers who as they fled warned pedestrians to stay away. Moments later, a section of the front wall crashed into the street in a shower of timber, brick, and glass. Within an hour, another section came tumbling down as well.

No one was injured, although the *Pioneer Press* reported that a 50-year-old woman who witnessed the initial crash "suffered a heart attack and shock and was taken to her home in a police squad car." One can only hope she called her doctor from there.

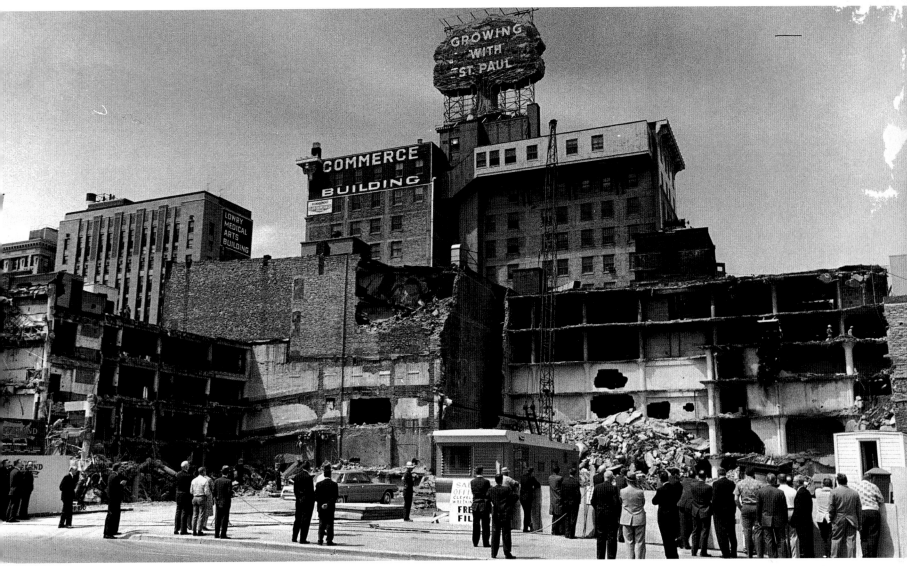

Dispatch / John Connelly

MAY 1 5 1964

CITY BOOSTERS are not known for a well-developed sense of irony, but photographers sometimes have other ideas. Looking at this picture from 1964 of a demolition project, one has to wonder whether photographer John Connelly was offering a sly comment on the remaking of downtown St. Paul. Connelly, who was the newspapers' photo editor for many years, framed the image so as to highlight a large tree-shaped sign

for Midwest Federal Savings and Loan (now defunct) that read "Growing with St. Paul."

Growing in this case meant the destruction of several old buildings at Kellogg Boulevard and Wabasha Street, where a new Hilton (now Radisson) Hotel would soon be built. Connelly took other photographs of the demolition, including one in which he described city hall as standing "over war-like ruins."

DEC 0 3 1965

Pioneer Press / Spence Hollstadt

TO ANYONE FAMILIAR WITH DOWNTOWN ST. PAUL in the 1960s, it must have seemed at times as though a great cataclysm had struck the city. As old buildings fell on block after block, great gouges appeared to the north and west of downtown to accommodate new interstate highways. One of the largest of these digs was for the interchange of Interstates 94 and 35E in front of the State Capitol Mall.

In this photograph from December 1965, looking southeast toward Wabasha Street, the excavation resembles a small open-pit mine. The picture was taken from what would today be a point near 12th and St. Peter Streets, and it gives a good sense of the scale of the work involved in creating the interchange. Today, we take the freeways so much for granted that it's easy to forget how laboriously they had to be dug out of the city of old, at costs that today would be staggering.

This interchange and its ribbon of freeways cost more than mere dollars. It also severed Summit Avenue from its historic link to downtown while all but destroying the historic neighborhood around Miller Hospital. But it did make for much faster traffic, at least as far as Spaghetti Junction.

Pioneer Press / Don Spavin

JAN 1 7 1960

AS THE CITY OF OLD began to come apart in the 1950s, new communities grew with amazing speed all around St. Paul and Minneapolis. Here's an aerial view of the "Thompson Grove" residential neighborhood in Cottage Grove, taken in December 1959. "Thompson" takes its name from Orrin Thompson, a home builder who in the 1950s and 1960s was to the Twin Cities what William Levitt was to Long Island. The "grove" part of the name presumably refers to Cottage Grove, since nary a tree or shrub is visible here. The houses all appear to be compact, one-story ramblers. Every house came with a driveway, but only a few had garages at this point.

According to an advertisement in the *Pioneer Press,* some of these beauties—among them a model known as the "Cinderella Chalet"—could be bought for a mere $12,175, with nothing down (if you were a veteran) and monthly principal and interest payments totaling $67.10. No wonder everybody was moving to the suburbs.

THE PHOTOGRAPHERS

THIS BOOK INCLUDES THE WORK OF 25 PHOTOGRAPHERS, all but five of whom were employed full time by the *St. Paul Pioneer Press* and *Dispatch*. These are some of the men (and one woman) who took the pictures that made this book possible and the number of photos of each that are included:

Jack Loveland (*22 photographs*) began his career with the newspapers in 1925 and remained a staff photographer for more than 40 years. The photos used in this book were taken between 1941 and 1958.

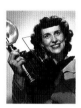

Betty Engle LeVin (*2 photographs*) was the sole woman on the photo staff of the *Pioneer Press* and *Dispatch* during the years covered by this book. Her tenure—during World War II—was brief. She went on to enjoy a long career as a wedding photographer in St. Paul.

Ted Strasser (*22 photographs*) worked at the newspapers from the 1940s until his retirement in the 1970s. The tremendous range of images he produced shows just how quick and versatile news photographers of the period had to be.

Hi or **Hy Paul** (born **Hyman Paulinski**) (*15 photographs*) was a "character" known for his imperfect command of the English language and his outgoing personality. He worked for the Pioneer Press and Dispatch from 1944 until his retirement in 1972.

Don Spavin (*14 photographs*) started at the newspapers in 1948 and retired in the 1970s. Both a photographer and a reporter, he covered "outstate" Minnesota for many years and also specialized in aerial views.

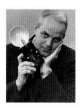

Roy Derickson (*10 photographs*) trained as a photographer in the U.S. Navy during World War II, joined the newspapers in 1946, and stayed for 44 years. He was among the first staff photographers to master the intricacies of color reproduction. Derickson is one of three retired photographers interviewed for this book.

David (D. C.) Dornberg (*10 photographs*) also began his photojournalism career in 1946. He was known for his technical skills and invented a number of special-use cameras for the newspapers. He left in the mid-1950s to go to work for the Minnesota Mining and Manufacturing Co. (3M Corporation).

Larry Anderson (*6 photographs*) became the newspapers' first full-time overnight photographer in 1946. Information about Anderson is sparse, and it appears he worked for the *Pioneer Press* and *Dispatch* for only a few years.

Sylvan (Sully) Doroshow (*13 photographs*) hired on at the newspapers after World War II and stayed until the 1990s. He can still recall the day in August 1965 when he was assigned to cover a rock-and-roll group he'd never heard of—the Beatles—on their first and only visit to the Twin Cities.

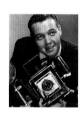

Dick Magnuson (*21 photographs*) had a relatively short career at the newspapers, from about 1948 to 1958. Even so, he produced a superb body of work. Blessed with an uncanny knack for being in the right place at the right time, he was responsible for some of the finest "spot news" photographs of the era.

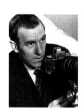

Dennis (Buzz) Magnuson (*8 photographs*) came from a family of news photographers that included his father, Chet (who worked for the Associated Press), and his brother, Dick. Buzz Magnuson's career at the *Pioneer Press* and *Dispatch* began in 1955 and lasted for 46 years. He was of great help in putting this book together.

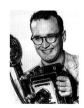

Spence Hollstadt (*12 photographs*) started work for the *Pioneer Press* and *Dispatch* in 1959. In the early years of his career, he was the newspapers' overnight photographer. Hollstadt retired in the early 1990s.

ACKNOWLEDGMENTS

THE WRITING OF HISTORY is always a collaborative act, even if only one name appears on the book cover. With that in mind, I wish to extend my thanks to a number of people who provided assistance over the two years it took to research and write this book.

Three retired *Pioneer Press* and *Dispatch* photographers—Dennis (Buzz) Magnuson, Roy Derickson, and Sylvan Doroshow—graciously consented to interviews. Their recollections offered many insights into their work and that of the newspapers' photo desk during the Speed Graphic era. Buzz Magnuson was also kind enough to show me photographs from his own collection, several of which appear in this book, and to give me a personal lesson in the use of the Speed Graphic camera. His daughter, Jodi Magnuson, also helped by providing a handy list of photographers who worked at the *Pioneer Press* and *Dispatch* during the period covered by this book.

Two other retired newspapermen—John Finnegan, former editor and assistant publisher of the *Pioneer Press* and *Dispatch*, and longtime "Oliver Towne" columnist Gareth Hiebert—also agreed to interviews. Both gave me much useful information about newspapering as it was practiced in the 1950s.

I owe a special debt of gratitude to *Pioneer Press* librarians past and present who helped me locate photographs, answered countless questions, and tolerated my constant rooting around in the library files. The librarians include Ruth Ehmcke, Deb Nygren, David Holt, Paulette Myers-Rich, Erin Pfeiffer, Kathy Rysgaard, Pat Thraen, and Chris Wareham. It's fair to say I could not have done this book without them

I also wish to thank Harold Higgins, publisher of the *Pioneer Press*, for permitting the use of the copyrighted photographs that appear here.

As I was putting this book together, I received crucial research assistance from Susan Dowd, who spent many hours tracking down the newspaper stories that go with the pictures. Her volunteer services are greatly appreciated.

At the Minnesota Historical Society Press, I wish to thank the director, Gregory Britton, for his enthusiastic support. As always, my editor at the Press, Sally Rubinstein, did expert work in gathering all the threads together and keeping my prose in line.

I'd also like to thank Jack LeVin, who provided a wonderful picture of his wife, Betty Engle LeVin, the first woman photographer at the *Pioneer Press* and *Dispatch*.

I'm grateful as well to John Camp (better known to readers as John Sandford), a former newspaper colleague at the *Pioneer Press* and now a best-selling author. John readily agreed to take time out from his impossibly busy schedule to write the wonderful foreword to this book.

Finally, I wish to thank my wife, Stacey, and my two at-home children, Lexy and Corey, for their support and encouragement as I toiled away on yet another book.

NOTES

1. Virginia Piper, wife of a wealthy investment banker, was kidnapped from her Orono home on July 27, 1972. She was found two days later chained to a tree in Jay Cooke State Park near Duluth after her husband, Harry Piper, had paid a $1 million ransom. Two men—Kenneth Callahan and Donald Larson—were arrested five years later and convicted of the crime. However, a new trial was ordered by an appeals court, and the two men were subsequently acquitted. Most of the ransom money has never been found.

2. The estimate of two million clippings, which does not strike me as unreasonable, was made by Roy Swanson, the newpapers' chief librarian from 1939 to 1971, in an article he wrote in February 1955 for the *Press-Dispatch*, an in-house publication. The library, founded at the *Dispatch* in 1906, employed as many as 14 librarians at its peak and also functioned as kind of public information agency. In his article, Swanson estimated the number of photographs in the collection at one million—a number that seems high but is not beyond the realm of possibility.

3. The *Pioneer Press* has donated thousands of negatives and a lesser number of prints from its collection to the Minnesota Historical Society. However, many of the photographs featured in this book can be found only in the newspapers' archives.

4. Author interview with John Finnegan, May 30, 2003.

5. Author interview with Gareth Hiebert, October 28, 2003.

6. For more on Bomberg, see Don O'Grady, *History at Your Door: The Story of the* Dispatch *and* Pioneer Press, *1849–1983* (St. Paul: Northwest Publications, Inc., 1983), 80. See also Nate Bomberg, "St. Paul and the Federal Building in the Twenties and Thirties," in Eileen Michels, *A Landmark Reclaimed* (St. Paul: Minnesota Landmarks, 1977), 49–61.

7. Finnegan interview.

8. Author interview with Dennis Magnuson, April 10, 2003.

9. Magnuson interview.

10. The photo editor at the *Pioneer Press* and *Dispatch* during the Speed Graphic era was Earl L. (Curly) Vogt, who began working for the newspapers in 1925. He is credited with many innovations, including the deployment of cruising photographers in the late 1940s to follow police and fire calls. Vogt retired in 1970. See O'Grady, *History at Your Door*, 72, 113.

11. John Connelly, "Hy Was Never Shy, but Now He's Retiring," *On the Scene* (in-house publication of the *Pioneer Press* and *Dispatch*), Autumn 1972, p. 16–17, copy in *Pioneer Press* library.

12. Magnuson interview.

13. O'Grady, *History at Your Door*, 128.

14. Author interview with Roy Derickson, June 2, 2003.

15. O'Grady, *History at Your Door*, 113.

16. Timothy Takahashi et al., "The Graflex Speed Graphic FAQ," at www.graflex.org. This web site is one of the best sources for information about the design, history, and use of the Speed Graphic camera. The site includes model descriptions, technical specifications, and links to many articles about the camera. The Speed Graphic still has its passionate admirers. In an article for *Camera Shopper* magazine in August 1995 (available on the Graflex site), Mike Roskin wrote: "I still feel, deep inside, when looking at young photographers and their click-whir machines, that if you haven't cut your teeth on a Graphic, you're only a pretend photographer."

17. Weegee [Arthur Fellig], *Naked City* (New York: Essential Books, 1945; Cambridge, Mass.: Da Capo Press, 2002), 240.

18. Derickson interview.

19. William Hannigan, *New York Noir: Crime Photos from the Daily News Archive* (New York: Rizzoli, 1999), 19.

INDEX

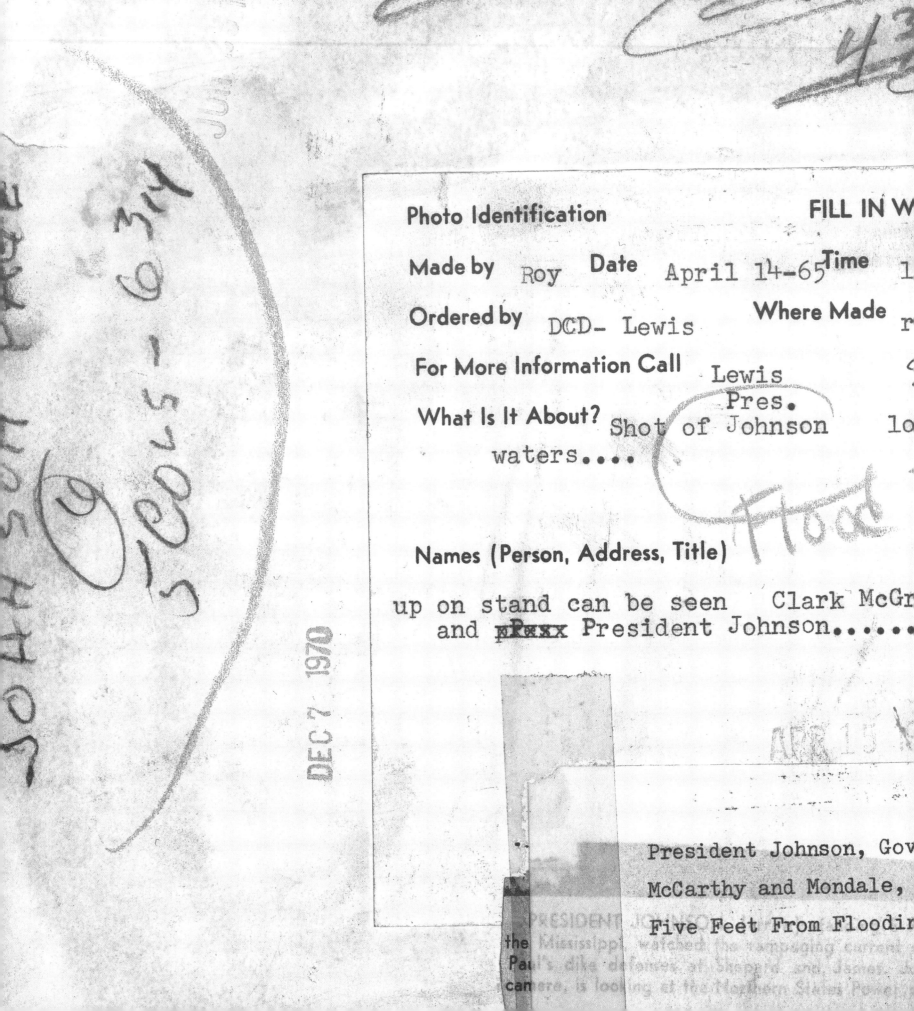

Photo Identification FILL IN W

Made by Roy Date April 14-65 Time 1

Ordered by DCD- Lewis Where Made r

For More Information Call Lewis

What Is It About? Shot of Johnson Pres. lo
 waters.... Flood

Names (Person, Address, Title)

up on stand can be seen Clark McGr
and ~~Pxxx~~ President Johnson........

President Johnson, Gov

McCarthy and Mondale,

Five Feet From Floodi